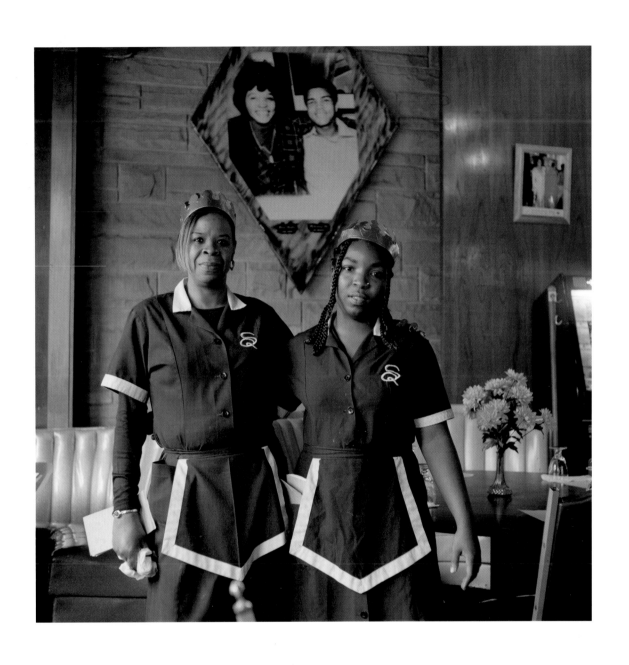

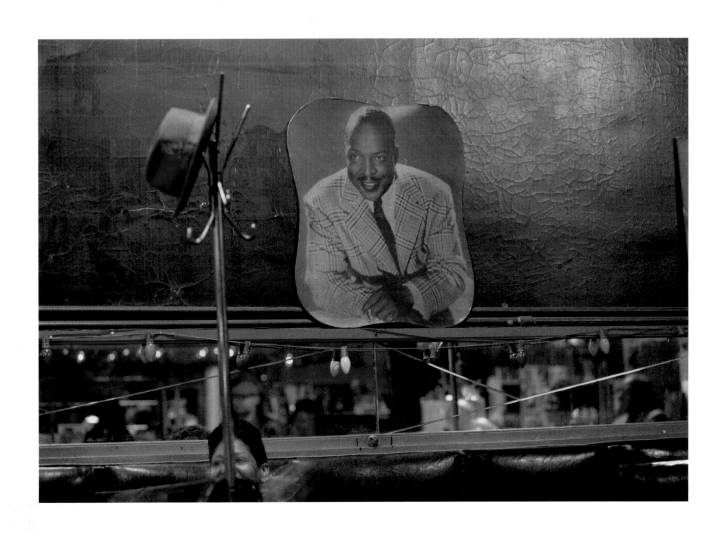

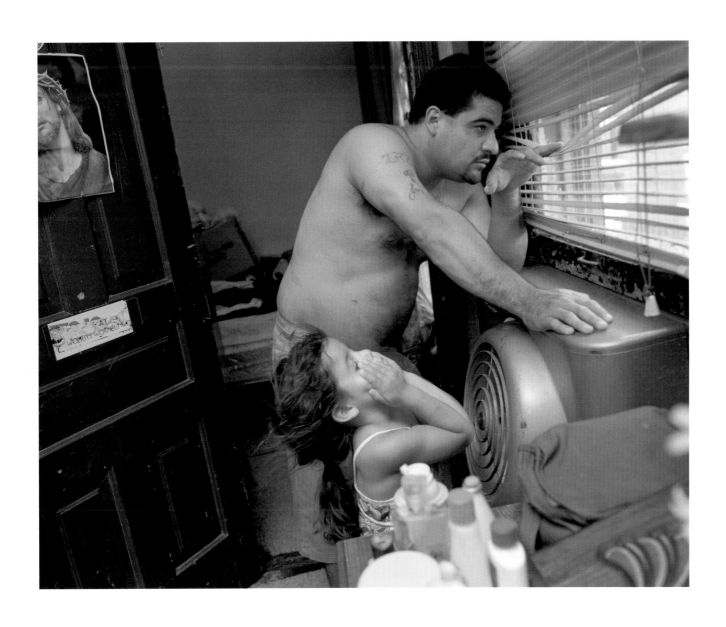

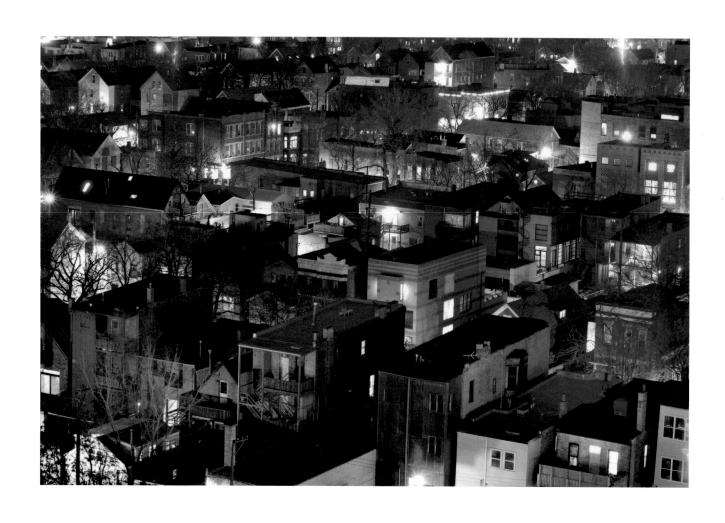

city

The collection of photographs contained in this book is a small sampling of the images in the *Chicago In The Year 2000* archive. This archive is a result of a project documenting Chicago at the moment between two centuries. Not only do these images show a glimpse of the lifestyles, architecture, spirituality, and personality of the city, they also show how passionately and creatively photographers can tell the city's story.

The accompanying text—prose and poetry, fiction and essays—is also a sampling, from Chicago authors at the dawn of a new century, and it serves as a thread weaving its way through the photographs, making connections while adding another level of description about the city. Each piece discusses a corner of Chicago that many of us know like the backs of our hands, but others among us are yet to discover. That is what makes Chicago—and this project—so interesting: its fluidity, mutability, and openness to continual evolution.

What you will see in the images and text that follow are memories, both of a city, and the people who make up that city.

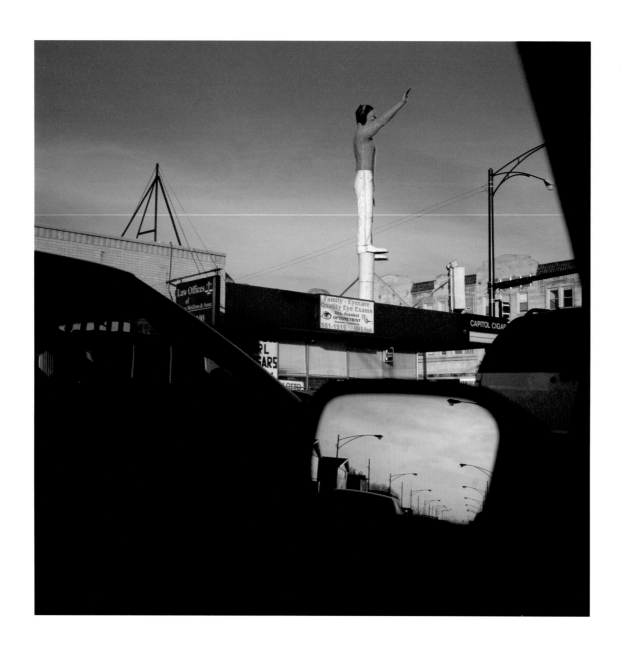

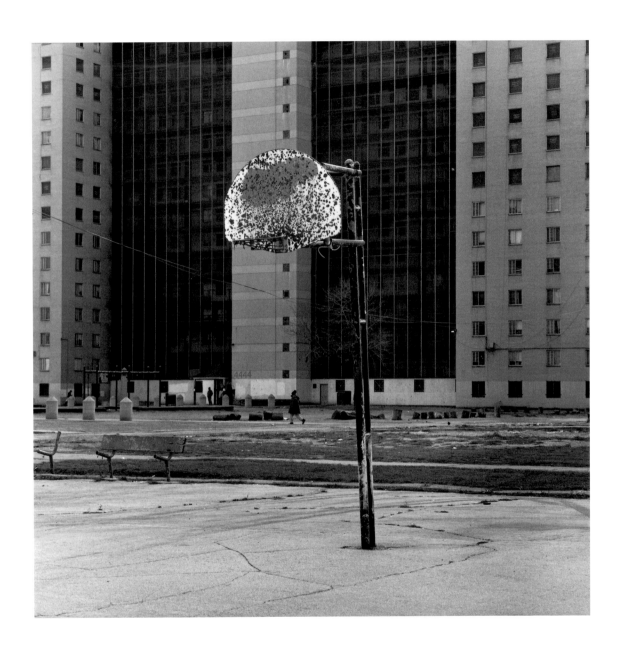

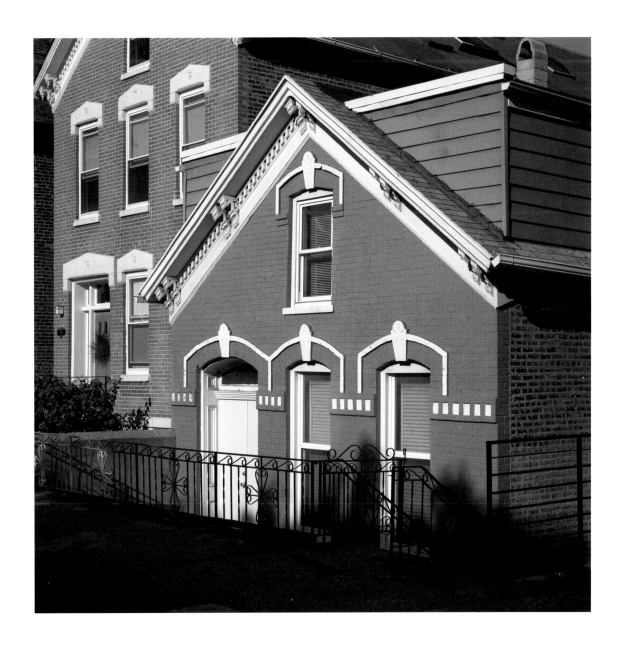

It all began on an early morning drive up Michigan Avenue from Roosevelt Road toward the Loop. I was admiring "the Cliff," that magnificent façade of buildings—Chicago's great architectural heritage from the 19th and 20th centuries—across from Grant Park. Beyond, and to the right, I could see the cranes and equipment assembled to build Millennium Park, and, to the left in the distance, the concrete and glass towers of modern downtown Chicago. I thought to myself, *a thousand years from now, on the eve of the next millennium, what would we see looking up this street?*

A city is constantly reborn. It lives, it grows, it dies and it is born again. When I go back to my birthplace on the South Side of Chicago, the changes that have taken place in just 50 years render it almost unrecognizable. My alma mater, Hyde Park High School, still stands, but where are the 63rd Street "L" trains, the Southmoor Hotel, the Jeffery Theatre and the Bryn Mawr Bowling Alley? Along with the bright orange Gary trains, they are gone and few remember that they were there.

Even 100 years from now, it is unlikely that the buildings along the Cliff will exist, much less 1,000 years from now. These buildings will be ghosts. We will all be ghosts—you, me, our children—the entire city as we know it today will be part of the distant past.

So, with an eye to the future, the idea was born to take a yearlong snapshot of Chicago, beginning the first minute of the new millennium and ending the last minute of the year 2000, to make it a photographic record documenting who we are and what we were; of how we worked, how we lived and how we played. What better way than to use images at the dawn of the digital era to preserve a memory of ourselves and of our city for our children and grandchildren, and for all the generations beyond them.

CITY 2000 became a monumental project and involved thousands of Chicagoans from Mayor Richard M. Daley, who gave it his blessing and the city's cooperation, to the many people who allowed us into their lives in a very personal way.

In particular, I want to thank Lee Eisenberg and Dan Okrent who gave us the name, CITY 2000—"Chicago In The Year 2000," and give special thanks to Rich Cahan, who believed in the idea and resigned from his job as a *Chicago Sun-Times* photo editor to become director of CITY 2000. Rich brought together the "Great 8," the full-time staff of amazing photographers who worked with more than 200 contract photographers to freeze our city in place at the beginning of this new era. In a short time, CITY 2000 was staffed by a select group of photo editors and image technicians—the best in the business. Our beloved city was captured on film with love and compassion and art. Everyone's unique talents made the project come alive.

The final tally of CITY 2000 images numbers more than half a million. They are preserved and archived at the University of Illinois at Chicago campus, in the Richard J. Daley Library.

The book you hold in your hands is the first selection from this archive to appear in printed form. It has been given life by Editor and Producer Teri Boyd, who was also lead editor of the original CITY 2000 team. Teri has brought together a wonderful selection of images and married them with essays from a range of Chicago writers: some familiar voices, as well as emerging talent. This book is a first remembrance of what will hopefully be a thousand-year-long trail, a living record of one year of life in one great city.

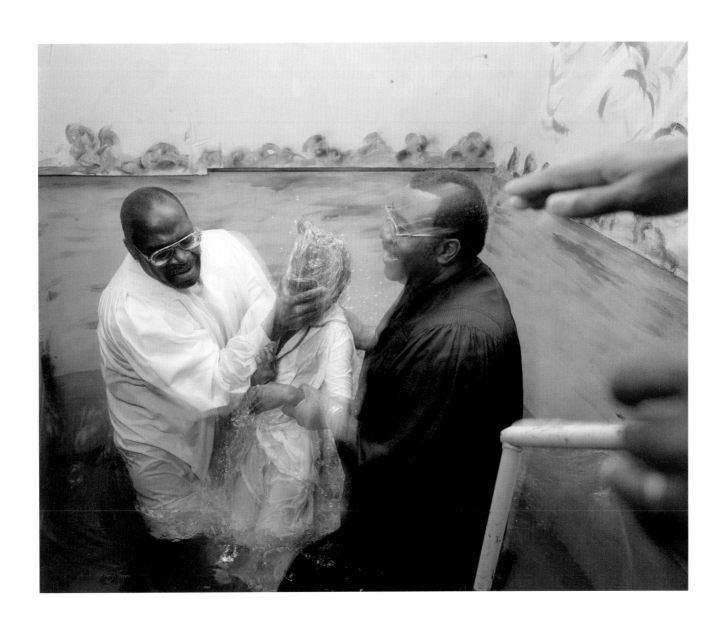

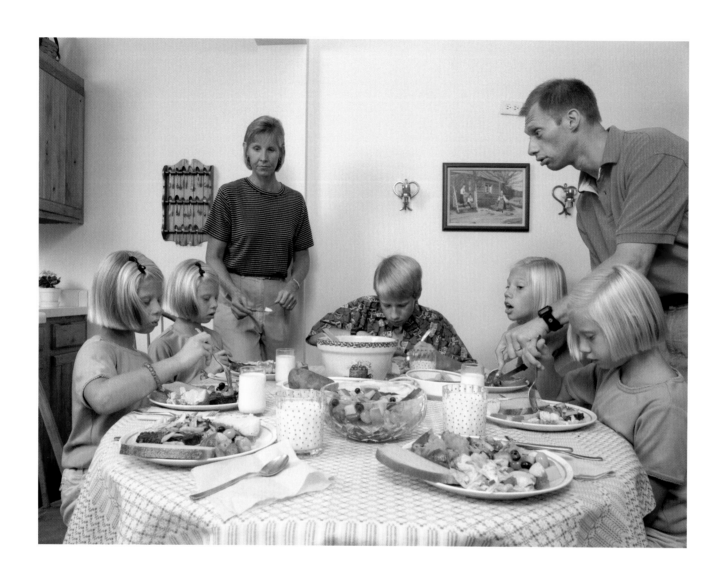

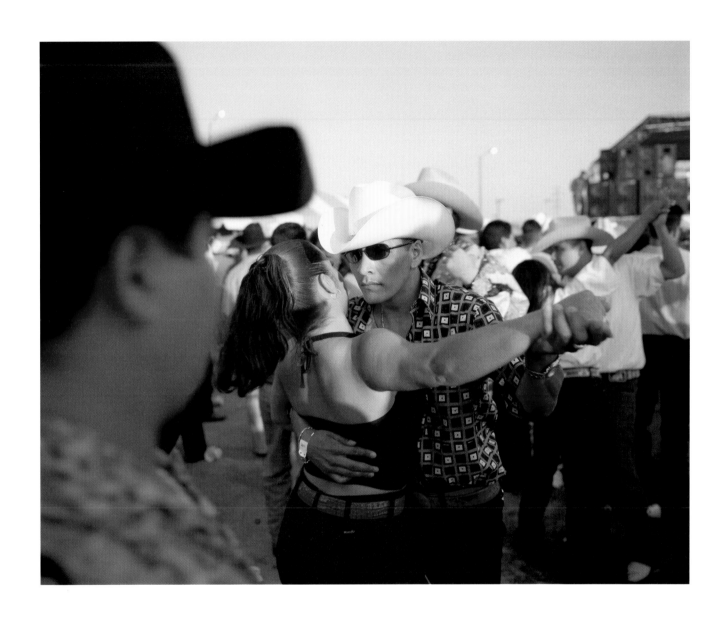

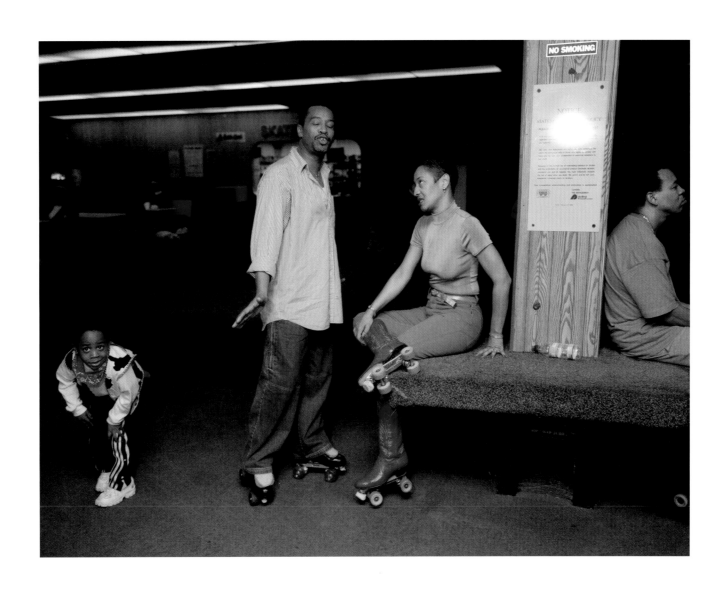

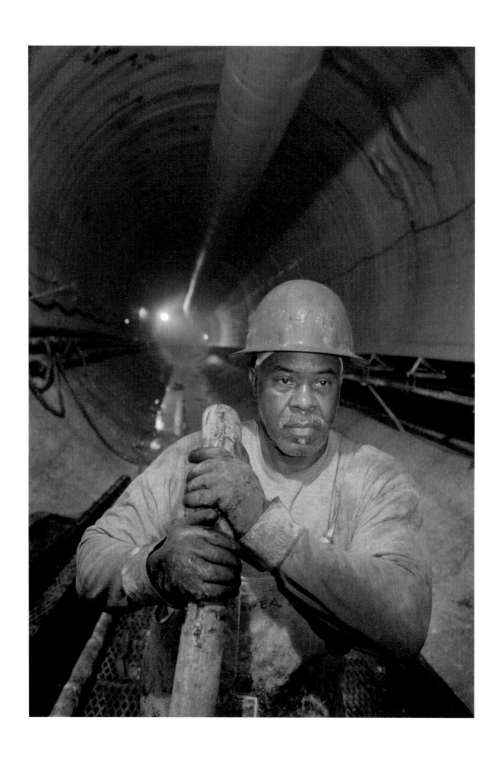

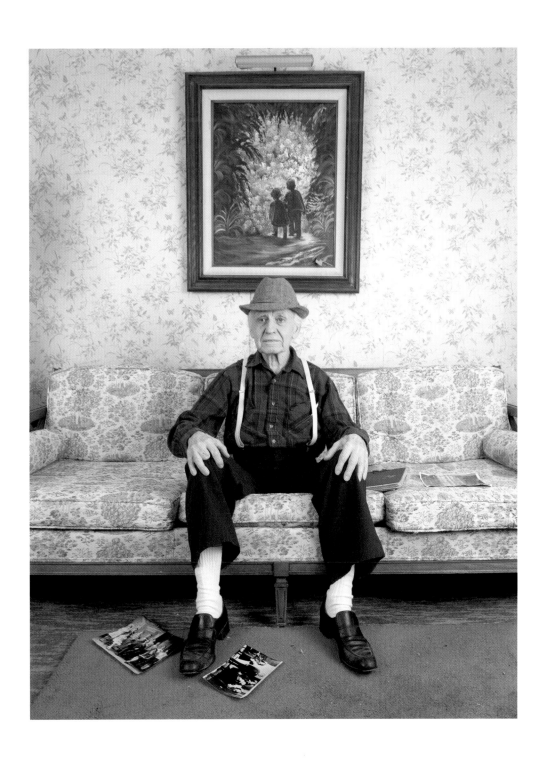

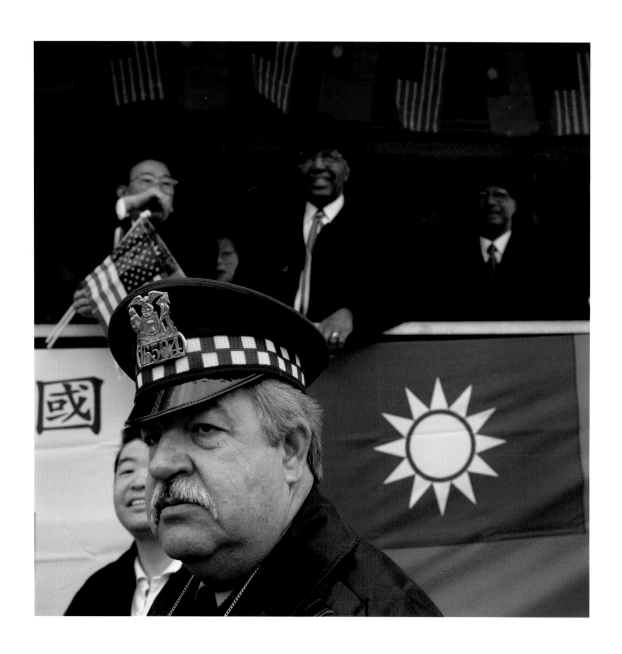

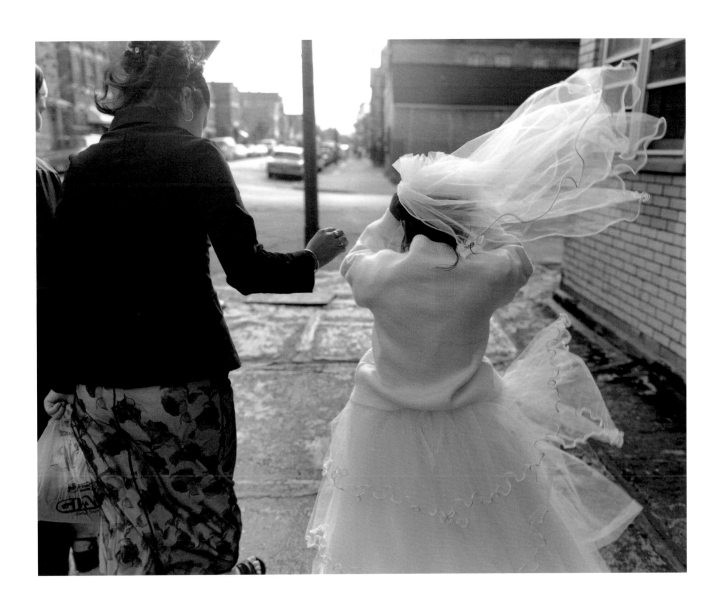

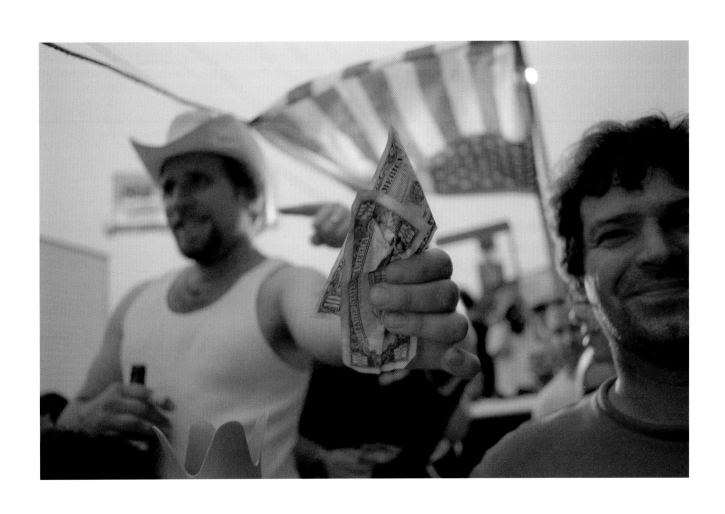

In that instant when one millennium passed into another I was on the Michigan Avenue Bridge. It is where time for me stands as still as it can stand and the whole wild, soft, raucous, snazzy, jazzy, determined, boisterous, insecure, vigorous, audacious, competitive, prideful thing that is Chicago comes together in a blast of buildings and water and sky; where the present sits in stone, brick, steel and glass and whatever is to be made of tourists' open-mouthed amazement; where the future signals mysteriously from holes in the ground and birdlike cranes reaching up into the skyscraper air; and where, if you listen closely, the past will whisper to you: *Checagou.*

The word came when the Algonquins, fleeing the bloodthirsty Iroquois, found skunk cabbage and wild onion on the banks of the river and affixed to the site their name for those earth products.

It's a fool's game to imagine what they might say now: What is an Indian word for "Wow"? Or what might any of the millions of others who have come here since have to say about what we are now, this city that all of them, in ways large and small, helped to shape? And what will you say about it tomorrow? The city is an organic thing, changing every day, every hour, and trying to capture it at any given moment would seem a crazy notion.

But that's what Gary Comer wanted to do. This child of the South Side, who would build his business and raise his family here, wanted to capture the city in a year—2000.

And, so we got it, CITY 2000—thanks to Comer's vision and perseverance, the efforts of dozens of photographers and editors, and a change of purpose that brought people, lots of them, as well as buildings into the mix—in the more than 500,000 images now tucked away at the University of Illinois at Chicago.

What you see before you has 199 of those photos. They do not represent a "best of" gathering but rather are great photos that capture us in public and in private, in every neighborhood, at a moment in time.

Comer said, "I see the entire project as a message to the future." But for all of us, the future is now, and so we should demand, "What is the message?"

In order to find an answer, you first should listen. When I listen, I hear the sound of a typewriter, the typewriter on which my late father banged out—two fingers pounding furiously—books about the city. He was a newspaperman in love with Chicago and its past. He wrote books, with others and on his own, about that history. But before I was old enough to read any of them, my father wrote Chicago stories in my head and on my heart.

There we were, yes, standing on that same Michigan Avenue Bridge, and I heard from him the tales of the massacre at Ft. Dearborn. There we were, driving down 63rd Street, and I listened to stories about the amusement park named White City, which led to stories about the first Ferris wheel and the World's Fair of 1893. Wherever we went and whatever we did, it was possible to feel the pulse of the past: Nelson Algren, Studs Terkel, Win Stracke and so many others would sit in our living room, adding their stories to the mix.

Let the academics moan, but history should be taught on the streets, not just in the classroom. It should first be heard as stories about characters, not facts; stories told at the places where events took place and people lived. It's a more visceral and intimate experience. The books can come later.

You can go out and wander, see a Chicago that is not all spit and gleaming Millennium Park "bean," a city that the late, great newspaper writer M.W. Newman described as the "old-time streets behind the skyline where the city lives (or withers) with miles of empty lands." Or as a poet puts it in this book, "The city is full light, but no one's seen a thing."

Look! All of the writers in this book look—in vastly different, often surprising but deeply personal ways. They are explorers in search of the city's soul. And they have found it: in a plot of grass, in the curve of a South Side boulevard, in a real blues bar, on the changing face of a North Side Street, in the lake.

Yes, it is out there, in the uncelebrated city, embodied by Thomas Gaither, for more than 20 years a buck-a-bag peanut vendor on an Eisenhower Expressway off ramp who speaks with pride of his kids and says, "You can't expect a good day every day. You gotta be patient. And no matter how that wind blows, you gotta keep smiling"; and by Bouchaib Khribech, who came here as a 23-year-old from his native Morocco in 1990 and— while working full-time at the Billy Goat Tavern—became an American citizen, and two years ago opened his own joint, the coffee shop/restaurant Marrakech ExpressO on the North Side, and who says, "It will be hard, but my family will help, and I like hard work. It is like a dream. When I first come here I sleep in the park four blocks away. Now I have this."

They too—along with, maybe more than, the movers and shakers and Oprah—define and shape the city.

You will hear it argued, as it was in a Chicago Tribune commentary a couple of years ago, that "Chicago remains resolutely non-famous, off the radar screen, the fly-over city, the world capital of nothing, unsung except in musicals like 'Chicago,' which celebrate the city for all the reasons we've been trying to live down since the days when Chicago truly was famous. Chicago's problem is that, if it has an image at all, it's 50 years out of date. Al Capone, Carl Sandburg, City of the Big Shoulders, all that sort of thing. You know: We're that roaring, brawling, true-gritty city by the lake, crooked but rollicking, that toddling town, not ready for reform yet...That old Chicago probably is gone forever."

It is not. That old Chicago echoes across the years and the sound goes on: Carl Sandburg is in the poetry of Marc Smith, founder of the Poetry Slam at the Green Mill; Muddy Waters lives in the fingers of Buddy Guy; Louis Sullivan whispers to a young architect dreaming of buildings in the sky; Mike Royko guides the eyes of a cub reporter.

All of the photographers and writers in this book are inspired by the city, even those who are not from Chicago, even those who have come and gone. The Algonquins came and went. The city's first citizen, John Baptiste Pointe du Sable, came and went. We all come and then we go, leaving our marks— and those marks become our history and they cannot be erased.

Here I am, and there is not a day that passes that I do not find my head filled with Chicago. It comes at me from pictures, from words in books, from stories told, sights seen, or some weird combination of all those things. From way back, I imagine the massacre at Ft. Dearborn or Sally Rand dancing with her fans. From the recent past, captured in this book's photos, I see Gerri's Palm Tavern on the South Side, shuttered in 2001; I see a woman standing on State Street, still a "great street"; I see the Wentworth White Sox, a Little League baseball team; and, I see Lake Michigan shimmering in its different colors.

The images and words in this book will connect you to the city in real ways, allow you to touch the soul of this distinctly American place. But they will also make you wonder about what the city will be when we are gone.

There will, surely, be miracles and mistakes, wickedness and wonders. But, just as the Indians who first claimed this land could not imagine it today, we are incapable of imagining it tomorrow. Future generations will be able to hold what you now hold in your hands, this "message to the future," but what will they see and hear?

One of them will be my new daughter, just learning to walk as I write this. I have shown her this book. She began to eat its pages. But one day I'll show it to her again and she'll devour it differently, reading its words and diving into its photos. And if we later happen to be standing on a bridge that spans the river, she might hear a whisper and look up at me. Maybe she will be getting the message and in her eyes I will see a bright reflection of our city, caught in a moment and forever.

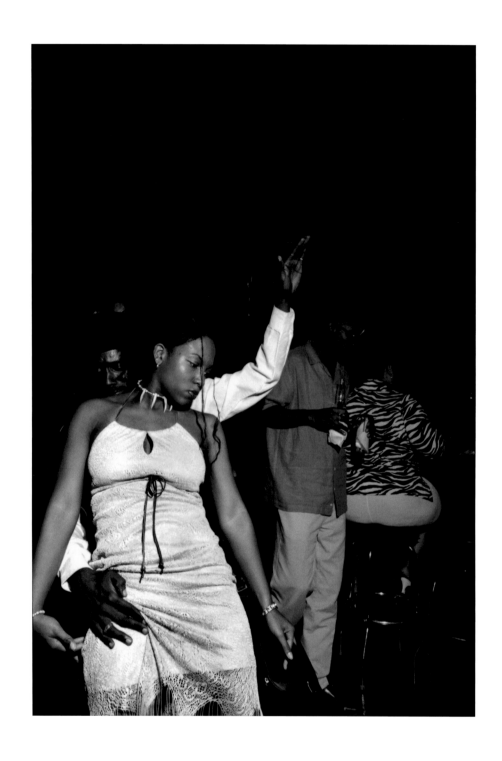

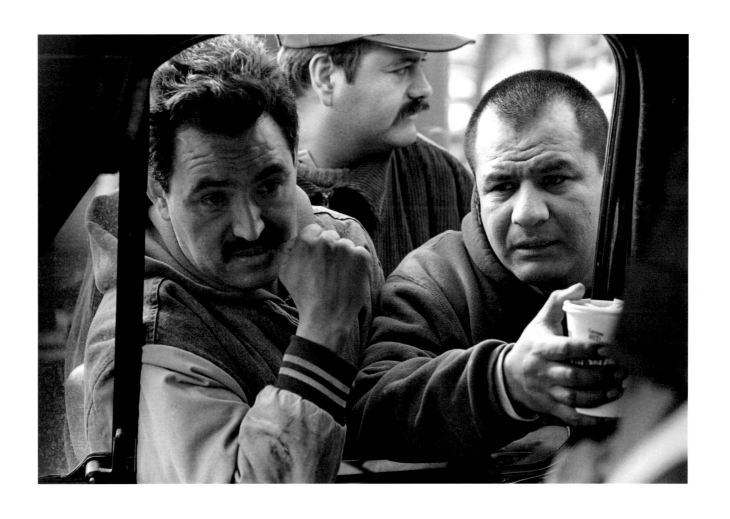

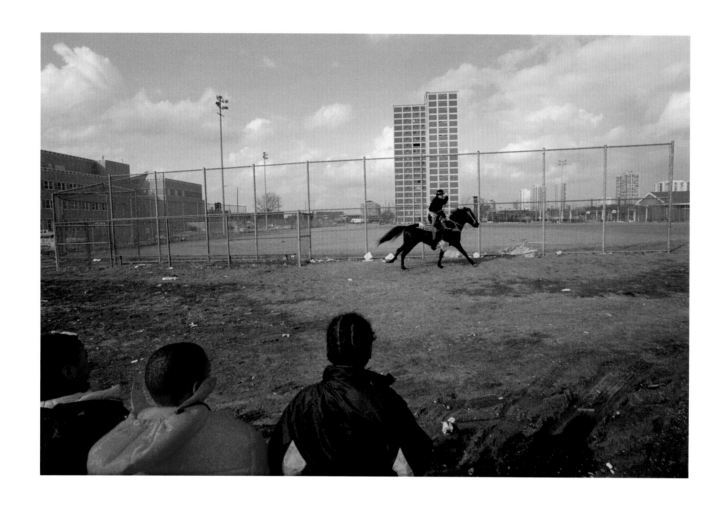

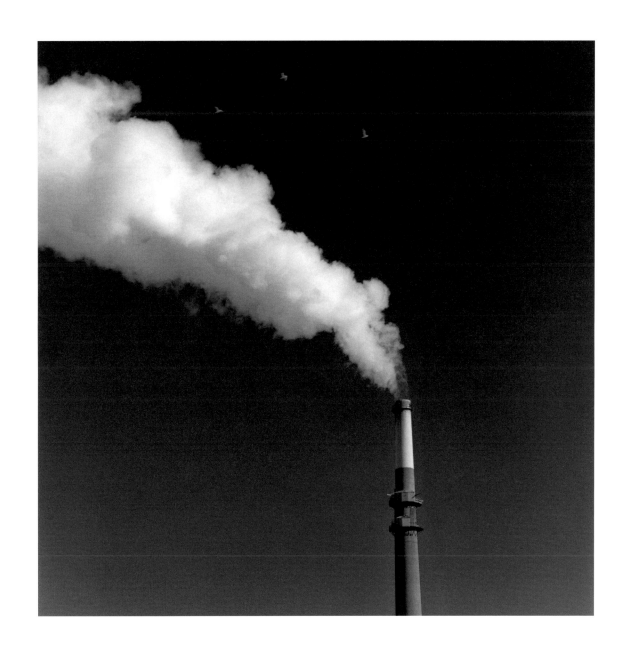

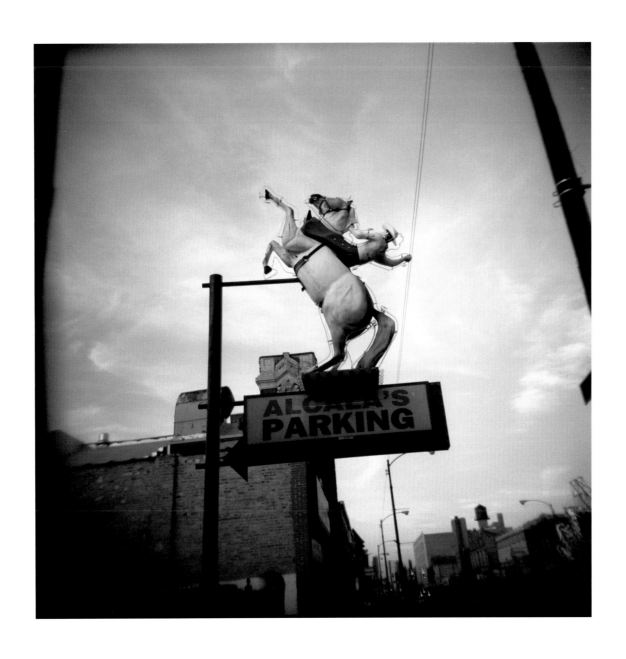

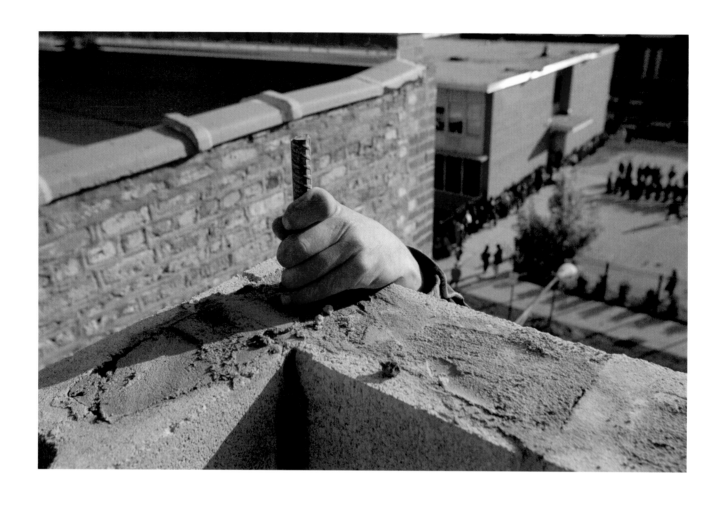

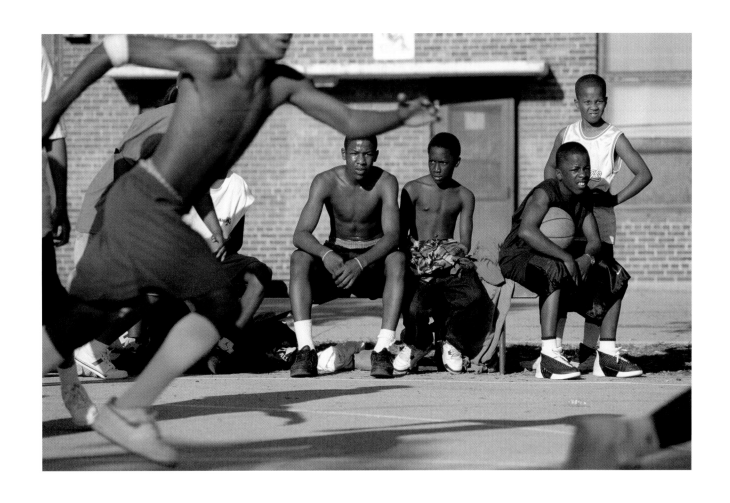

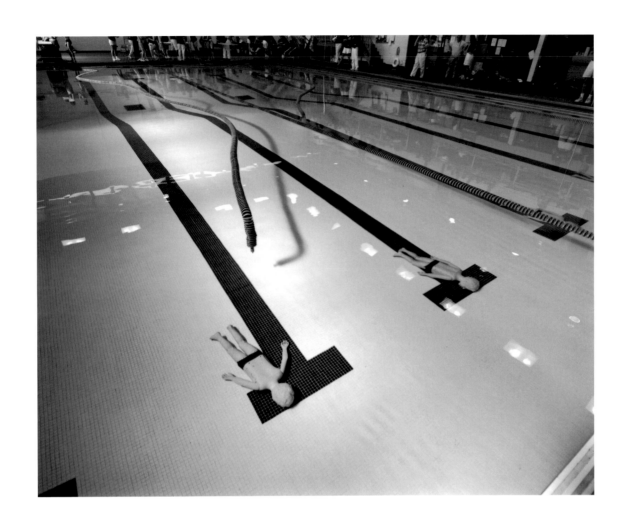

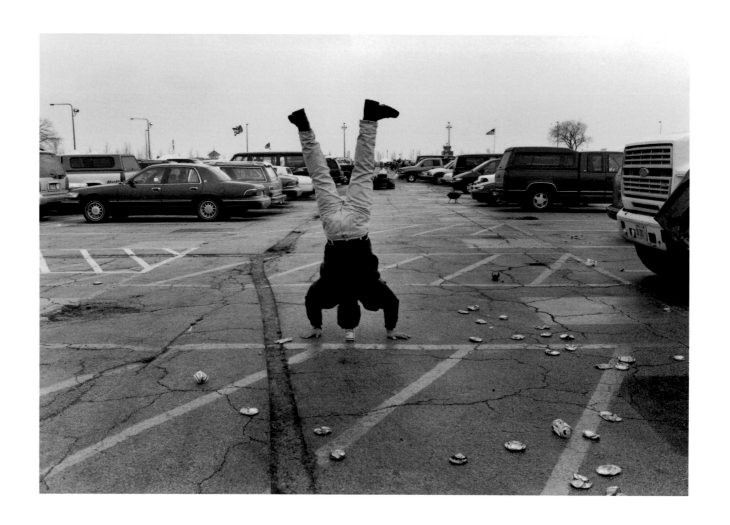

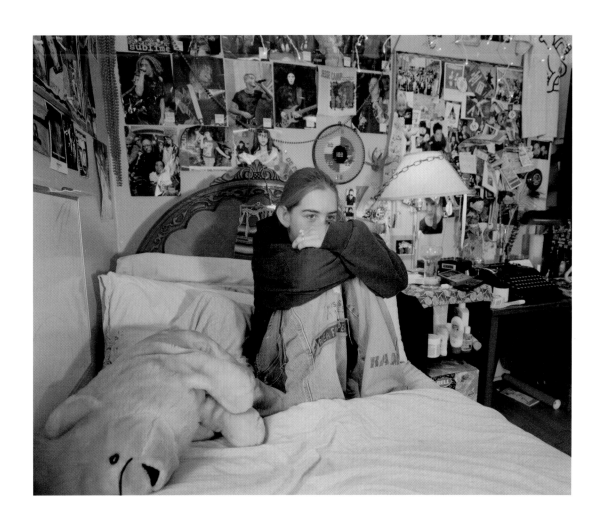

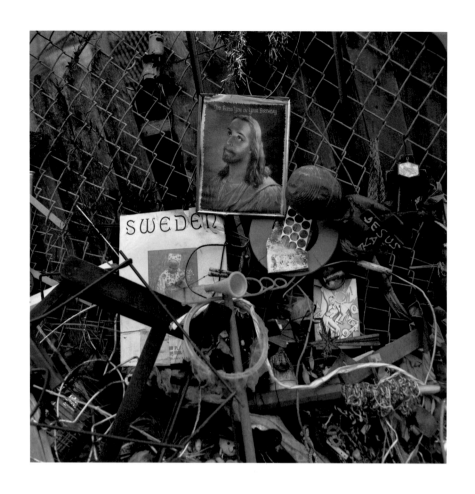

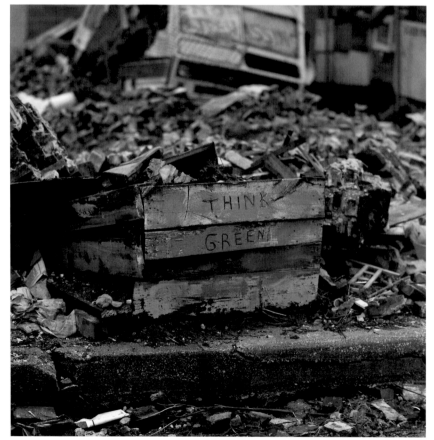

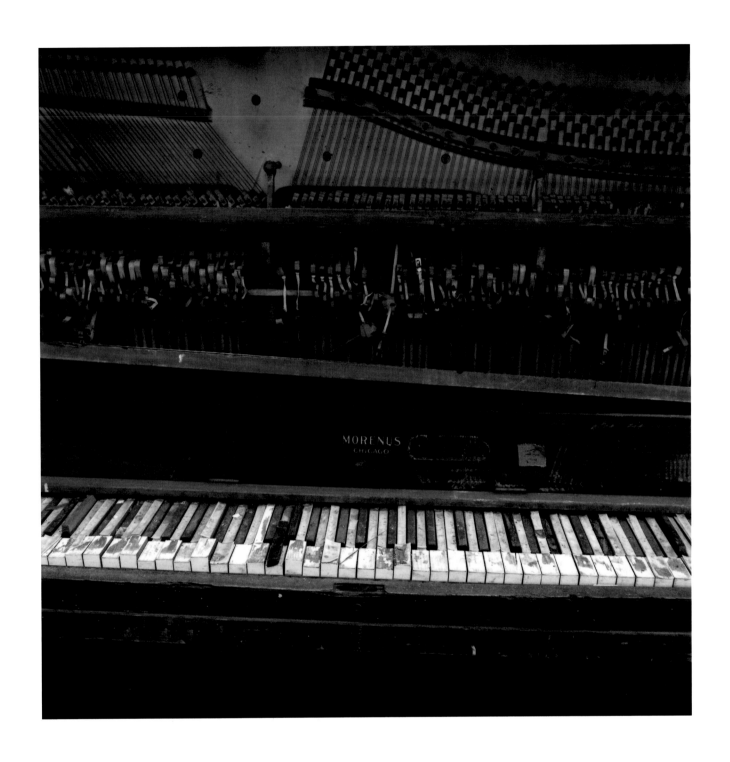

My old friend Stephen Deutch was a great photographer, able with his camera to capture the whole scene, whatever and wherever that scene happened to be. Simply put, he saw it, he felt it, he snapped it.

Photography has changed since Steve's time, which was roughly from the 1930s into the 1980s, but I think he would be pleased by what is in this book. Here, the "whole scene" is Chicago, which has proven for generations an ever-elusive character for poets carrying cameras or pens.

The photographs in this book were not meant for the society pages. These photographers' grails are elsewhere and they have gone where the action is: a rodeo in Little Village; a baseball game on a cracked concrete field; on a lonely lakefront or on a dying Maxwell Street; the lonely old gaffer or the tough old doll on the park bench. They have caught people and places that many of us may see but never really catch beneath their surface. Not all of the pictures are pretty, but in the so-called ordinary city the photographers have found, and captured, a certain and real majesty that is extraordinary.

Hope peppers this book, the hope that Chicago will remain diverse and alive, no matter the efforts toward homogenization and boredom; that it will continue to attract people from various places carrying their new versions of the American Dream and will nurture those people and make the dreams real, keep Chicago real. It becomes in this remarkable and moving gallery what it has always been—our archetypal American city.

One can always look back on life as a series of snapshots of the mind. I have lived 93 years, almost all of them tied to this place. Now, I can add these new and powerful photos to my life. I do not know all of the people in this book, all of the places. But in the pictures I see, indelibly, the whole scene. More importantly, I *feel*, as I suspect, you will.

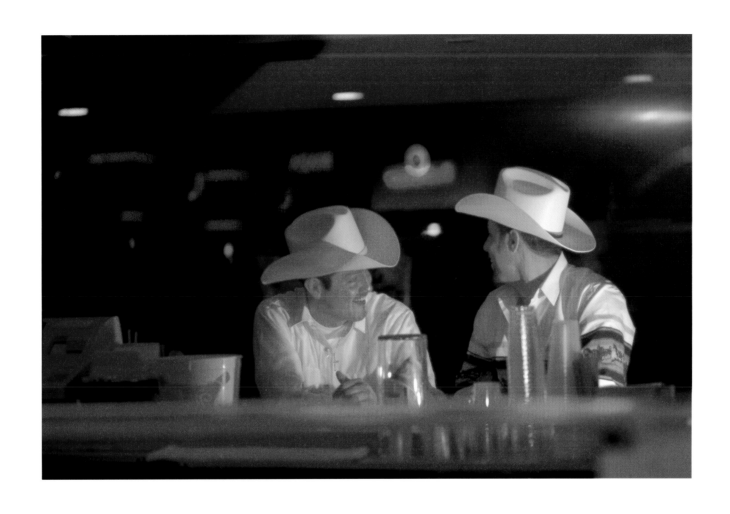

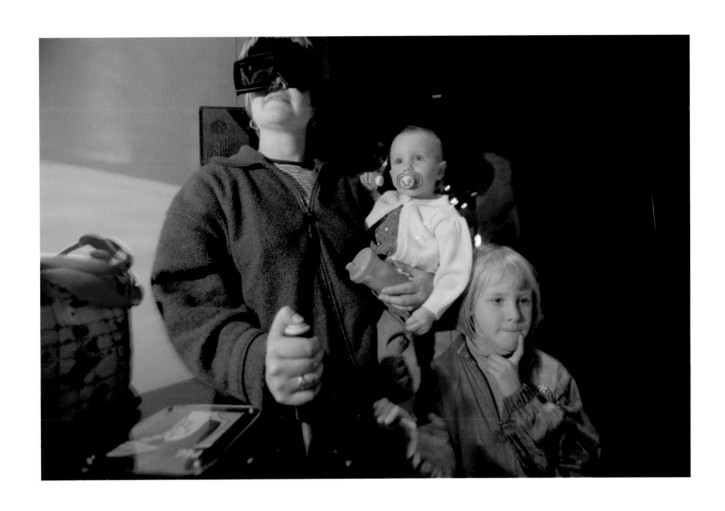

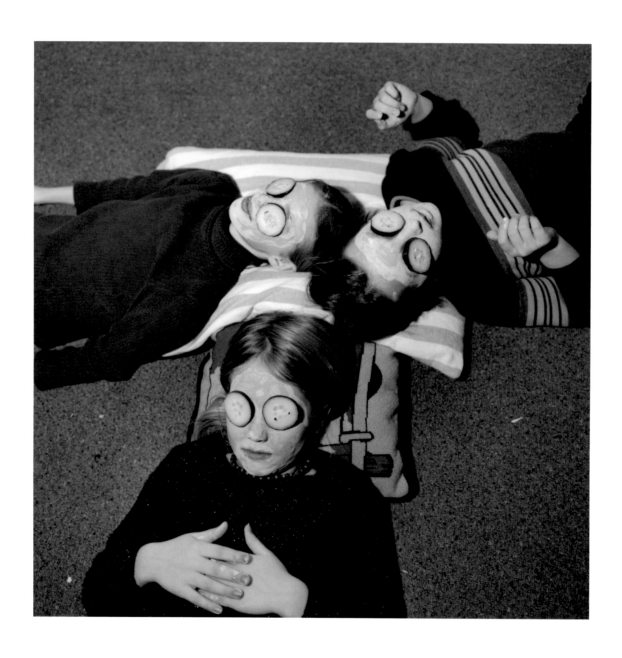

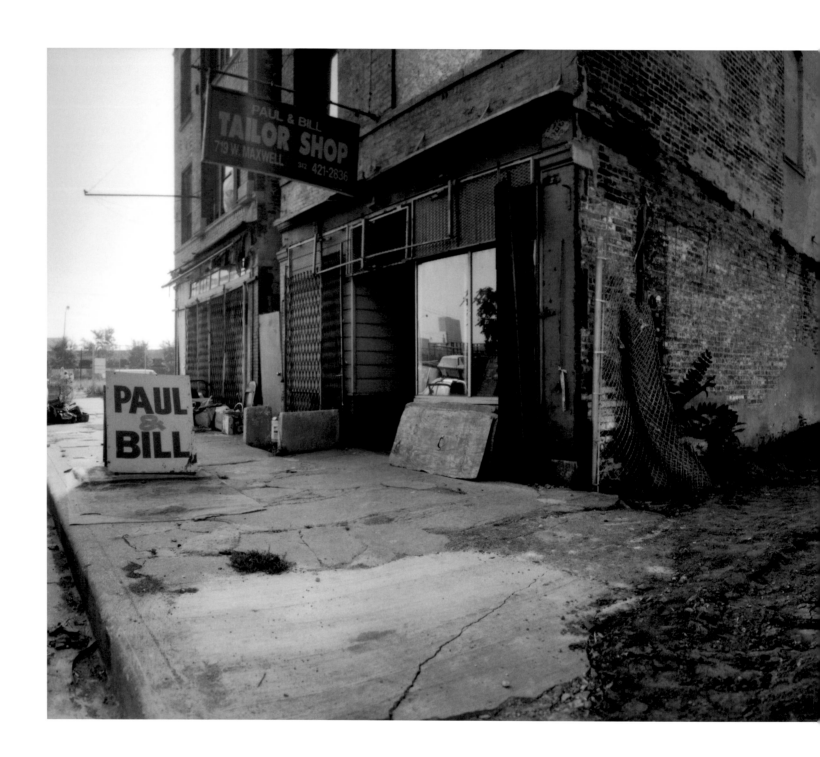

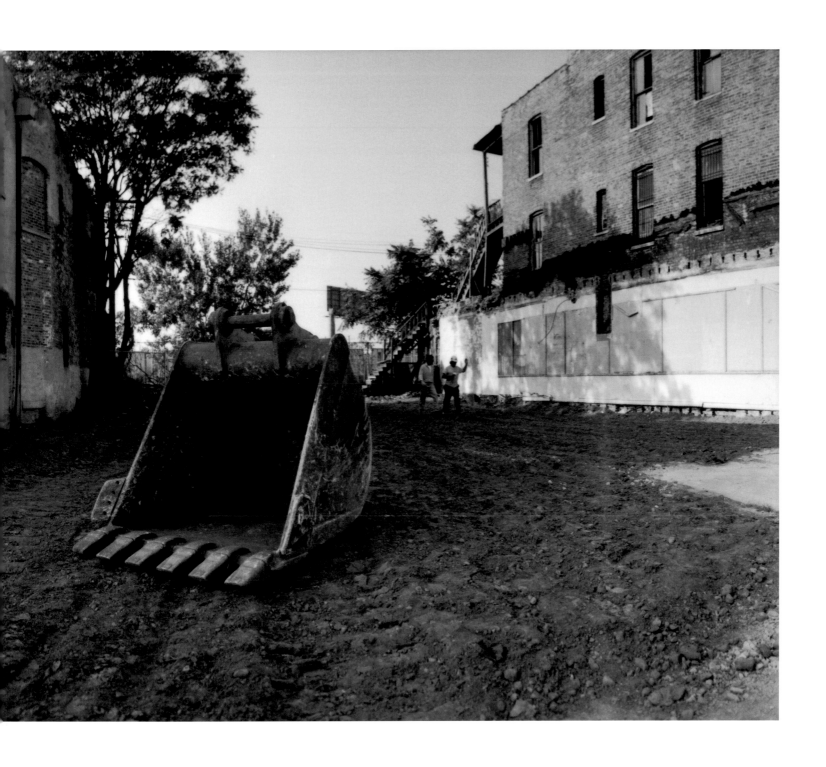

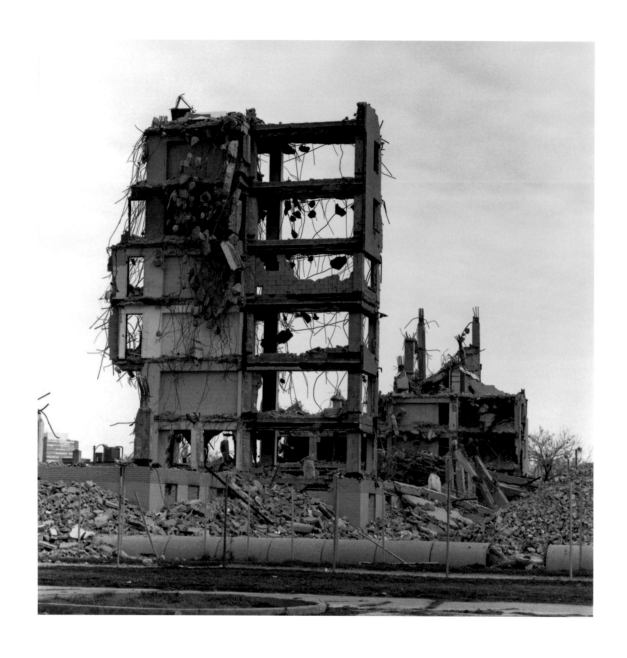

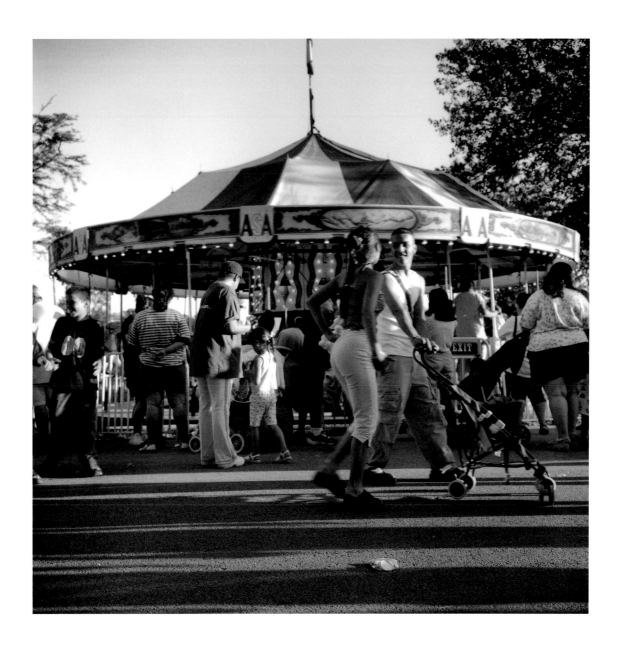

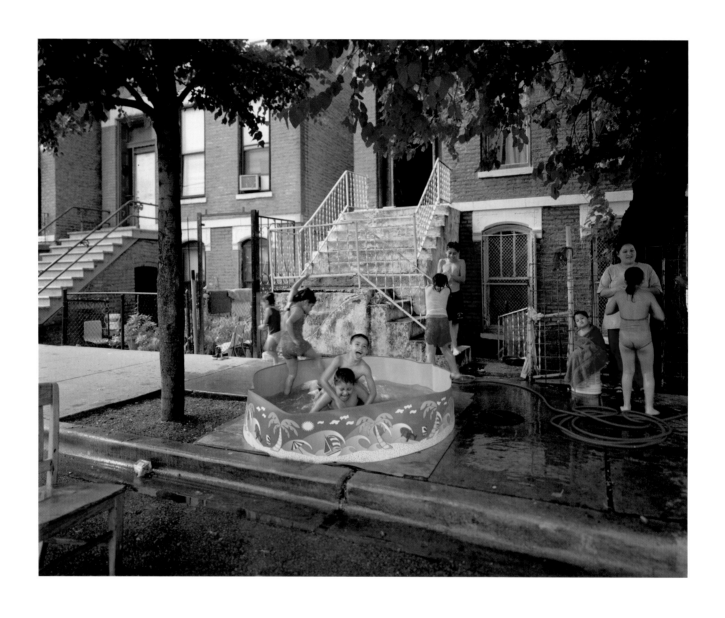

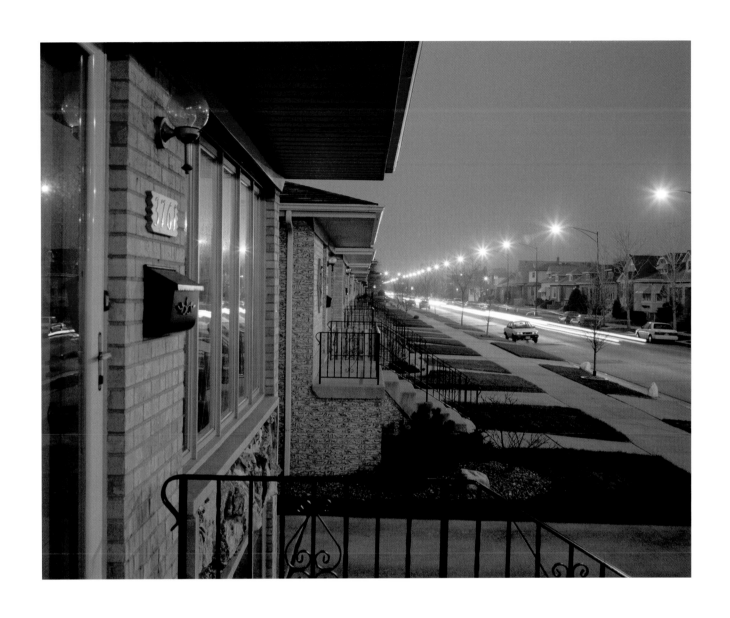

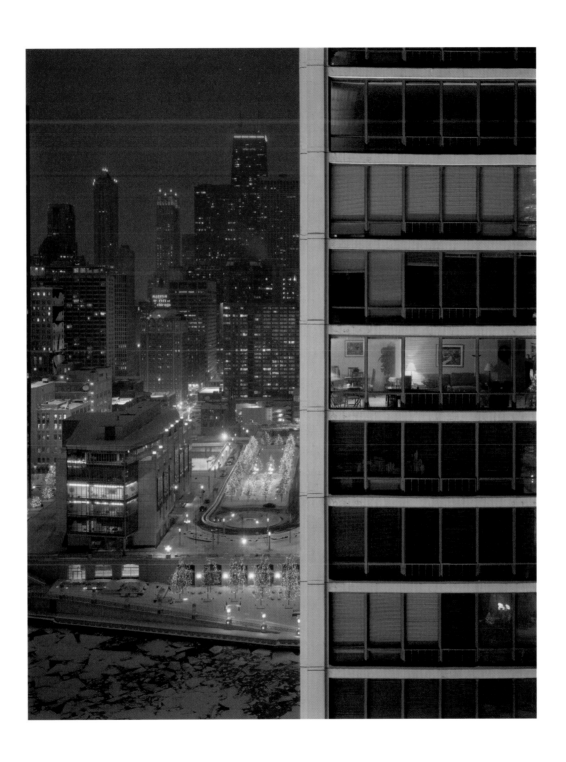

We begin our journey through Chicago with the city at a distance, a glowing grid surrounded by great waters on one side, prairie on the rest. That's how most people see the city: as the plane banks and circles O'Hare, landing or taking off. On a sunset flight to Tokyo, London or New York, they look down on a quilted plane of neighborhoods. The streetlights reveal the template that made the city possible—a rationalized, predictable system created to make the rapidly growing urban landscape more efficient. But these travelers miss the complex threads, the different patterns of stitching, the frays and mends that give the city its richness. They miss, as well, the depth of the city, the patches laid one upon the other by historical circumstance.

Down on the street, a different order prevails. At State and Madison, the zero-point of the grid, buses block the intersection, bike messengers weave around taxis, pedestrians crowd the sidewalks and periodically dart out into the traffic or, when the light is theirs, walk slowly in front of the drivers of limos and Lincoln Navigators who edge into the crosswalk hoping for a jump on the light. Perhaps it's you on the sidewalk, threading your way through the dense fabric of impressions and now setting your city senses to the task of getting out of here, out to the airport, up and away, to some different metropolis, similar in outline, perhaps, but deeply different in feel and meaning.

On the corner you look up for a moment as the light flares off the curtain walls of a downtown once full of life and activity, a triumph of modernity a century ago that is now, after a long hiatus, alive again. You may lose yourself in the regular patterns of windows and columns that define Louis Sullivan's Carson, Pirie, Scott Building, or the dark corridor of Wabash, under the L, a block eastward. Then the cop shouts, the horns blare and you're back to work.

This moment serves as a reminder that the grid is not in itself the fabric of this city; it is instead the frame upon which the city could be assembled, and is being assembled and reassembled continually by forces that pull against its restraints even as they employ its efficiencies. The dynamics of traffic reflect the journeys of citizens and visitors; and the cultural memories they carry with them as they move from place to place along the city's lines of force reflect the unities and conflicts of city life at the turn of a millennium. Over time, these repeated journeys wear tracks in the city's structure, invisible to the eye but real nonetheless, and perceptible to those who traverse them, if they carry the expectation, knowledge and memory. As these hidden paths are shared, formally or informally, those who know and use them to criss-cross the city form a community of citizens set apart from the visitors, the casual dwellers, the uncommitted.

Not everyone who is in the city is part of that community. Tourists going home might be standing by the side of the Palmer House hotel a couple of blocks south, waiting for the Airport Express; more seasoned travelers are hailing taxis, cell phones in hand. Chicagoans and others who've fallen prey to this city, learning its secrets, are heading two blocks north to Marshall Field's, bustling through its century-old atrium stocked with moments-old fragrances and fashions, down the escalator and out to the underground pedway leading to the Blue Line. For under two dollars, you get the fastest trip to O'Hare, and you move through a slice of the city—underground, then above ground, then under, above and, finally, under at the end. This is a secret shared among natives, drawing the legendarily isolated city-dweller into a community that transcends language, ethnicity, class, race.

Not just the rapidity of the trip is a shared secret; so also is the experience of the L in Chicago, whether it's the oldest line, the Brown, or the newest, the Blue and Orange—an opportunity to move diagonally across the city and, in the process, look into the rear windows of working-class two-flats and upscale condos. When you're traveling out at dusk, the lights inside glow, and you might see a man holding his child as he opens the fridge, and then, an instant later, a woman reading in a lawn chair on her back porch lifts a glass and looks up for a moment, catching your eye.

You pass from neighborhood to neighborhood. Below ground, the train speeds through downtown; just out of the Loop, it rises up into Wicker Park, then passes above Bucktown, before it drops below Logan Square and re-ascends far west—Portage Park, then Jefferson Park—before entering the thin pipe of the city that connects it to O'Hare. There, you can look out at the exurban metropolis that was supposed to replace Chicago—the office parks and planned developments in Norridge and Park Ridge that culminate in the line of sleek high-rises with corporate logos on them in Rosemont.

They once signaled the death knell of the downtown, but you just came from there, and it's doing better than ever; "creative destruction" turned Chicago from a city that produced, to a city that served, and then, with new energy, to a city that sustained and entertained, drawing suburbanites and exurbanites back to Navy Pier and Michigan Avenue's Magnificent Mile, pulling young professionals back into neighborhoods once resolutely ethnic and working class—the very neighborhoods you've passed through, Wicker Park, Bucktown and Logan Square. Now these sons and daughters of suburb and exurb reverse commute, living in the city and working in office parks and high-tech industries out here by O'Hare.

Like most Chicagoans, you share a sense of resistance to the changes that mark a vibrant urban center. Most everyone agrees that the decay, shrinkage and collapse of a city (think of Detroit, once Chicago's rival) are matters for mourning. But transformative growth, too, brings jarring dislocation from individual and cultural memory, and a sense of loss, even outrage. The pejorative term, *gentrification*, has become a common theme: We don't want the city to lose its character, its traditions, its locality, even if our own actions may contribute to that loss. But it's been going on for generations. In the 19th century, the Pilsen neighborhood was Czech, and now it's Mexican, and its residents are fighting its gentrification. The Czech-revival façades front bodegas, and the signs advertising *cerveza fria* obscure the older names of German and Czech beer distributors from a hundred years earlier, when the new immigrants washed in from Eastern Europe to work the assembly lines and the mills, the tanneries and the factories.

Looking out the windows of the CTA car, you may long for a mythic past when the neighborhoods were cleanly defined and fit easily into the neat frame of the grid. But you are also caught up in the adventure of the city's changes, the challenge of keeping up with them, the fluidity and intermingling of differences that these transformations bring, and the opportunity to be inside rather than above them, *down there* rather than *up here*. In so doing, you are in communion with those around you—workers on their way to the terminals, flight crews with their uniforms and carry-ons, families heading out to meet their relatives at the International Terminal, business people, athletes, emigrants and all the rest who share the secrets of this route through this city.

After the train, the terminal and the gate; on the plane, you rise above the city into the daylight that still lingers at 3,000 feet. From there, your 737 slides eastward and you can see the wall of tall buildings that face the lake. Then you turn south and the empty holes of the abandoned steel mills come into view. Beyond them there's the endless streetscape of South Chicago's bungalows, wooden two-flats and rooming houses where the steel workers used to live. Today the Colombians are moving in, and Immaculate Conception Polish Catholic Church has stopped holding masses in Polish and started holding them in Spanish.

The plane banks west. The city is dark, lit by strings of streetlights that extend toward the horizon in their orderly squares. As the captain adjusts the flight path, you head a little southward, and you can see where the city ends in darkness. You are leaving the city behind, but you will return, and when you do, it will be a different place. It will be different because you have seen other cities, but also different because, while you were gone, houses sold and buildings burned, aldermen passed resolutions, signs were taken down and others put up in their places. You will be surprised to find that you hold the city in your head, and you resist its changes. You know what its voices will sound like, where you will go to eat what you have a taste for. You will know that, in Chicago, you speak of desire as *having a taste for* something, a uniqueness of language that's a common thread across the quilt, one among many that stitch the city together. Out on the West Side, somewhere, you don't yet know where, someone will open a blues joint, even as another closes down. You'll mourn the one and find the other. Someone already has—that cop or that bike messenger or the homeless Streetwise vendor or the man who runs the hot-dog stand. You'll have to talk to them. You can hardly wait to get back, to remap the city and its changes into memory and plan.

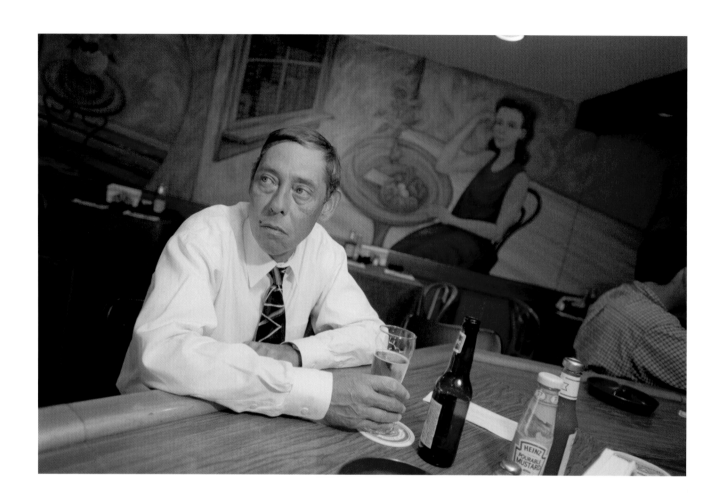

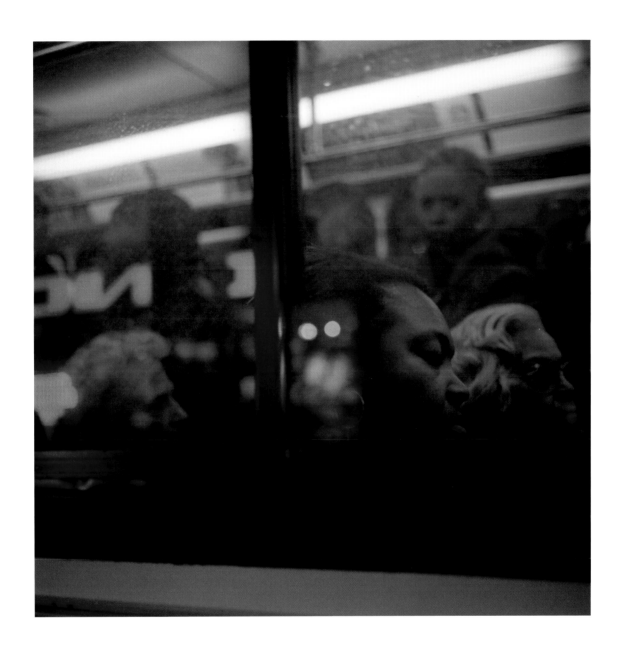

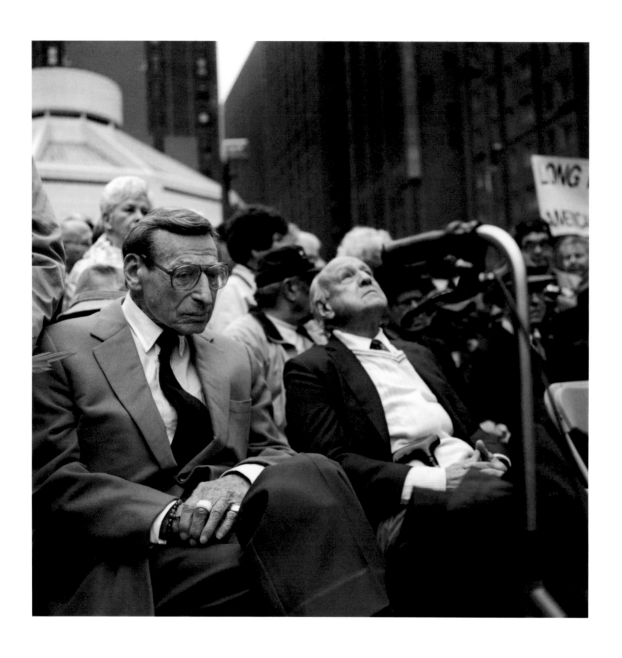

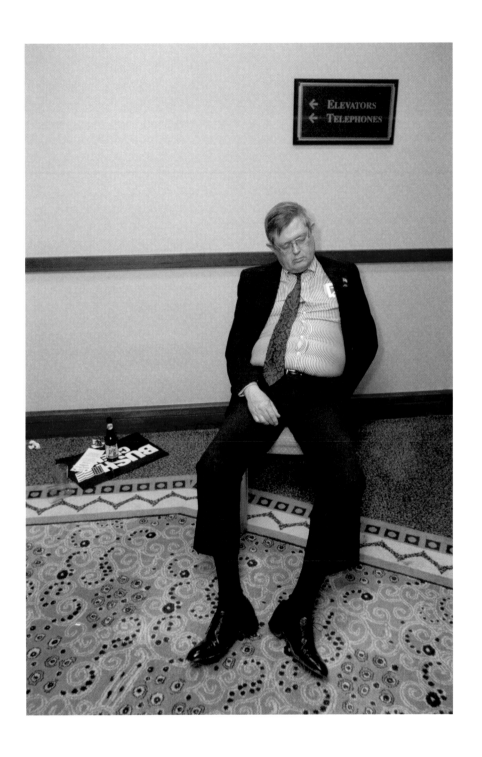

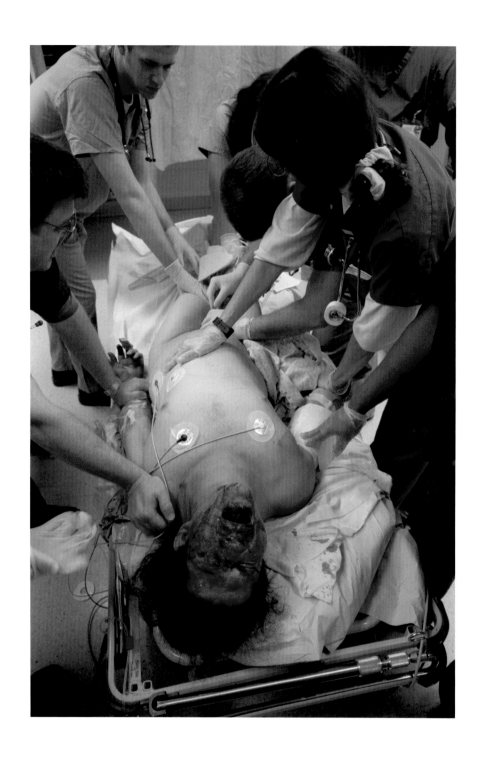

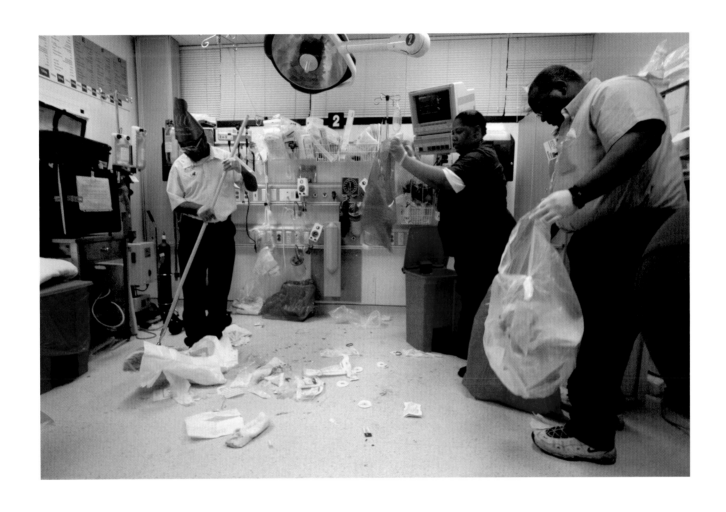

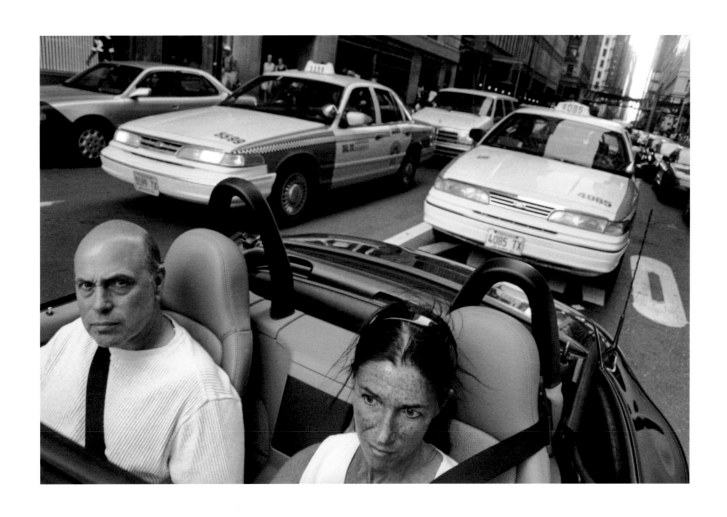

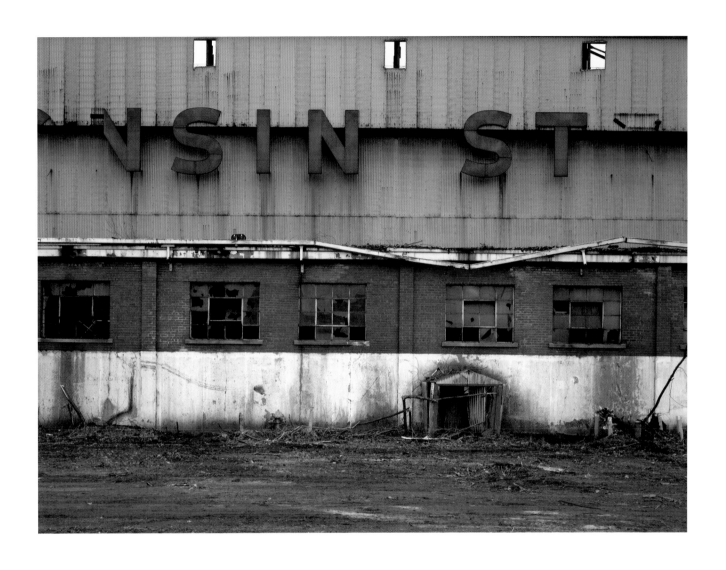

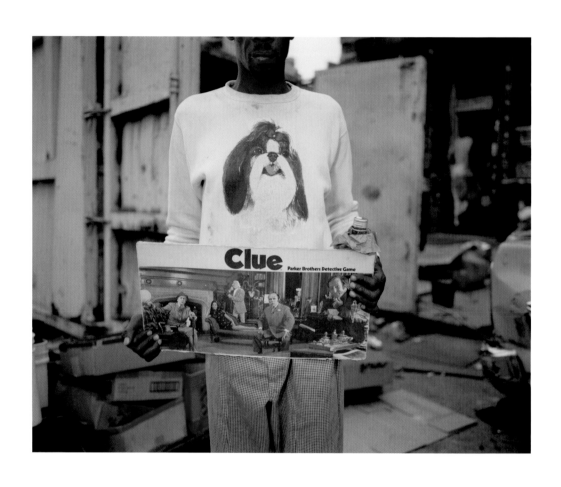

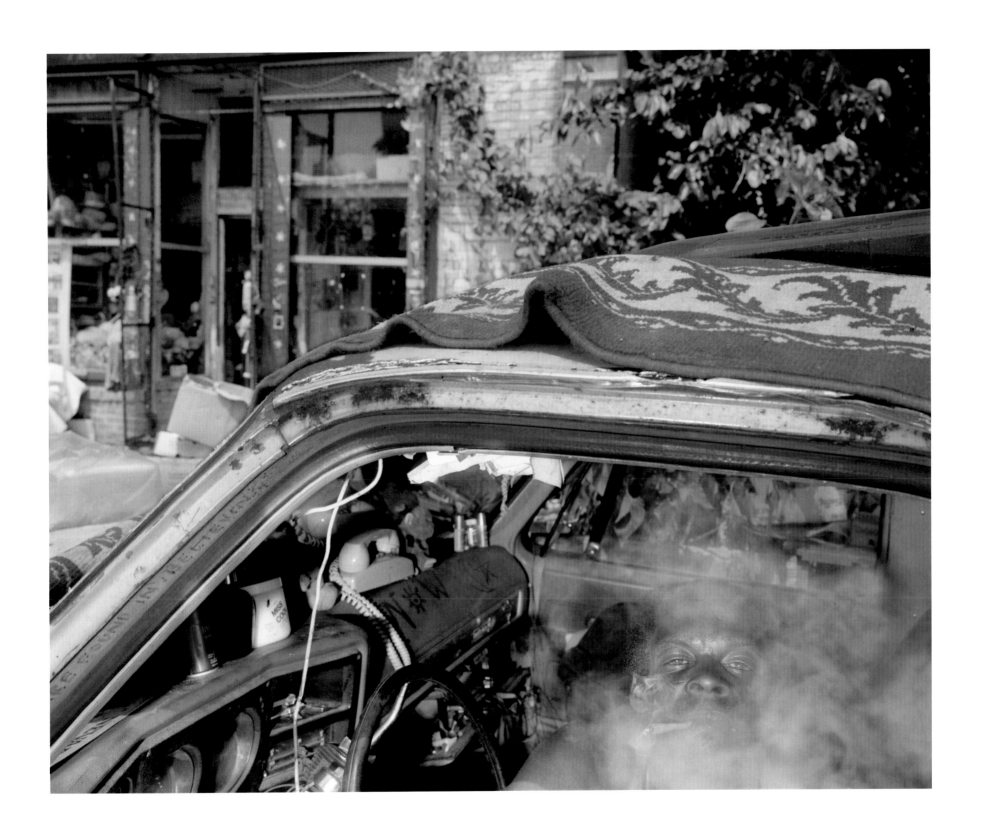

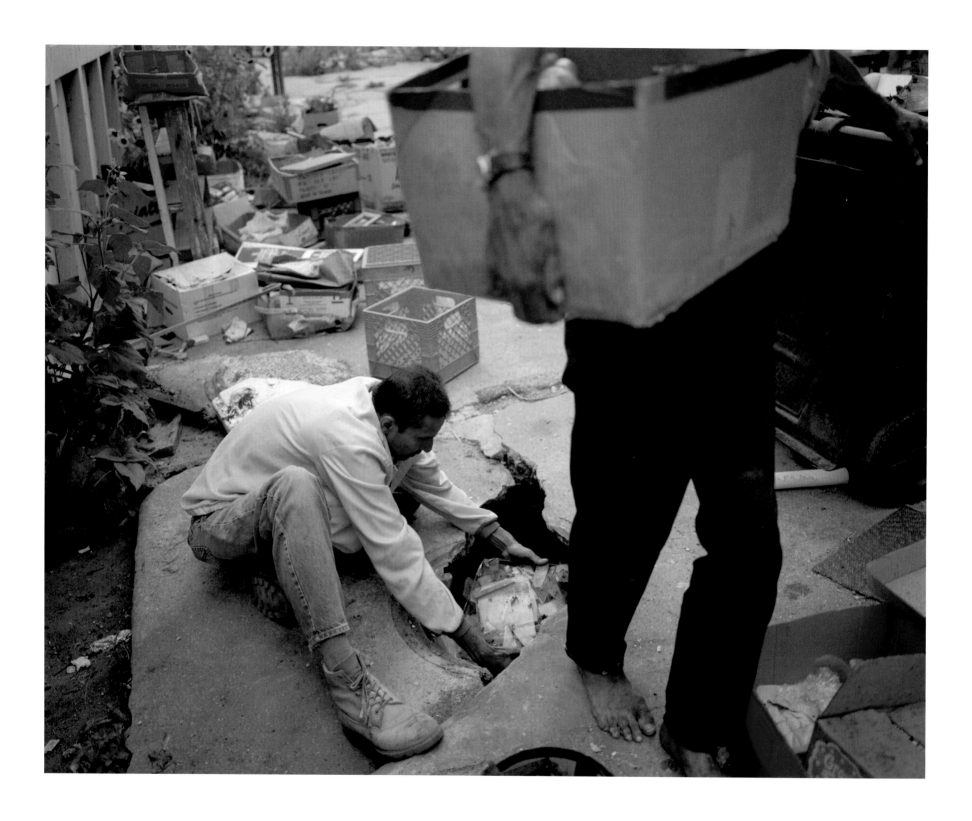

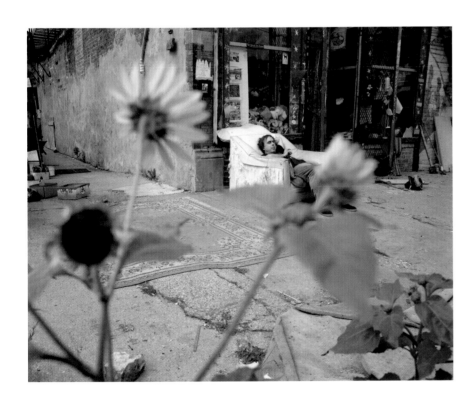

On a recent spring day I stopped at the intersection of Springfield Avenue and Jackson Boulevard, a rough spot on the city's West Side. On the corner lamppost was a memorial to a Tony Perry a.k.a. Tone Bone who, I would later learn, had been affiliated with the Vice Lords street gang and who had been shot several times with a 9 mm semiautomatic weapon. Friends of Perry's had tied red and white balloons around the post, along with a teddy bear with a red heart which read "I love you." At the base of the lamppost friends had also left four half-filled bottles of Hennessy cognac, two large bottles of Paul Masson brandy, a pint of Remy Martin cognac, a bottle of Budweiser and a can of grape soda, all drinks which Perry presumably enjoyed. There were plastic roses scattered about, and on the back of a STOP sign, graffiti which read "Love always the Harrison girls," "Never be4gotten" and "Rockwell 15 R.I.P." As I stood there taking in this makeshift memorial, a young man walked by, and commented, "Well, he was well known whoever he was."

Such might be the signature for Chicago, a town which has a propensity like no other to acknowledge its own, sometimes because of their accomplishments, sometimes because of their notoriety and sometimes because—to be blunt about it—they have that distinctly Chicago muscle which we simply call "clout." There are monuments for just about everyone in this town, from the likes of George Pullman, who treated working people as if they were misguided children and who had a towering Corinthian marble column erected at his gravesite, to the Pulitzer prize-winning poet Gwendolyn Brooks, who viewed people like Pullman with a measure of disdain. Not without irony, the high school which Pullman built in the 1880s is now named after Brooks. In 1916 Carl Sandburg bemoaned the fact that there were no monuments to the little people in Chicago, and wrote a poem he bluntly titled "Ready to Kill."

Ten minutes now I have been looking at this.
I have gone by here before and wondered about it.
This is a bronze memorial of a famous general
Riding horseback with a flag and a sword and a revolver on him.
I want to smash the whole thing into a pile of junk to be hauled away to the scrap yard.
I put it straight to you,
After the farmer, the miner, the shop man, the factory hand, the fireman and the teamster,
Have all been remembered with bronze memorials ...

Then maybe I will stand here
And look easy at this general of the army holding a flag in the air ...

Sandburg's plea has been heard. Sort of. Since 1964 the city has erected more than 1,100 honorary street signs which are used to designate a corner or in some cases a stretch of road. There are streets named after idealists such as the attorney Clarence Darrow and the labor organizer A. Philip Randolph, or after the practical like former Chicago Bears coach Mike Ditka and the turn-of-the-century businessman S. Florsheim, or the famous whose connection to Chicago is somewhat tenuous such as choreographer Bob Fosse, who was born here, and Diana, Princess of Wales, who once visited here.

But for the most part the names on honorary street signs are people—to paraphrase the gentleman on the West Side—who are well known whoever they are. Not long ago, in talking with the city's cultural historian, Tim Samuelson—a man who knows everything there is to know about this city—I chose at random ten individuals who have been honored with street signs, and ran the names by him. Names like Sophie Madej, Richard X.G. Irwin and Theresa Tiffany Debunk. He could identify only two, both owners of restaurants which he happened to frequent. Madej, for instance, ran the bygone

Busy Bee, a Polish restaurant in the Wicker Park neighborhood. As for Irwin and Debunk, both of whom are honored in the 42nd Ward, a spokeswoman for the alderman there, Burton Natarus, told me "I have no idea who they are." (Aldermen submit candidates for honorary street signs to the City Council, where almost all get approved.) She told me it would take at least a couple of weeks to rummage through their files to find out what gave them such status.

Some say this chest-beating has gotten out of hand. A portion of Pulaski Road is now—redundantly—also Honorary Casimir Pulaski Way. (Pulaski was a Polish general in the American Revolutionary War). When I went to the unveiling of Jerry Kleiner Way—Kleiner is a restaurateur—at the corner of Randolph and Green Streets just west of the Loop, the local alderman mistakenly kept referring to Jerry Kleiner as Jerry Mickelson, who's another local businessman. And then there are the honorary street designations which are not so honorable, such as the one commemorating Hyman Tucker, a ghost payroller for the city (he collected city paychecks for four years after moving to Florida) or the one celebrating Orlando Catanese, who once owned four adult bookstores and was deemed the heir apparent to Mike "Fireplug" Glitta, who oversaw the Chicago mob's interests in the sex trade.

Mayor Richard M. Daley once threatened to introduce an ordinance that would have limited honorary street signs to a fixed period of time—say, a couple of years—but backed off when he realized how dear they were to aldermen, who clearly see them as one of their entitlements, or in the Chicago tradition, a tool in the arsenal of clout. It's been suggested that the reason for the unusually high number of honorary street signs named after ministers—I counted 249—has nothing to do with this being a city of God, but rather has everything to do with the preachers' ability to turn out the vote. "You don't have a hell of a lot of powers and everybody here is out to take [them] away from you," 50th Ward Ald. Bernard Stone once complained to a newspaper reporter when told the mayor might mess with the permanence of honorary street signs. Stone, himself, has carved up his ethnically diverse Devon Avenue into Gandhi Marg Avenue, Golda Meir Boulevard, King Sargon Boulevard and Sheikh Mujib Way, to name just a few.

There is a small-town quality about such nods to its own, as if we all know, or ought to know, who these people are. But it's so Chicago. Boastful. Prideful. A city always, as Sandburg wrote, "with lifted head singing." Such bluster I suspect also stems from our deep-rooted insecurities, that somehow we won't be recognized as a world-class city. Who will honor us if we don't honor ourself? And so we lift our own, raising their names on honorary street signs like flags beating in the winds. It's as if to proclaim, look who we count as our own. We lay claim to those we know and love like Curtis Mayfield and Studs Terkel, to local heroes like Nancy Jefferson, a community organizer, and Milton Davis, the co-founder of the nation's first community development bank—along with folks such as Alphonse "Fonz" Davino and Daniel D. "Moose" Brindisi, people who, it has been said, are surely well known whoever they are.

 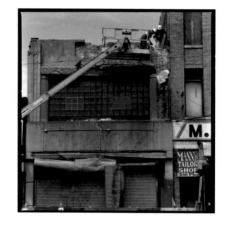 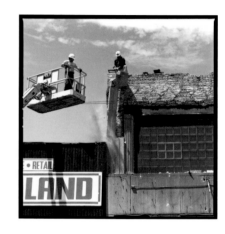

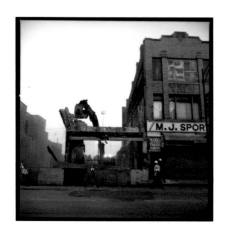 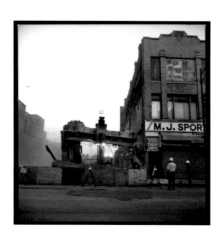

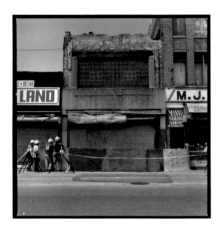

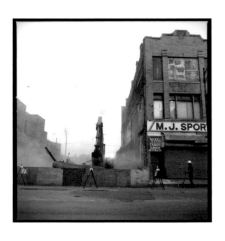 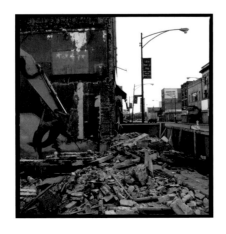

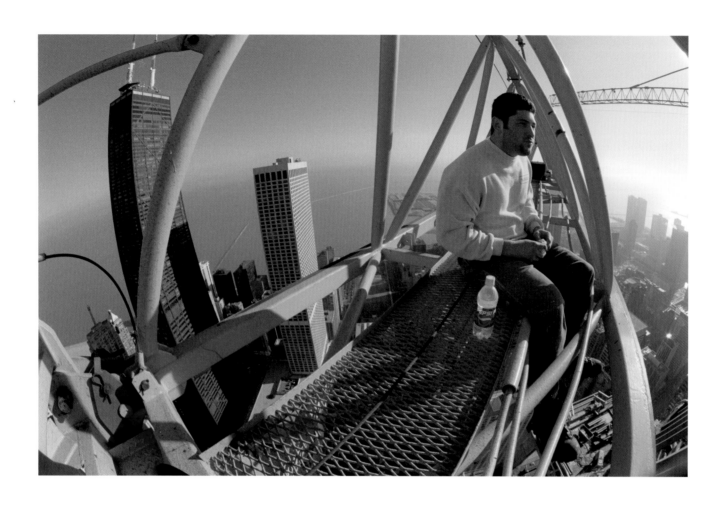

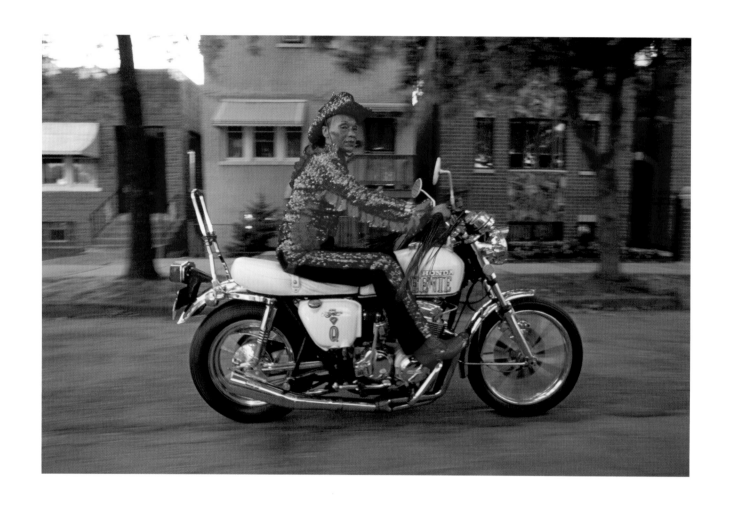

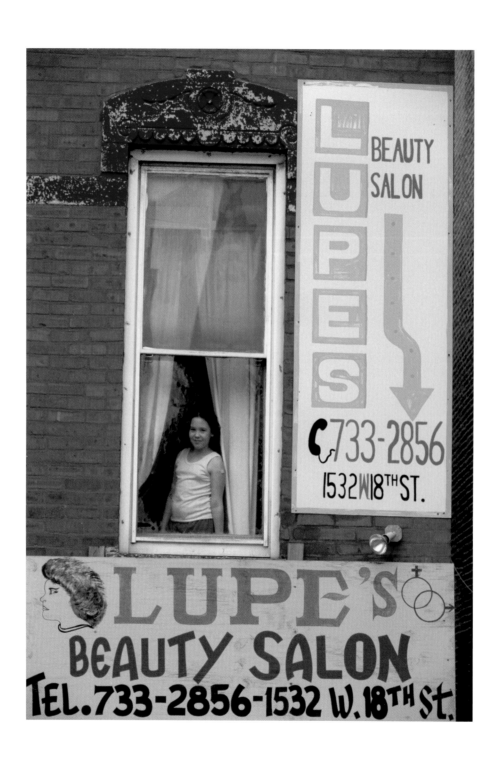

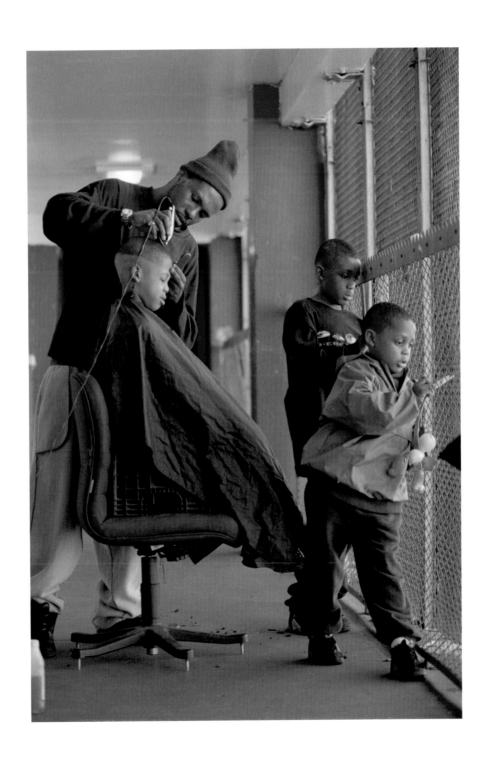

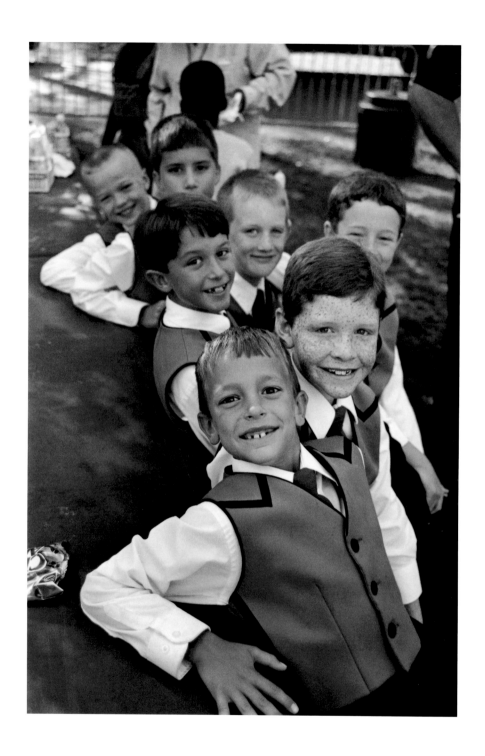

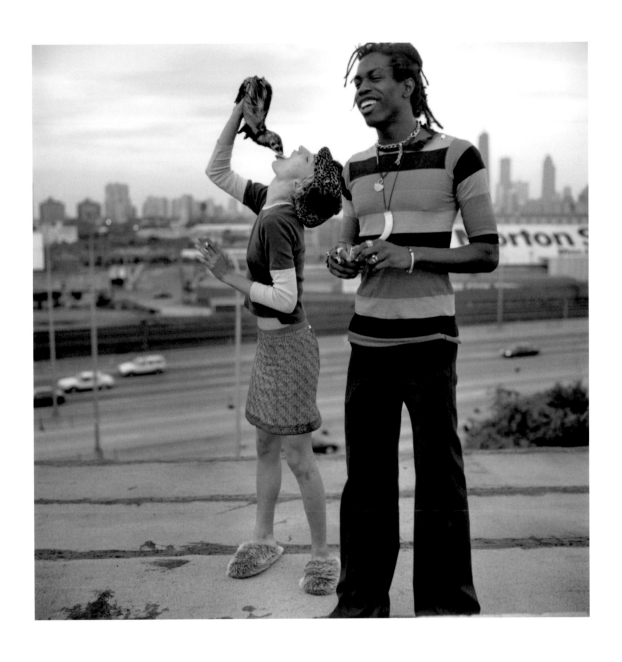

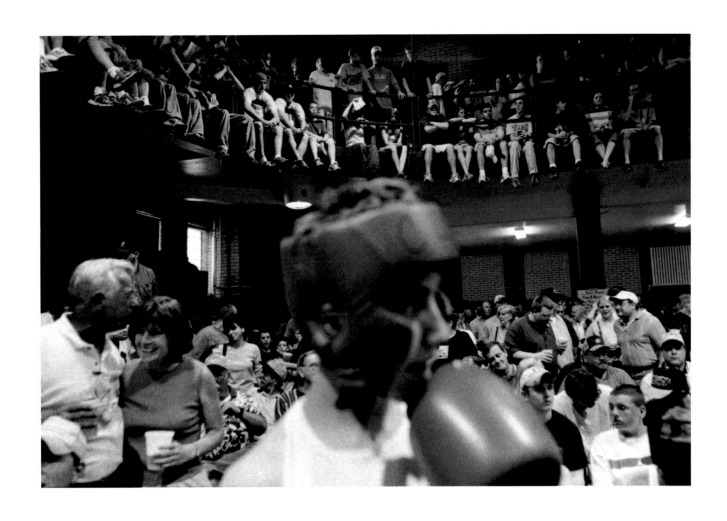

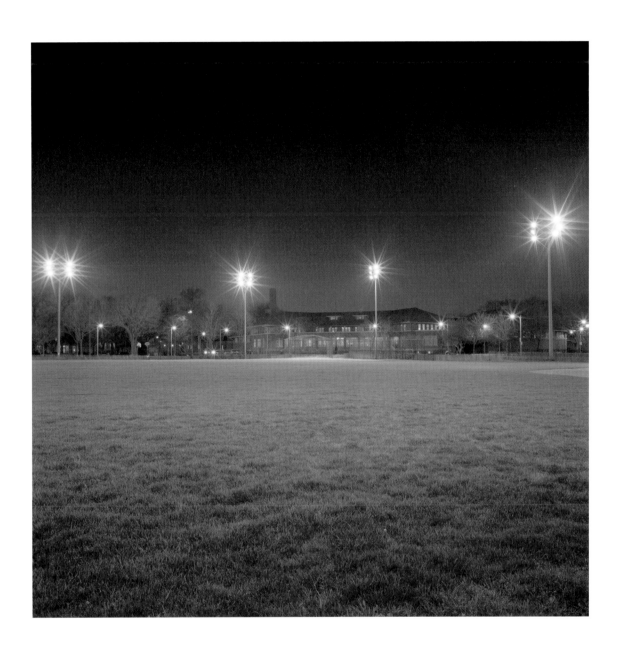

On the corner of 25th and California Boulevard, across the street from acres of asphalt, concrete and brick row houses that comprised the public housing project called Lawndale Gardens—*Gardens*, perhaps for the mangy patch of grass beside each door stoop—a wilderness sprouted behind a Camel billboard.

It was known as "the Prairie" by the few kids who noticed it at all—a localism for most any vacant lot gone to seed—but in steamy midsummer when bees zoomed and each step catapulted grasshoppers from weeds and wild flowers spiked waist high, I waded in as if it were my private refuge, part Eden, part Congo. My first specimens were caught there: a tiger-furred red-tailed bumblebee (*Bombus ternarius,*) the steel blue cricket hunter wasp (*Chlorion aerarium,*) armored in a metallic element yet to be recorded on the periodic table, and butterflies, each enveloped in its own exotic wind storm.

My homey, Dennis Zacek, the artistic director of the Victory Gardens Theater, now owns the Prairie. Though the billboard could have been a steady moneymaker, he had it taken down, and he's fenced the 25 by 125 foot lot which runs alongside the gray stone bungalow he bought when he moved back into the old neighborhood. True, the Prairie has been tamed by agriculture—in summer, Dennis grows tomatoes, strawberries, and rhubarb there—but he's kept it green.

When it was overlooked and wild there were cornflowers, chicory, Queen Anne's lace, clover, ragweed, milkweed, thistle, burdock. I'd emerge with my jeans and the laces of my gym shoes impaled with the burrs we called "stickers" and sit on a curb picking them off, sometimes saving a few to booby-trap my brother's bed. Back then, except for milkweed, I couldn't have identified a single plant. I recognized milkweed, not because its dissilient silky pods are hard to mistake, but because I'd read how it attracts monarch butterflies. The monarch, uncoiling the black lash of its proboscis, laps the milkweed's poisonous sap as if it were nectar, and the plant imparts to the butterfly a taste bitter enough to discourage predators. It's a survival strategy so effective that other, non-milkweed imbibing butterflies such as the viceroy, mimic the monarch's protective coloration.

I collected not only insects but also the curious details about them: the way honeybees communicate through dance; the gruesome incubation practices of wasps, which lay their eggs on paralyzed, living hosts; the cannibal sex of the praying mantis. Facts fuel the imagination; such information made excursions to the Prairie more exciting. Twice a month I'd ride my bike to the Gads Hill branch library for books on my favorite two subjects: Greek mythology and entomology. Besides metamorphosis, gods and insects had in common the power to provoke wonder at the mysterious, complex, richness of life.

The inner-city neighborhood on Chicago's industrial Southwest Side that I was born into seemed more often than not to be at war with its impoverished population of animals. Warnings about rat poison were stapled to wooden phone poles at the mouths of alleys. Down those alleys, animal control trucks cruised for strays while watchdogs snarled behind back fences and feral cats acquainted with Nazi cruelty of boys slunk into shadow. The alleys were an avenue of animals. Along their crack-rutted concrete the horses of peddlers left a golden trail of manure. Pigeons wooed on garage roofs, sparrows squabbled on wires. I remember a day when a squirrel was spotted tight-roping along phone wires, and a lynch mob of kids armed with rocks, bb guns, and a Whammo slingshot formed to hunt it down; I remember a night when a dive-bombing bat cleared a corner of gang bangers. Those few species, along with the ornamental carp in the garden-hose-fed pond in the grotto of the blue Virgin at the rear entrance to St. Roman Church, represented the fauna.

Only the micro-world of insects suggested Nature's profligate diversity. To enter that world it was necessary, as it was for Alice sliding down the rabbit hole, to change perception. Not that a perceptual shift is a conscious decision: a focus on insects automatically readjusts the proportions by which the world is viewed. There's a Zen parable in which a man who wishes to become a great archer is instructed by his sensei to sit in stillness until he can see the eye of a gnat, rather than to practice with his bow. It takes time to accomplish, but finally, when the man can see the gnat's eye, everything appears so much larger that an archer couldn't miss.

One follows a butterfly into a narrow, scruffy, inner-city lot and finds a hidden wilderness that will become a gateway into the natural world. Once such a transformation happens, it can be made to happen again, and as with love or any transformative power comes the desire to exercise it over and over.

In his book, *Biophilia*, the noted entomologist, Edward O. Wilson, theorizes that "we are human in good part because of the particular way we affiliate with other organisms. They are the matrix in which the human mind originated and is permanently rooted, and they offer the challenge and freedom innately sought. To the extent that each person can feel like a naturalist, the old excitement of the untrammeled world will be regained. I offer this as a formula of re-enchantment ... mysterious and little known organisms live within walking distance of where you sit. Splendor awaits in minute proportions."

The Prairie behind the billboard was my personal confirmation of Wilson's thesis. I imagine that for many who've grown up in cities there's a like place associated with the discovery of the natural world, some island of relative virgin wilderness of which the virginity is one's own. As fairy tales have it, a charm might be required—a wand, a looking glass, seeds for a beanstalk—a magic passport to facilitate crossing the border into another reality. It might be a fishing pole, or binoculars and a guide to birds, or a pocket knife, basket, and a book on mushrooms, or a guide to stalking the wild asparagus or to any of the myriad kinds of collecting that are an expression of the innate hunter-gather. For me it was a butterfly net.

I wasn't a kid with a knack for building model planes, and though each spring I did manage to fashion from newspaper a kite that actually flew, a butterfly net was the most inspired construction of my childhood. I made it the summer I was eleven to capture a gorgeous tiger swallowtail I'd been unable to catch by hand. My friend, Eddie Boy, and I bent wire clothes hangers into hoops and fit them into hollow, bamboo fishing poles that served as long handles. We reinforced the connection with duct tape, then, with needle and thread borrowed from my mother's sewing basket, stitched cheesecloth to the hoops. The resulting nets were lopsided, baggy rather than conical, but not bad for the first sewing either of us had done.

I can still picture wind inflating the streaming cheesecloth on California Boulevard as, almost as if flying kites, Eddie and I scooped the atmosphere above our head where dragonflies mated in midair. Ear-stingers, as dragonflies were called in the neighborhood, evoked for me a vision of prehistoric times. Unlike our main quarry, butterflies, dragonflies were predatory. Darners, petaltails, clubtails, spiketails, cruisers, emeralds, skimmers—the dragonfly was my totem insect, and, except for the few I kept for my collection, it was catch and release. When a dragonfly hit the net you could feel the impact. I'd carefully untangle it from the mesh and allow its jaws the revenge of nipping my fingertip—it wasn't painful—then set it free.

In *Speak, Memory*, Vladimir Nabokov remarks on how he "found out very soon that a 'lepist' indulging in his quiet quest was apt to provoke strange reactions." This was indeed true on the South Side of Chicago. A guy running around with a butterfly net attracted the wrong kind of attention. By age thirteen I'd taken to stashing my net along the railroad tracks that laced our neighborhood and sneaking it out when I went collecting. By then the gateway of the Prairie lot had opened onto other enclaves of urban wilderness unmarked on any street map. Each summer, guided by butterflies, Eddie and I explored further along the flyways of railroad tracks and the Chicago Ship and Sanitary Canal. Behind the cyclone fences surrounding deserted factories vast wasteland reverted to prairie. Off 31st, behind the Dickenson company's broken-windowed, abandoned complex, lay a wetland sentineled by red-winged blackbirds, a pampas of cattails inhabited by muskrats, water snakes, frogs, possums, raccoons, rabbits, foxes. Pheasants exploded from underfoot, blue heron lifted into a hawk-patrolled sky. There were rumors of other predators: crazed hermits living in cardboard lean-tos, railroad dicks with pepper guns, freight-riding hobos called Jayhawks who preyed on boys. Real or imagined, the danger couldn't discourage our fascination with butterflies—migrating monarchs, swallowtails, fritillaries, buckeyes, skippers, blues, sulphurs, painted ladies...

When, in my twenties, I left Chicago to teach junior high school on an island in the Caribbean where I could dive each day on the reefs, I was following a trajectory that began in the secret islands of urban back lots. To this day, each wild place, no matter how foreign, still seems a sanctuary in the way a scant patch of nature does in a city, a gift, essentially surprising, and all the more beautiful for the toughness of its will to survive.

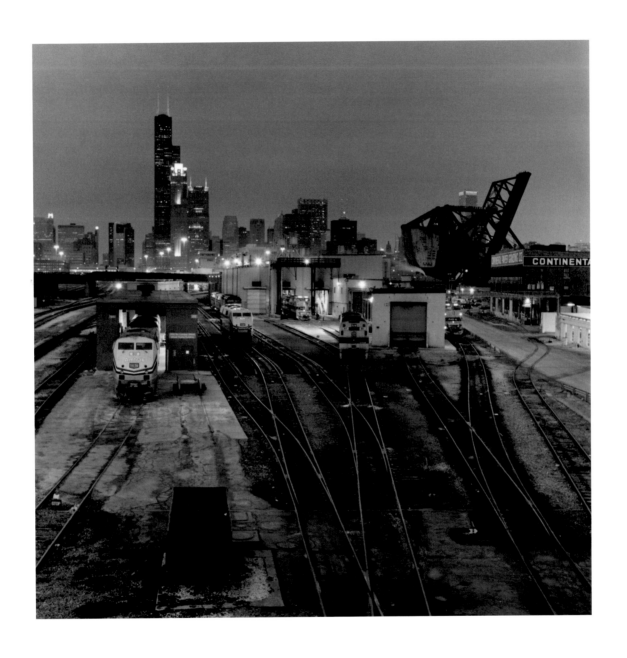

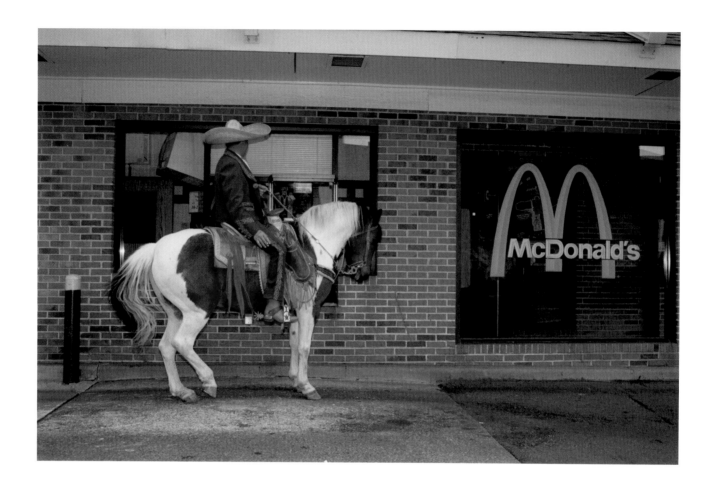

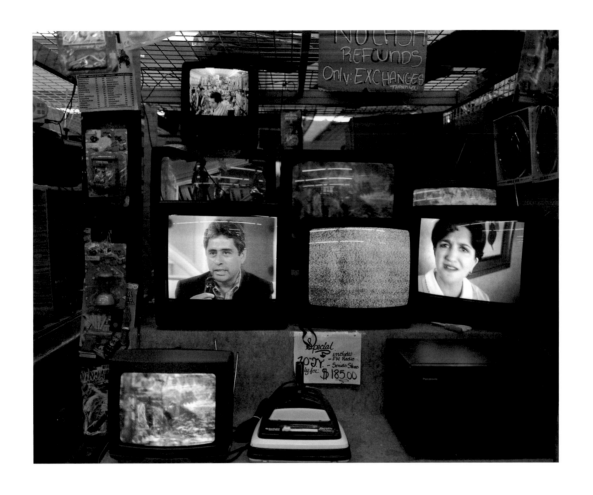

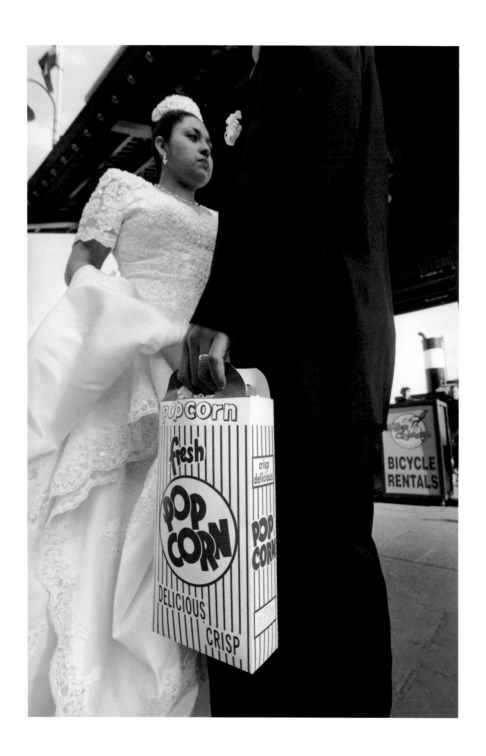

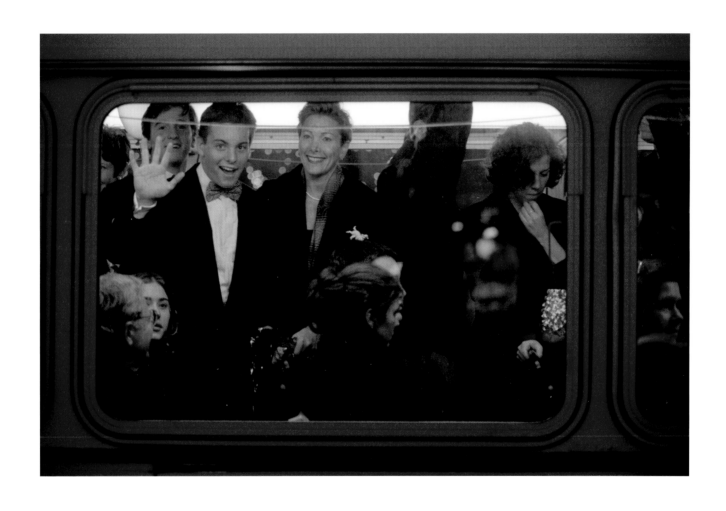

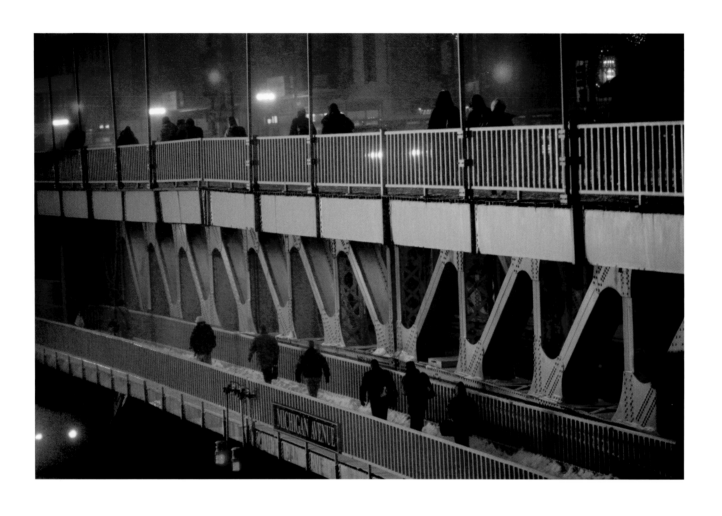

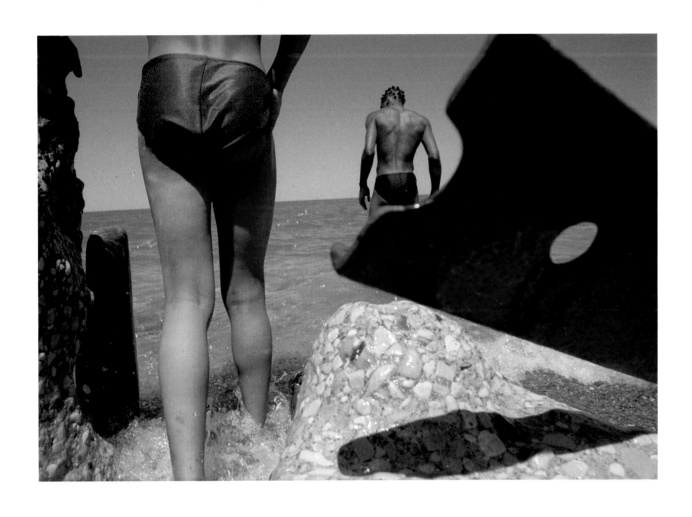

There is something of the autumnal to Chicago, even in the very blossoming of spring. Here, things fuse, merge, blur. Sometimes in March—sometimes April—the ice smears off the lake's stone lip, little green buds begin to sprout on the most rickety of branches, and clear, lucid light cuts through the gray patina that's covered the skies for months.

Chicago's deceiving that way, and not just about the seasons. It'll make promises in a proud working-class brogue then reveal a South Side saloon where students from the University of Chicago worry in East Coast accents about Malouf, Foucault and Borges. It will boast ties to Al Capone but get all huffy and quiet about the torture allegedly practiced by former police Commander Jon Burge only a few years ago. It'll talk up Holy Name Cathedral, with its surprisingly easy seating on almost any Sunday, but ignore the traffic jam on Stony Island Avenue any night after services at the Nation of Islam's palatial mosque, a standard-bearer on a strip that's both run-down and up-and-coming at any given time.

In most portraits of Chicago, this is a black and white city; Latinos are some sort of static, neither one nor the other, interruptive. There's Richard M. Daley and Jesse Jackson, the Blackhawks and the Bulls, North Side and South Side.

But the truth, as frequently happens here, is something else entirely. Chicago hasn't been a white town for a long, long time. The city itself has an African-American plurality whose culture—its real culture: blues, house music, ribs and soul food, speed chess, Rev. Johnnie Coleman and Saint Sabina's, Oprah, every hustle on Madison west of Western Avenue—is rooted in the black experience, good and bad, and has been for more than a century.

But there's a whole other reality—let's call it an *emerging tautology*—which is that the city's bubbling these days with an entirely different culture, that of Latinos. Right now, there are more than half a million Hispanics in Chicago, making it the third-largest concentration in U.S. cities after New York and Los Angeles. As I write, Latinos make up about 27 percent of the city's 2.8 million residents.

Chicago can claim writer Sandra Cisneros and Grammy-nominated salsero Angel Melendez, White Sox coach Ozzie Guillen, Radio Arte, the FALN, the oldest Latino international film festival in the U.S., art star Tania Bruguera, and La Cueva, quite likely the oldest Latino drag bar in the world. Chicago is also where to find Our Lady of Guadalupe Church, home to the national shrine to Saint Jude, patron saint of impossible causes.

In less than a generation, Chicago's majority will be Latinized if not Latino, not just immigrants but the children and grandchildren and great-grandchildren of all those people who've crept up from the Rio Grande and the Straits of Florida.

When I was growing up in northwest Indiana, where Chicago glimmers like Emerald City across the lake, my family—sometimes just my dad and me—would come to Chicago for vital Latino supplies: black beans, gnarled taro roots, little envelopes with bright orange saffron. There were a handful of Cuban bodegas back then and my dad knew everybody. They'd call him Pepito, the diminutive a sign of both familiarity and affection. Sometimes they had a domino game going and my dad would sit in for a bit, the pieces clickety-clacking. It was a Cuban game, with double nines instead of double sixes, but there was always a Puerto Rican on a team, or a Colombian who'd take a turn.

Officially, we rarely heard Latino voices outside the neighborhoods, except on WOJO-FM, which wasn't geared just toward Mexicans in those days but to every Latin- American immigrant in radio range, employing a lulling kind of international pop as its welcome. Now and then you'd see a Latino community activist on TV, usually Puerto Ricans asking for better education, better jobs. There were melees in Humboldt Park in 1966 but all seemed forgotten after the catastrophic riots that befell the city when Martin Luther King, Jr., was murdered. Puerto Ricans took to the streets again in 1977, rising up after yet another unjustified killing by police, but nothing ever quite seemed as grave or devastating as the King aftermath.

When I came to Chicago in 1979, I was young and hungry—mostly for a sense of self and direction. I wondered then how I'd navigate through what seemed a very different world than the Cuban enclaves of my childhood. Where did I belong on 26th Street, with its snakeskin boots and whole hogs in storefront windows? Who'd watch out for me on Division Street, where Latin Kings roamed free? Who'd know me at all on Milwaukee Avenue, where the Cuban presence had more to do with business than old island hometowns or my dad's generous spirit?

It all hit me one day at a botanica, one of those little religious-goods store that serve up aerosol sprays to scare away spirits and teas to cure every ill. I had been looking for a candle to the Seven African Powers. And I found it all right, but they weren't African at all. Instead of the usual black men sprawled on the candle's label, the botanica's version boasted seven Native Americans in full headdress.

"Indios!" I said breathlessly. It had never occurred to me that the orishas—African deities so precious to Cubans—could be anything but black. Here in Chicago and so far from the island, the possibilities abruptly opened up.

I started to put things in order then: how almost anywhere in La Villita, you can be strolling the streets to the piped crooning of Mexican superstar Juan Gabriel when suddenly the air will crackle with the intensity of Cuba's Celia Cruz. Or how, at almost any restaurant in the city with a Latino menu, a little basket of tortilla chips is de rigueur. Or how, only in this city, could a Puerto Rican independentist like Luis Gutierrez be elected to Congress from a district with a Mexican-majority population.

This is Chicago's mundane magic, unique in this hemisphere: We come here from Mexico and Puerto Rico, Cuba and Guatemala, Venezuela and the Dominican Republic, Colombia and Peru, and we become something else, something that allows us our specific national identity but transforms it into a jumping off point for a broader, deeper understanding. In Chicago, to be Cuban—or Puerto Rican, Mexican, Honduran, whatever Latin American— is not an end-all but a beginning.

Sure, Los Angeles has more Latinos, but Mexicans dominate numerically, culturally, politically, gastronomically. As does New York: But there Puerto Ricans rule in all the same ways. Miami threatens but there all things are Cuban.

Historically in Chicago, Mexicans have made up about half the population, Puerto Ricans a quarter, and the rest of us divvy up what's left. But though there are neighborhoods of near exclusivity—La Villita, for example—we are tossed, thrown together. In Pilsen, Mexicans flourish but there are also Central Americans. Logan Square has Puerto Ricans, Mexicans, Central and South Americans, and other Caribbeans. Uptown has representation from the whole hemisphere, plus Africa and Eastern Europe.

This has been going on here for a generation or two, in a way unlike anywhere else. When Teatro Luna—an all-female Latina theater company whose three founders are Mexican, Cuban, and the other a complicated hybrid—debuted, they sold T-shirts that named what we've become: Mexiruvian, Chiledorean, Argentexican, Guaterican, Texican, Jewban.

Because it's not that in Chicago we become Latino—though we do—we also become a version of each other. Our close proximity, the way the non-Hispanic world views us as one anyway, our huge variety here—it makes us know and care and become a part of one another's world.

Yo soy cubana. Y mexicana. Y colombiana. Y boricua. Y latina.

Of course you're not supposed to put jalapenos in black beans, or dance equally fluently on the one or the two, or wear bolos, or know anything at all about cactus if you're from the Caribbean. But this is Chicago, where we can—and we do. After all, we know about autumn in March, spring in a blink, and the constant promise of summer.

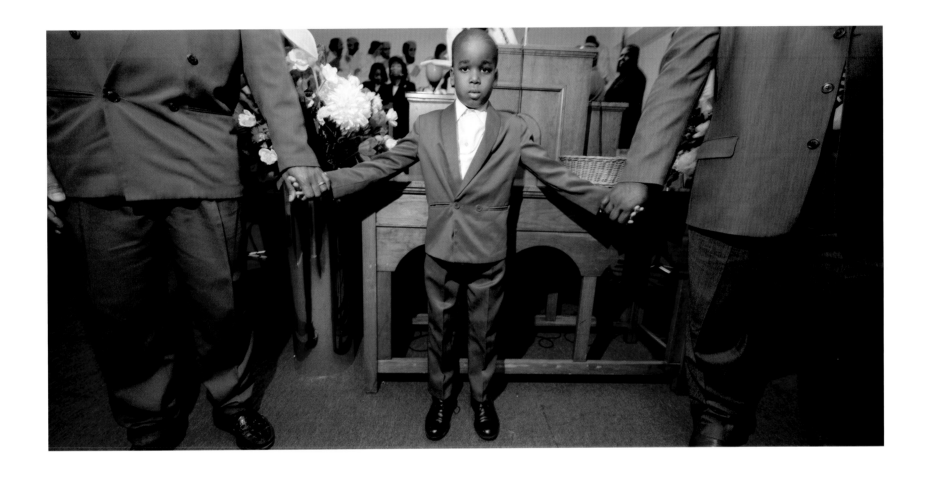

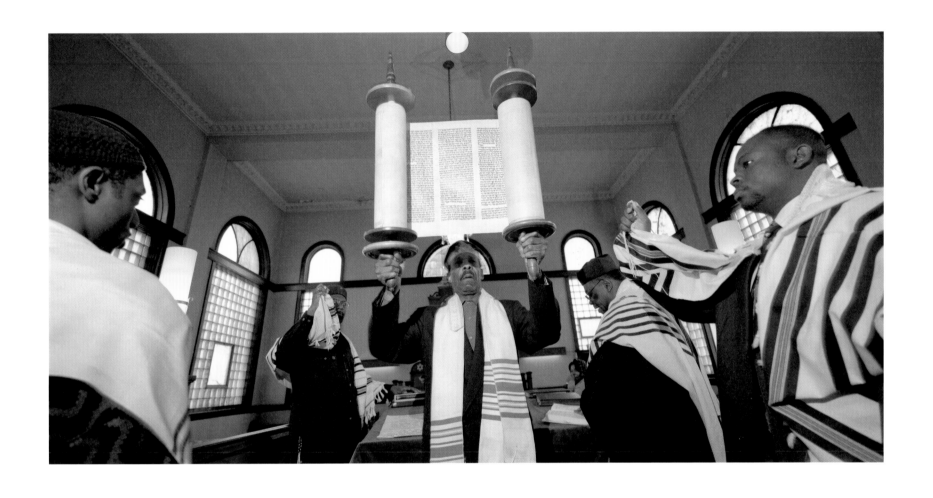

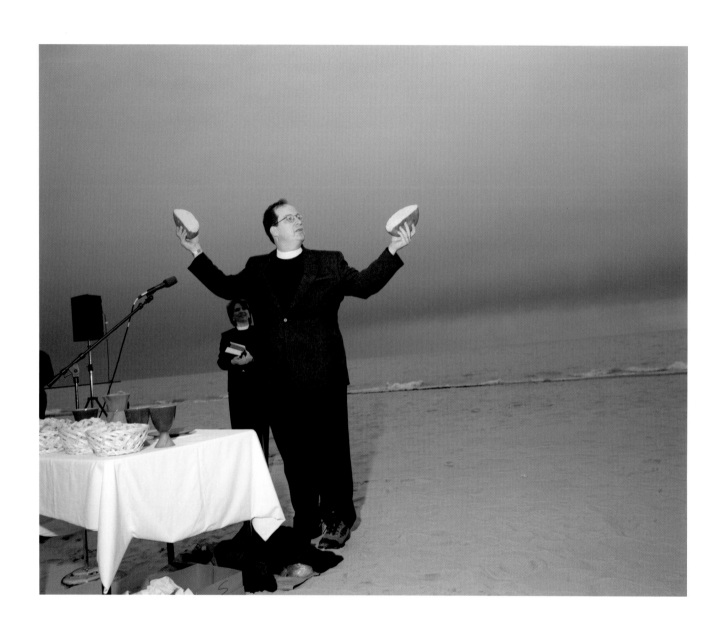

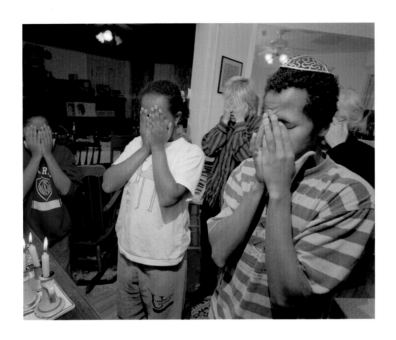

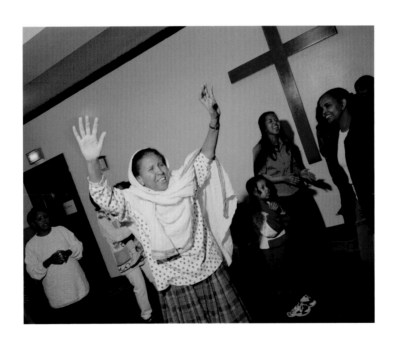

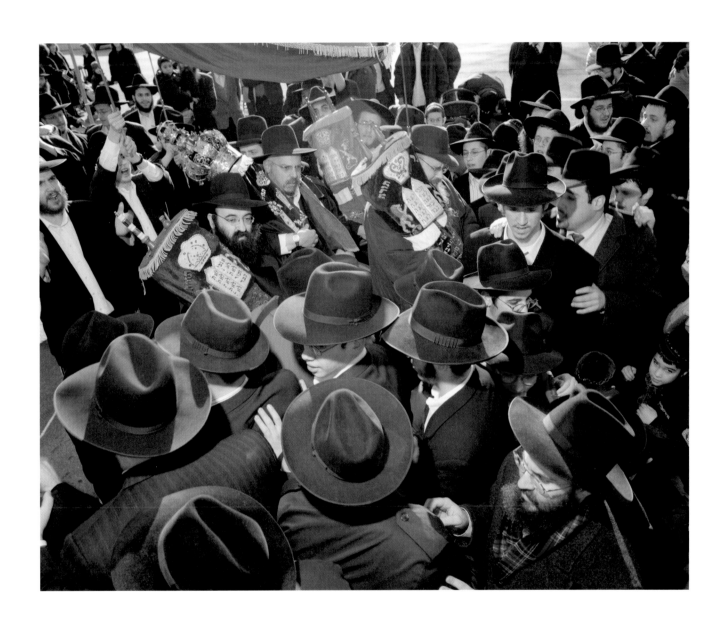

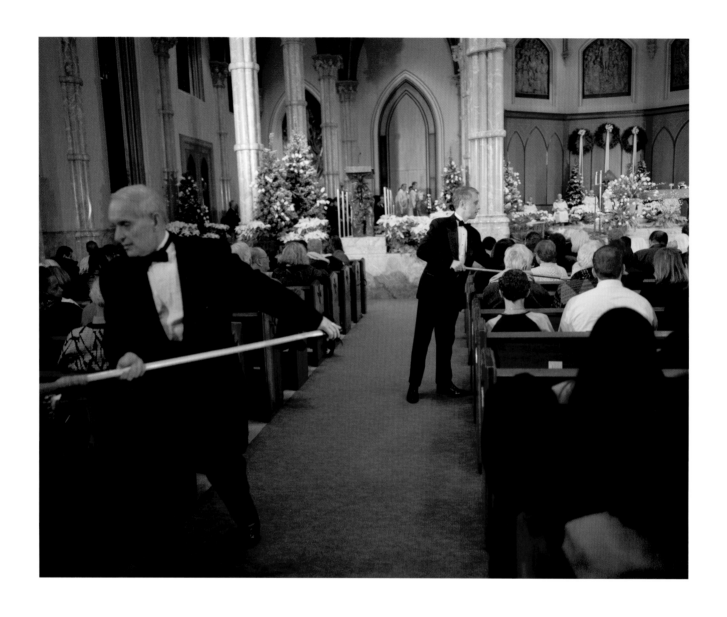

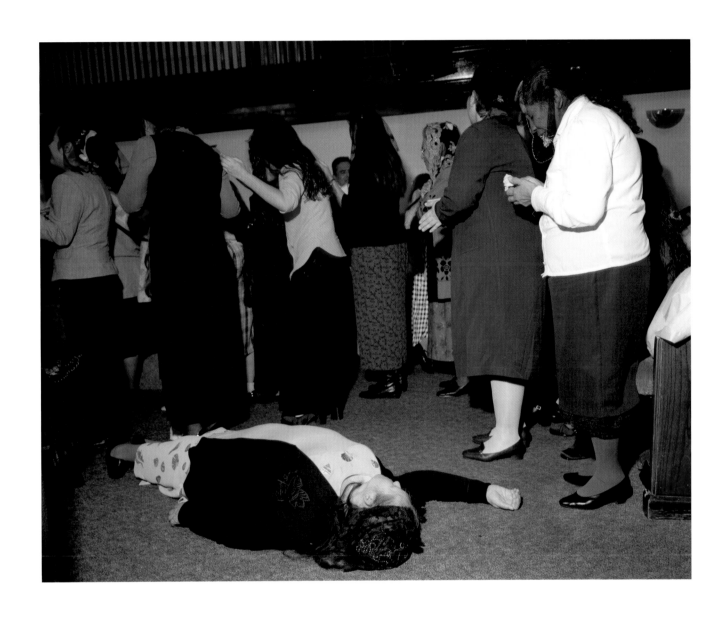

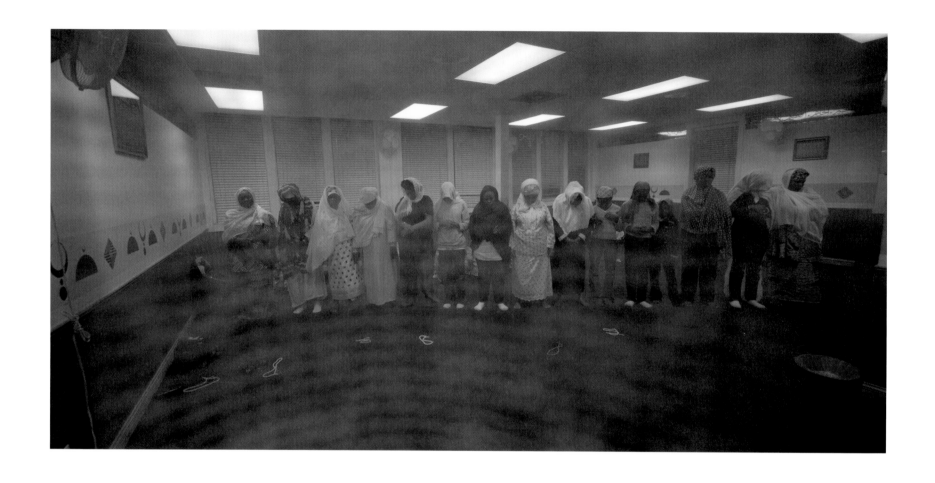

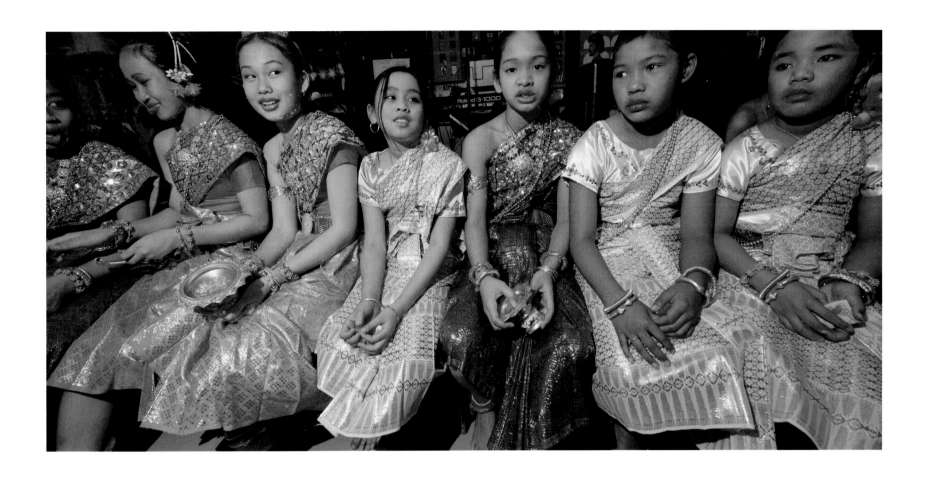

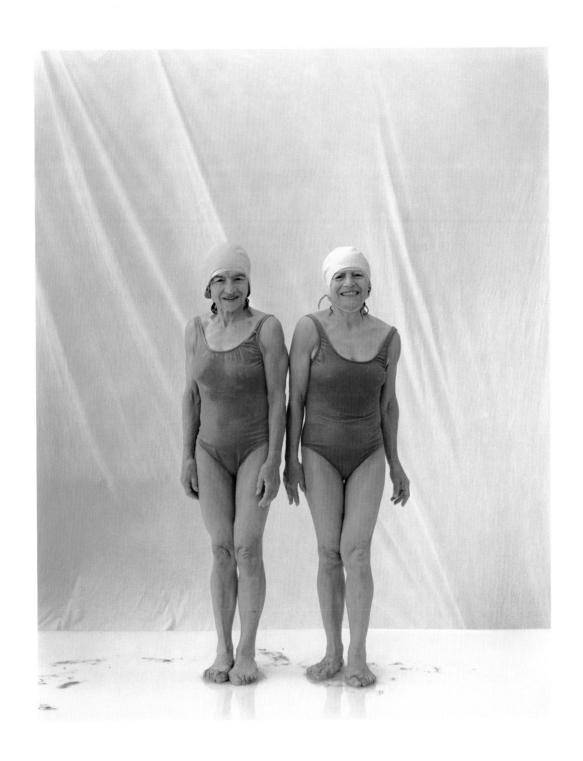

Everyone, we are taught, lusts after beach-front property. Malibu, Hilton Head, South Beach, Nantucket—cachet aside, it's the pleasure of the wide view of water that dazzles the affluent into opening their wallets to invest in frontage. Anyone who knows the ocean will testify to what a calming thing it is, tranquilizing the very beat of our blood, to watch the waves roll in.

I spent my teenage years in a distinctly landlocked part of Queens, that least romantic outpost of New York City, where getting to the beach was so oppressive a task that it often didn't seem worth the trouble. If I went with my friends to Jones Beach, which felt like a thousand miles away, it could take half an hour, blinded by glare off acres of bumpers, just to walk from the density of the parking lot to the density on the shore. There, sunbathers lay packed tight as bricks on coarse sand in need of another few million years of oceanic grinding to soften up.

If, instead, I went with my parents (bickering with my brother in the back seat), we drove to a not-very-elegant beach club because so much of Long Island's shore is private. For that pleasure we sat mired in traffic for hours, in danger of the radiator overheating, picking up our sunburns through the rolled-down windows. (For air conditioning, back then, you went to the movies.) And later, since everyone deserted the beach when the sunlight faded, there was an even longer ride home.

Chicagoans have no idea.

Half a lifetime after my long days' journeys to New York's shore, I logged more than a decade in Houston, which (having once been the seabed of the Gulf of Mexico) is as flat as Chicago but is lubricated only by a system of concrete-lined, odoriferous ditches called bayous. Though the bayous could overflow in a bad enough rainstorm to drown the unwary—"toad stranglers," they called those downpours—for me they didn't count as water; they counted as inefficient drainage.

Which explains why, with unspeakable gratitude to the embattled protectors of the Lake Michigan shore both current and historical, and to the wily settlers who, though they built their first shelter along the river, certainly had taken note of the water to the east, I sit here today writing this sixteen stories up, a block-and-a-half from the lake. I am so awed by this vista I'm quite certain that had it not been for the inland sea in my front yard, I would not be living in Chicago today. Lake-loving is not an idle affair for someone who took so long achieving it.

Ten years ago my husband and I came here from Texas for a year's leave and, by sheer chance, sublet the apartment of a friend that put nothing between us and the water but Lake Shore Drive and Promontory Point. Our windows were broad and uncurtained, a boon in this sun-challenged city; our sublet living room was so sun struck some mornings that I had to turn my back on the eastern view.

But the lake! The lake was so compelling that we kept a journal on our window ledge—perhaps we should have taken photos but, word people, somehow that didn't occur to us—so that we could record its changes.

Because what we discovered is that "our" lake is, truth be told, much more interesting in its variety than the ocean. Lake Michigan wears so many guises it's hard, sometimes, to believe it is the same body of water. The journal is a celebration of the awe of first sight, but I know I could add to it infinitely and never repeat an exact configuration of light and movement, never stop seeing some fresh detail. Here are a few entries, shuffled liked cards out of order:

- *Soft green—not Mediterranean aqua, more the rubbed matte pastel of sea glass, gentle, as if a deeper color were being restrained.*

- *It's steaming! The freeze must be withdrawing and it's smoking out there. It's still a vast snow-field but to see what's boiling off it, you'd think there were dozens of ice fishermen lighting bonfires to keep warm.*

- *Bruised purple stripe along the horizon. How strange that there are no clouds to account for it. What often happens at the horizon line—strict straight-edge, sometimes thin, sometimes wide—is totally inexplicable. Occasionally there are dark, irregular patches on the water like the shadows clouds make on a meadow, but no, the sky is utterly clear. A mystery.*

- *Tropical blue—looks like an invitation to snorkel for gaudy fish amidst the coral. This is a color so implausible, so frivolous, I don't think anyone elsewhere would associate it with our famously gritty, unglamorous, mid-prairie city!*

- *White water shattering against the rocks of the Point, all broken edges, tossed twenty, thirty feet into the air. Tide coming in, weirdly, on the diagonal.*

- *Must be a regatta—sails have massed like dozens of gulls, though no one seems to be moving.*

- *Pure Japanese. Through one little rent in the mist, a red sun burns without heat. And it's all one, lake and sky, unbroken.*

- *I woke to the most peculiar moment I've seen yet: Thunderstorm, the sky a menacing thick gray, lake exactly the same color, but between them a wide belt of light so even that its edges, upper and lower, look ruled. Pure abstraction, more rigid than a Rothko. More like Albers, color against color. In ten minutes it's breaking up, dissipating, and the day can start again.*

- *And on my daily morning walk along the shore, which I usually share with dogs and bicycles, though not today: A wild spray of water drops, frozen as they've hit the ground, has left the winter-dead grass covered with a vast, unbroken carpet of shiny glass knobs lit by the sun. I picked my way across them like an ancient crone.*

When we decided to stay in Chicago it was on one condition—that we always live within sight of this kaleidoscope endlessly shaken, endlessly incomprehensible. Our inland sea is the only coast I need.

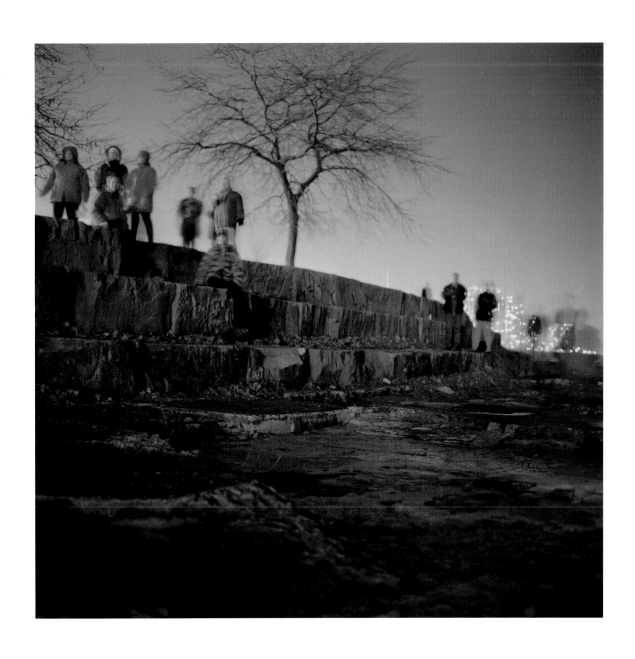

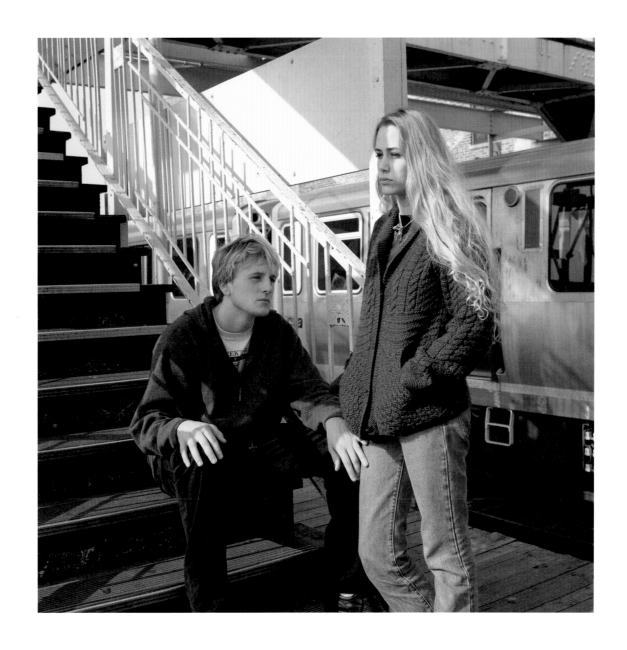

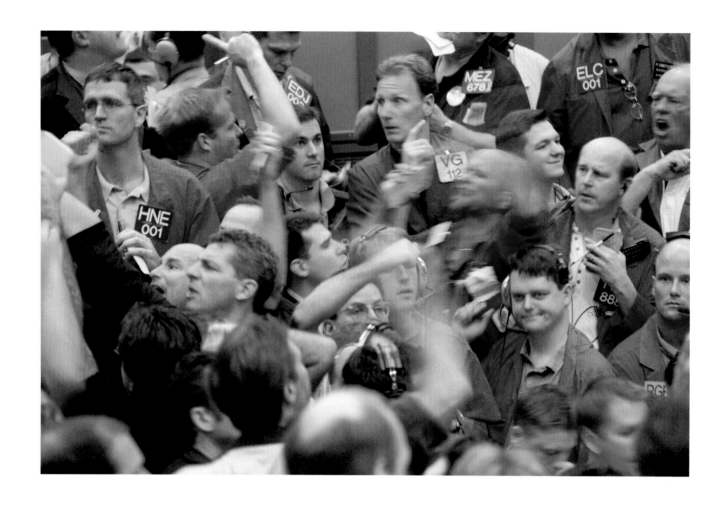

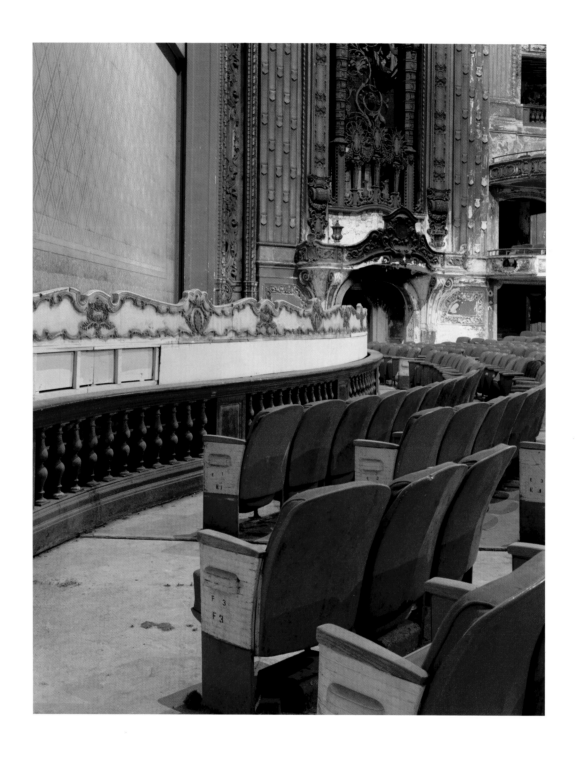

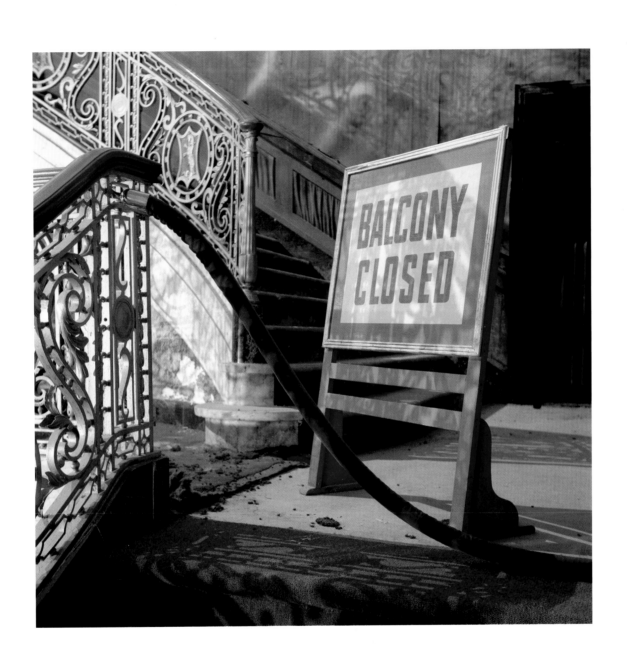

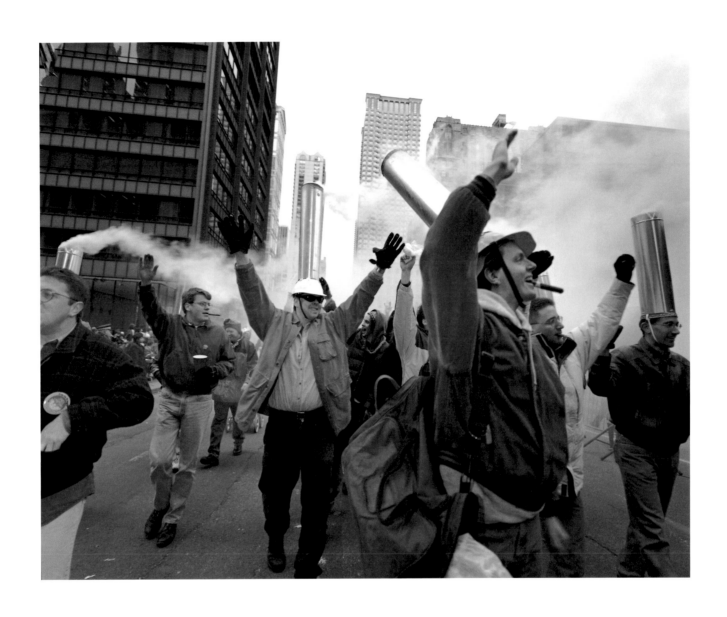

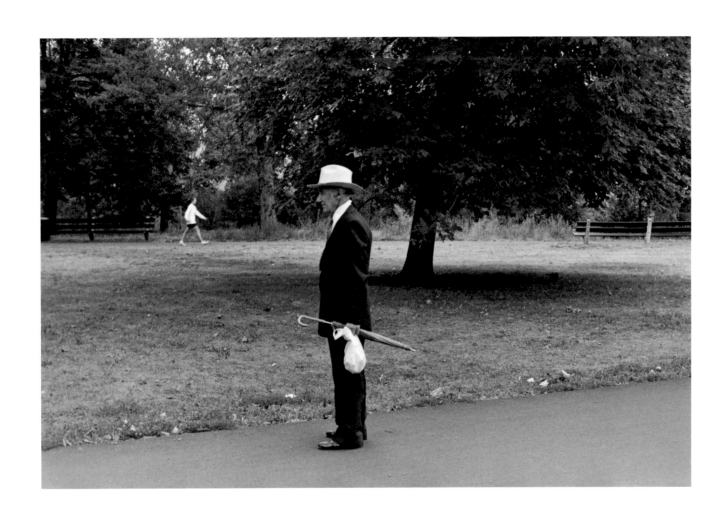

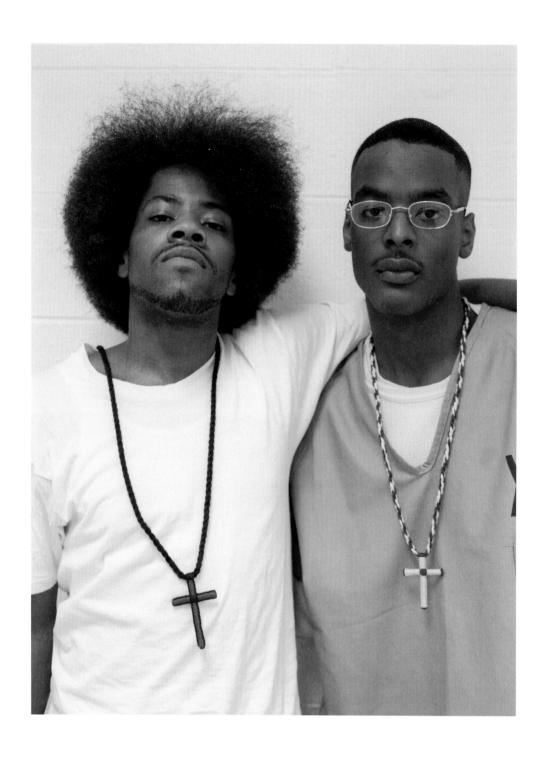

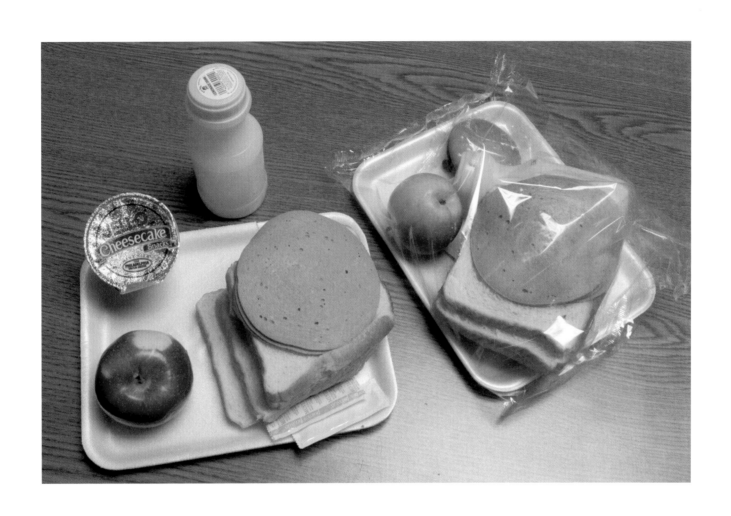

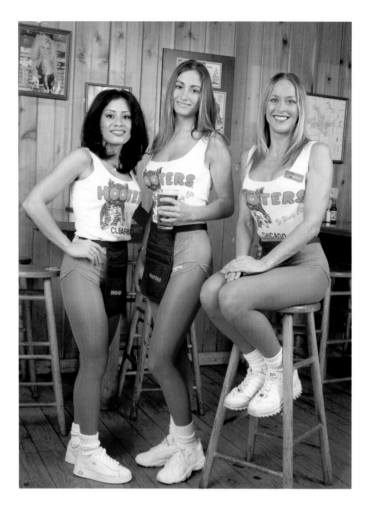

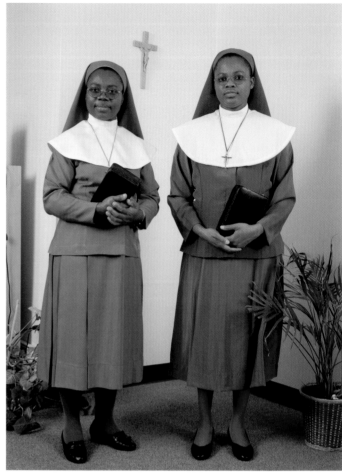

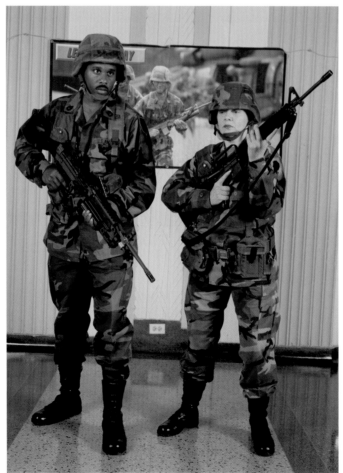

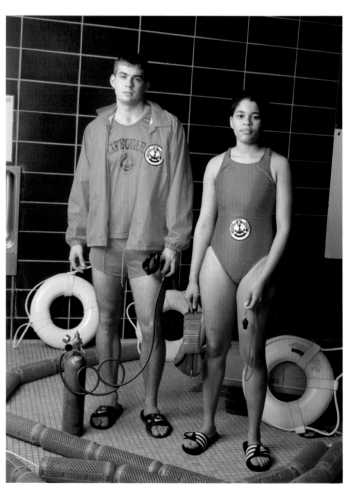

One summer Saturday night not long ago, I was standing with my wife and two Israeli friends on Devon Avenue at Rockwell, awaiting another couple with whom we were to have dinner, watching the flow of sidewalk traffic: jolly adolescent boys in cricket sweaters, older women in saris, younger women in knee-length tunics worn above baggy trousers, men in white pants and elegant silken shirts. I might, I thought, be in the city of Mysore. And I thought, too, of my own Devon Avenue, the one I knew and loved as a boy and how vastly different it was from the one I was standing on now.

In 1947, my father bought a two-flat at 6649 N. Campbell, a few doors from Northshore, for $14,000. The neighborhood, West Rogers Park, was, as we now say, "turning." That turn was from white-collar, middle-class gentiles to up-and-coming Jews, small-business men and professionals, attracted by the peacefulness and convenience of the surroundings. The greatest of these conveniences was Devon Avenue, whose main shopping area ran from Western to Kedzie.

Devon, an English place-name, is among the small number of streets perpetually mispronounced by Chicagoans. (Racine is another and Goethe is a third.) Devon (pronounced in Chicago with accent on both syllables: dee-von) was the first experience that I, then a boy of ten, had of a thriving commercial street. I had often been in the Loop, where my father worked as a costume jewelry salesman, but it seemed so vast that it was quite beyond my being able to take all of it in. Living on Sheridan, as our family previously had, I knew only scattered shopping: a small number of stores and shops on Morse, dominated by the locally famous Ashkenaz delicatessen, a family-run department store on Clark called Winsberg's and the Howard Juvenile Shop, just west of the Howard L station, where my mother took my younger brother and me to buy clothes and shoes.

Devon Avenue was something else entirely. Thriving, humming, intense, it was the heart of the retail action in West Rogers Park. There were stores of all kinds, restaurants, barber and beauty shops, drug stores, movie theaters (the Cine on Devon and the Nortown just south of Devon on Western), a large post office—much of it new and all of it seeming glittering and opulent. In the late 1940s and 1950s, two-car families were a rarity, not all that many women drove, and many fewer went off to jobs, and so local shopping was crucial: Stores needed to be within walking distance, and close enough for housewives to be able to carry their purchases home. Devon filled the bill perfectly.

Chicago neighborhoods in those years seemed more a series of connected villages than they do now. Devon was indisputably West Rogers Park's village center. Such seemed the richness and variety of what was on offer that there appeared little reason to leave the village. Within the eight-block run between Western and California, where the shopping was most dense, there seemed to be two of everything. The two barbershops were Al's and Henry's. Al was Jewish, had an immigrant's accent and kept a manicurist and shoe-shine man on the premises. The owner of Henry's was the father of Frank Ehmann, an All-City basketball player at St. George's who went on to be All-Big Ten at Northwestern. I went to Henry's, in whose second chair worked a small, dark quiet man named Ross, who gave the best crew cuts going.

Woolworths and Neisners, only a couple of blocks apart, were Devon's two dime stores, with Woolworths the larger, selling canaries and goldfish and small turtles. Two men's stores, Aidem & Dess and Turner Brothers, were four or so blocks apart. I worked one winter when I was in Senn High in the will-call department at Turner Brothers, a large store that took over the space formerly occupied by the Cine. Aidem & Dess was the smaller of the two and went in for "color-coordinated" windows, which meant that every item in the window was the same color. The desired effect was vaguely showbiz; men in those days dressed not yet cool but sought to be sharp, and sharp tended to run to the slightly garish.

Crawford's and Abram's, only a block or so apart, were Devon's two family department stores. Crawford's was the larger, and had a downstairs floor. (Upstairs reached through a separate street entrance was Devon Bowl, an eight-lane bowling alley.) Crawford's shoe department had a fluoroscope, upon which a child was asked to stand—"Wiggle your toes, please"—as the salesman bid mother to look into the machine and note that there was still plenty of room for the kid to grow into the new shoes. A few blocks down the street was an upscale (for that day) women's clothing shop called Seymour Paisin's. My mother told me that while shopping there, a customer was offered a cocktail, though no self-respecting woman in those days would be caught dead drinking in the early afternoon.

An A&P and a Jewel were in business near Talman, but the great grocery store on Devon was Hillman's, off Artesian, which also had a shop downtown. A coffee shop and cafeteria were on the main floor, and women shoppers and local merchants went there for lunch or a coffee break. At the entrance to the supermarket below was a fan-shaped marble staircase. I worked for a few weeks as a bagger *manqué* at Hillman's; the *manqué* part had to do with the quality of my work, which, as the fairly regular crashing of milk bottles going through the ill-packed bags of one of my customers on the marble steps attested, was wretched.

A Peter Pan hamburger restaurant was on the corner of Devon and Western. On the same corner at a newsstand, a heavyset, laconic, always bundled-up-against-the-weather fellow named Steve slipped people football parley cards: pick three college teams within the point spread and a dollar bet got you six bucks back.

In high school, I hung out a lot at Kofield's, an early Grecian spoon, on the northeast corner of Devon and California. But in grade school my restaurant of choice was Frank's, a hot-dog joint operating out of a hutlike structure between Washtenaw and Talman. A Vienna hot dog (everything on it, hold the peppers) and a sandwich-size bag of lusciously greasy french fries cost twenty-five cents (a bag of fries alone was fifteen cents). Wearing a paper hat supplied by the Vienna Sausage Mfg. Co., Frank, the owner, was a gentle, soft-spoken man, part of whose lower-jaw was chipped away, either in the War or in an accident, I never found out. The place seated four, five people tops, and my friends and I usually took our dogs and fries away to eat walking along the street.

Devon west of California was less crowded with shops. A large restaurant called Randal's moved in on the southwest corner, a small medical building on the northwest. The great store west of California was Manzelmann's Hardware, which also sold high quality dishes, small electrical appliances and other household items; its shelves and counters were well and tidily stocked. I bought a fairly unmenacing because smallish switch-blade knife there, which I hid in my sock drawer from my parents.

Devon ended with Thillens Stadium, the baseball park, then owned and run by a check-cashing company, where my friends and I spent summer evenings watching 16-inch softball games played at a very high level by teams sponsored by Martin Jewelers, Midland Motors, KoolVent Awnings and other companies and businesses. In my mind I can still hear a voice over the public-address system announce, "Bato Govedarica the batter, Solly Musaloni on deck." Beyond Thillens was some foresty land known as "Bum's Wood" in which, it was rumored, terrifying hoboes lived, and beyond that the clay pits, which then seemed like the end of the Earth.

What happened to the glittering Devon of my youth is that the more successful Jewish families moved out—to Skokie, to Lincolnwood, to Highland Park, to Glencoe—and the Old Orchard mall moved in to the west, draining interest in Devon as a shopping street. Drab discount operations began to occupy the sites of what were once swank shops. Storefronts remained vacant for long stretches. The street began to seem dreary, done-in; and, apart from a good bakery or two, no shops or restaurants of any interest, at least to me, any longer existed.

Devon was saved by the South Asians, who brought in their trail the teeming Indo-Pakistani bazaar that the street has now become, and by the ultra-Orthodox Jews, who opened up their less glittery shops and schools to the west of California. It is their turn now, and that is fair enough.

"The more things change," the famous French aphorism runs, "the more they stay the same." Not, I fear, true. Truer to say that the more things change, the more one recognizes that change is part of the deal of life itself. It's good to see Devon revitalized, boisterous and lively once more, even if it isn't, and never shall again be, my Devon Avenue.

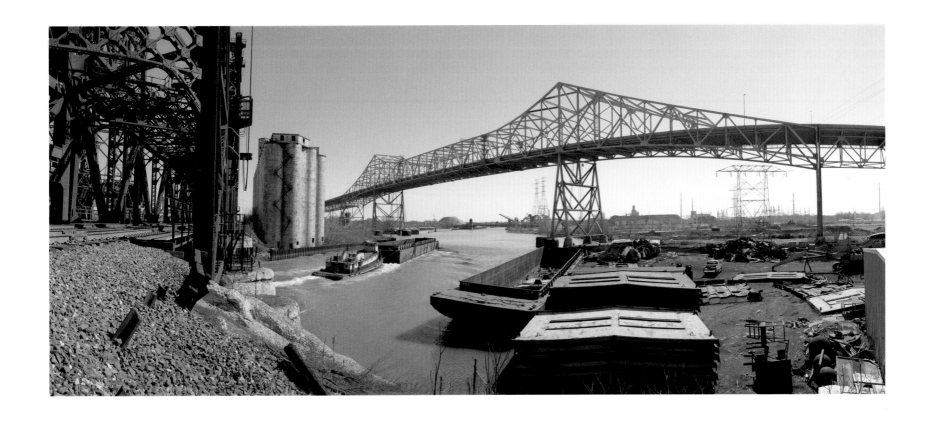

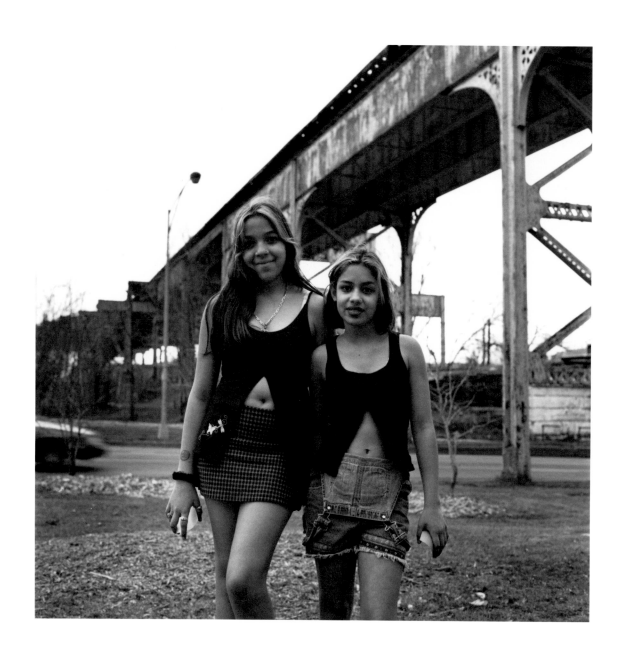

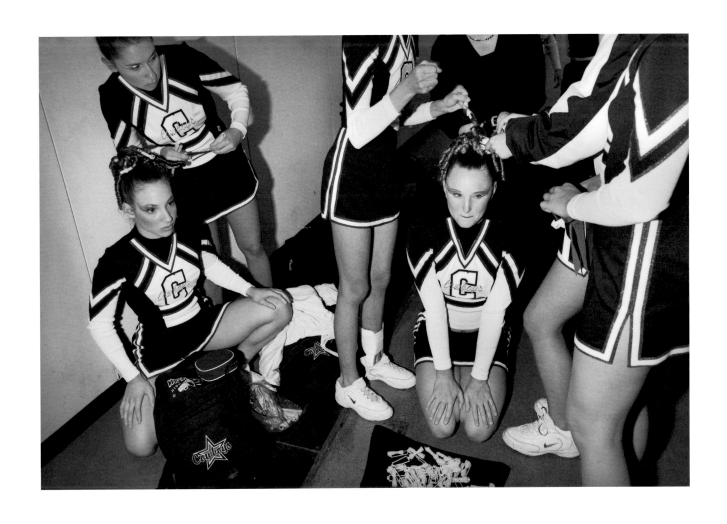

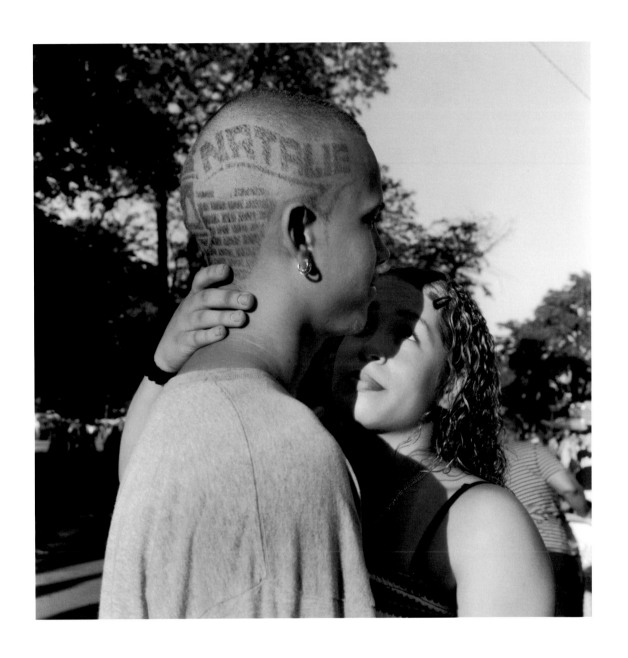

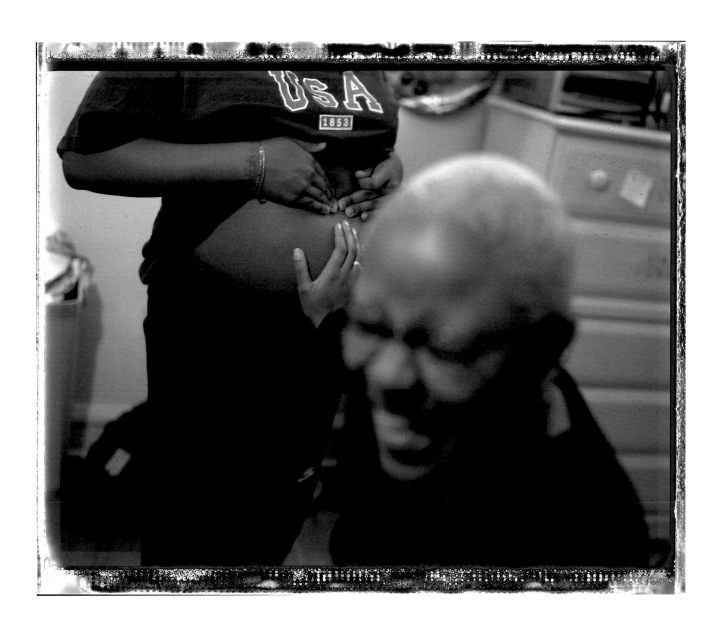

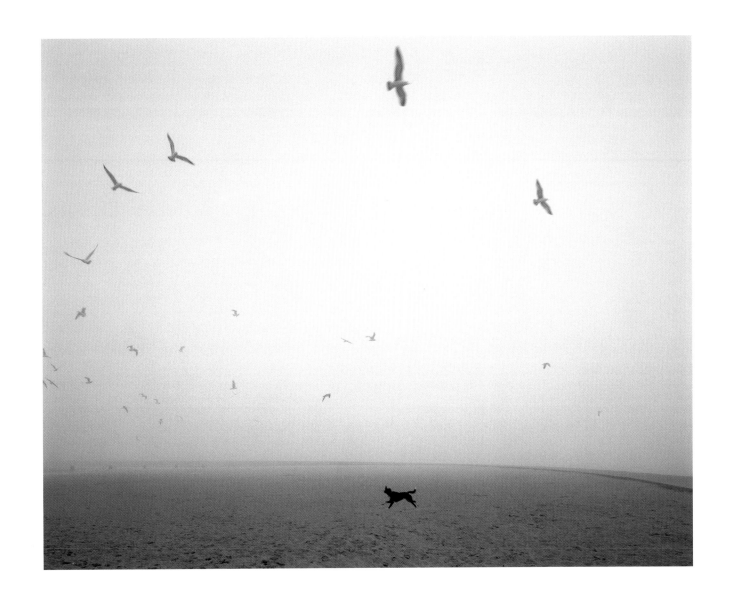

We go back, Chicago and I, way back, back before I was born, back before my mother was born, back before my grandfather first laid eyes on my grandmother and decided that no one else in the world would do. The city and I go back to the 1920s, an interesting time to be a young black man from Anniston, Alabama; a young black man with an itch to be a doctor, one of hundreds of thousands of black men and women piling out of the rural South and into the urban North, lured by the hope of a better way than the old way.

Still, a better way didn't mean an easier way. At the University of Chicago's medical school, my grandfather, Marque Jackson, discovered that while his tuition money (partially earned by the benefit of some high-stakes gambling, according to family legend) was most welcome, his light brown face in the all-white dorms was not.

He was forced to find housing off campus, living in a rooming house for black students, crashing there between classes, studying and working the graveyard shift at the post office, eating meal after spaghetti meal because that was all he could afford. I like to imagine him stealing some time for fun, a Cab Calloway look-alike haunting the city's smoky jazz clubs. He graduated from the U. of C. a doctor, a first for his family and one of the first at the U. of C., and went to work as an intern at Cook County Hospital.

His story reflects one aspect of Chicago's complexity: His success was accompanied by the backhanded smack of segregation. What makes Chicago unique and wonderful is its ability to juggle life's variety, it's light and dark and all shades in-between: Icy winters and sizzling summers; Ebony Magazine and KKK marches; Mies van der Rohe's majestic architecture and Cabrini-Green's cruel cinderblocks. It is working class and world class, as burly bungalows coexist with elegant gray-stones; deep dish with dim sum; hotdogs and homespun at Wrigley Field, with, a few blocks away in Boystown, leather chaps and dog collars; salsa with the blues. It's R. Kelly's multiple Grammys and his multiple child pornography charges; Harold Washington and the Daley dynasty.

Chicago, with its image of sweaty, big-shouldered muscularity, isn't supposed to have the world's greatest symphony, or the Joffrey Ballet or Tony Award-winning theaters or high-concept installation art. But it does. Has them all, and more than you could imagine; a surprise around every corner. It's not either/or, it's either *and* or.

Chicago has a hold on me. It has a hold on my family. For my father's youngest brother, Charles, it was a place to try on new identities, settling there as he did after the Democratic National Convention of 1968. He was a young dentist from a conservative family of New Orleans Creoles, hard-core Catholics. But far from home, my uncle shrugged off the constraints of Catholicism, finding in Chicago a place to embrace all things hip, from smoking pot to piercing his ear to exploring Transcendental Meditation. It was in Chicago that his sons—my cousins—grew Afros to rival the righteous splendor of the Jackson 5 and learned how to dance by watching "Soul Train," growing up in a groovy Hyde Park flat filled with beaded curtains, a pool table in the dining room and the sensuous sounds of Carole King and Marvin Gaye. As a young girl in New York and Atlanta—one whose hair never could get the hang of an Afro—I envied their life. From afar, Chicago seemed transcendent, free.

It was just a matter of time before Chicago lured me. I moved there from Manhattan in 1989, ostensibly to attend graduate school but also chasing after a man. That relationship mercifully did not work out but I fell in love with a city and that love affair endures. How could it not? For 10 years, I was a journalist living and working in the ultimate news town: A town where people read the newspapers; loved and loathed their columnists and their TV anchors; where getting the scoop mattered, whether you worked for the Tribune or the Sun-Times or the Defender or any of a dozen smaller papers.

As a cub reporter working on the city desk at the Tribune, I got an eagle's eye view of the city. I learned Chicago's intricacies; the best place to hit the Kennedy and when to avoid the Dan Ryan; that you could stroll into the dreaded Robert Taylor Homes on the South Side and find children who learned early on to "drop and roll" at the sound of gunfire. But there, too, you could find poets.

But this wouldn't be a real love story, not without some knock-down, dirty fights. You can dismiss them as mere lovers' spats, but there were times when Chicago made me mad. I hated the way Chicago divides itself along racial, religious and ethnic lines, fostering distrust and fear; how corruption and politics often do the two-step together in deals with the devil; that police officers swear allegiance to gangs such as Latin Kings or the Blackstone Rangers; that yuppies shove out poor folks in the name of gentrification. Not like a happy whole at all but ready to split apart for good.

In time I started to believe I was outgrowing Chicago, that I'd sampled all there was to sample, experienced all there was to experience. Like my grandfather 70 years before me, who eventually left the city to hang his shingle in Atlanta, I scrambled away, back east, to Washington, D.C., and a newspaper where they once ran a president out of office.

I ran, but I could not hide. Truth was, I missed Chicago, and I still do, maybe always will.

When I decided, at 42, that it was at long last time to marry, I reached back to Chicago and grabbed myself a husband, a man who loves Chicago as much as I do, even from miles away. Some years ago, my husband worked on a documentary film. It was about the Great Migration that brought hundreds of thousands of African-Americans including my grandfather to the cities of the North. What my grandfather found was a city that could sometimes kick you in the teeth at the same time it was offering a hand up, a city pulsing with complexity, a city that for a while he called home. He found Chicago, and because he did, I did, too.

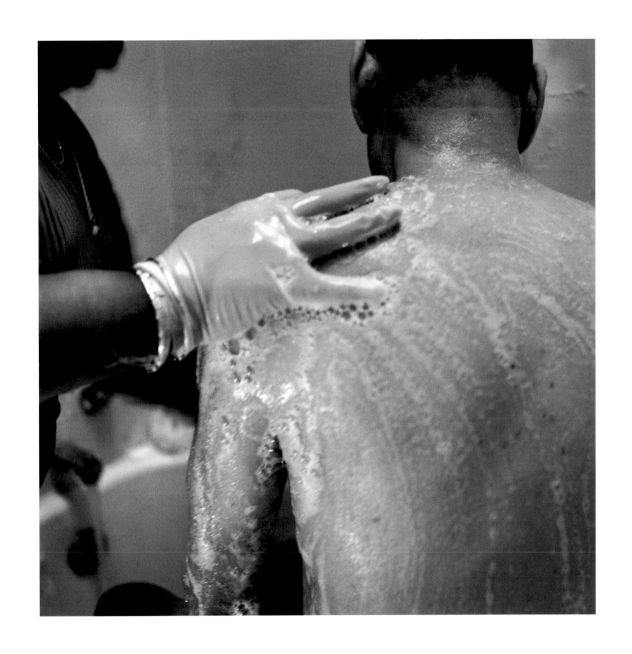

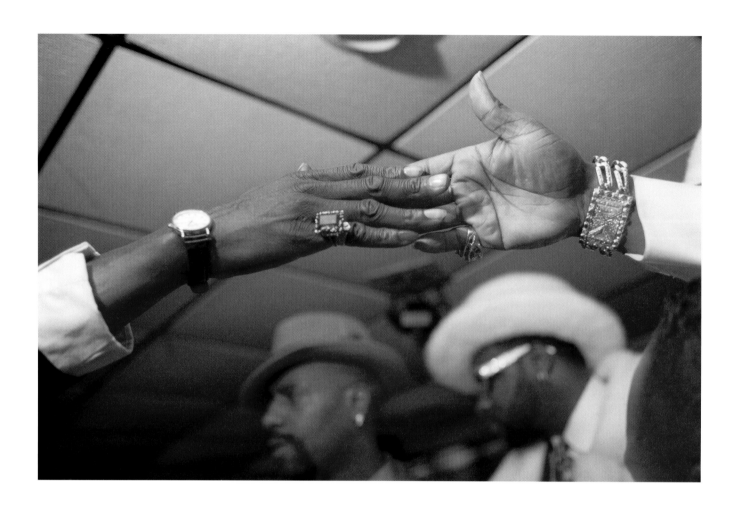

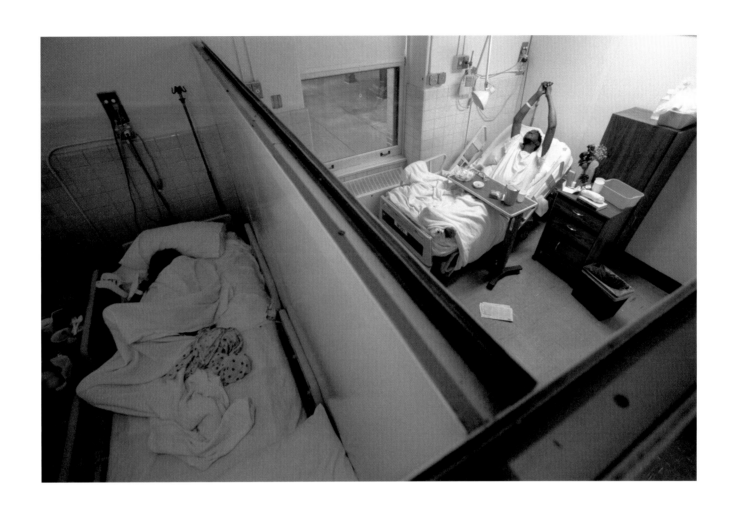

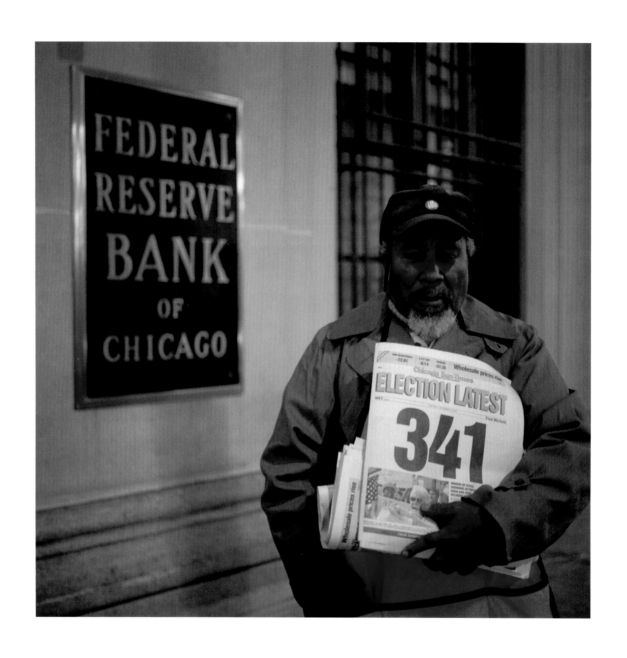

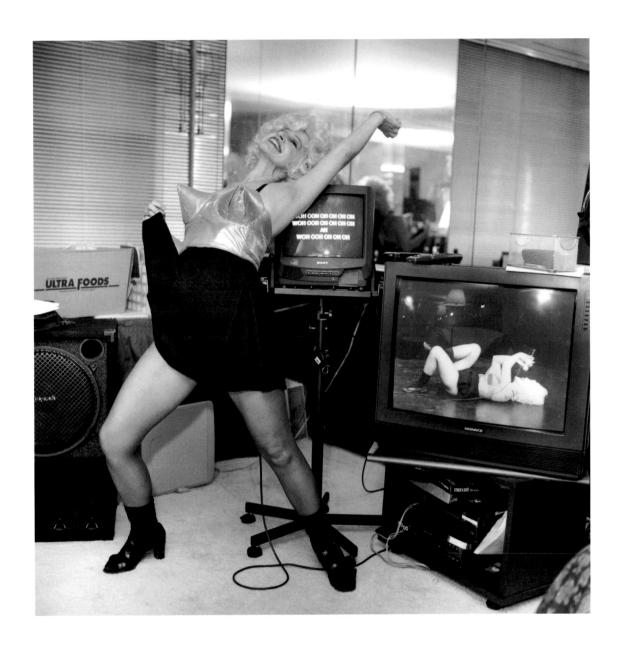

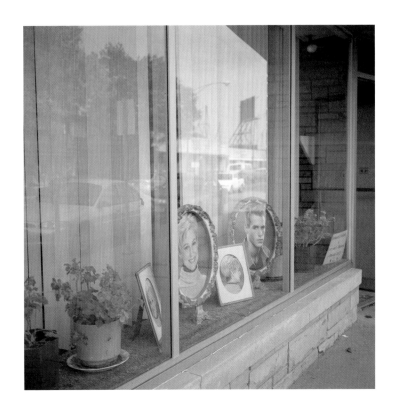

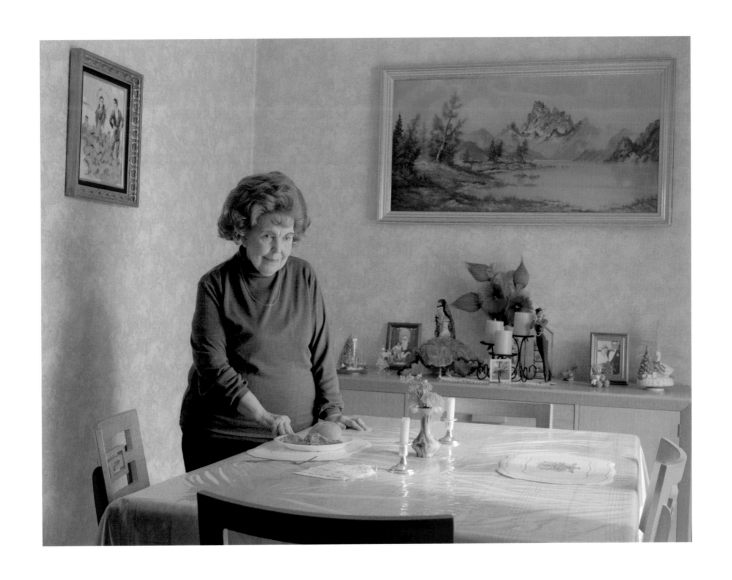

One night a few years ago, at the direction of a guitar-playing friend, I drove west across Chicago as far as I could go, in search of a bar with no name and the kind of blues not often heard these days in the city's nightclubs and music halls. I was instructed by said guitar player to reveal the club's location to no one, lest some cop or city inspector—or worse, a busload of tourists—get wind of the place.

I found the address without a problem. The sign out front marked it as a video rental shop. The windows were covered from the inside with paper. It had the look of another abandoned store in another abandoned block in another neighborhood of abandoned hopes. In other words, it had the look of a blues-lover's heaven. As I reached for the door and felt the beat of the bass guitar and drums shiver up my arm, I enjoyed for a moment the sensation that certain intrepid explorers must feel as they push ahead into uncharted territories. Never mind that I was an intrepid explorer with a pocket full of credit cards and a car parked right in front in case things got to be too much. But this is what it had come to: In Chicago, the city most closely associated with the electric blues, a city with a much ballyhooed blues festival, with dozens of blues clubs, with a blues-themed hotel, real fans of the music must journey to obscure, nearly invisible places if they hope to find anything resembling authentic Chicago blues.

How did it come to this? How did we reach the point in our cultural history where the best-known and best-loved blues clubs are almost all located in one of the city's most affluent neighborhoods, Lincoln Park? Today's clubs are packed with tourists and suburbanites who come not only to hear music but also to buy T-shirts and posters and novelty boxer shorts. They will leave believing they've had a genuine urban experience because they've heard black musicians playing in rooms with peeling paint.

How did it come to this? It has come to this in large part because of the ways in which our city has changed. When some of these blues joints first opened, they were the real thing. Even the clubs located in Lincoln Park were filled with diverse crowds—crowds that included factory men and bus drivers elbow to elbow with college students and professors. Chicago was still the city of broad shoulders, a place where men worked with their hands, and a place where the blues had some meaning. After all, the blues came up from the Mississippi Delta along with the same men and women who came here to work on those factory floors and drive those city buses. The music had something to say to those people.

But somewhere along the line, perhaps in the 1990s, maybe earlier, the blues as performed in most of Chicago's nightclubs became vaudeville. It happened, not coincidentally, just as the city's industrial economy began to vanish and a tourist-driven service economy took its place. You've heard the Muddy Waters song "Blues Had a Baby and They Named it Rock and Roll"? Well, the blues went on to have a grandchild, too, and they named it pure drivel. Most of the bands performing in today's popular blues clubs have been reduced to playing the same tired songs, set after set, night after night, week after week, year after year, as if some city law imposes penalties for failing to perform "Sweet Home Chicago" and "Mustang Sally" at least once an hour. For the musicians, it must be pure hell. For fans of the music, it's just sad.

But all is not completely lost. It's still possible to hear real blues musicians playing truly inspiring music, as I discovered on my journey to the West Side and the club with no name. As I pulled open the door that night, I saw a smoky bar with television screens at either end, a pool table, some folding chairs, and a couple of tables stacked with aluminum trays full of chicken and macaroni and cheese. The band stood at the back of the room, fronted by a tall, angular singer named James Y. Jones, who played under the stage name of Tail Dragger. He called his band The Lazy Boys.

Though Tail Dragger is black and a native of Arkansas, the Lazy Boys, it's worth mentioning, were all white. Most of them were graduates of the University of Chicago. It's no surprise that some of the best blues played these days in Chicago comes from young white musicians, because the laws of supply and demand make it possible for them to avoid the pitfalls that trap so many black bands. Most of the big clubs won't hire white musicians, because it's not what the tourists want to see. So, ironically, these are the musicians most likely to be found playing in bars filled with genuine Chicagoans who want to hear genuine Chicago blues. They are free to play what they want to.

Tail Dragger sang:

Hard rocks is my pillow
Cold ground is my bed
The highway is my home
And I might as well be dead

Sometimes he sat on a bar stool as he sang, like just another customer with his share of heartache and happiness. Sometimes he went to his knees and crawled along the carpet, as if the mournful cry of his mighty voice alone did not adequately suggest just how low he felt. It was a powerful performance, fueled by the passion of the audience. It was clear from their shouts and their back slapping that many in the audience empathized with the singer's condition. They were not just being entertained. They were being spoken to.

That night I asked Tail Dragger what would happen if a band from one of the clubs in Lincoln Park came out to this underground West Side hole in the wall and played "Mustang Sally" in the manner to which the tourists were accustomed. "These people would run you out," he said matter-of-factly.

And so the blues lives on—barely, almost invisibly—but perhaps in the spirit in which the music was intended. It remains above all the sound of struggle and joy.

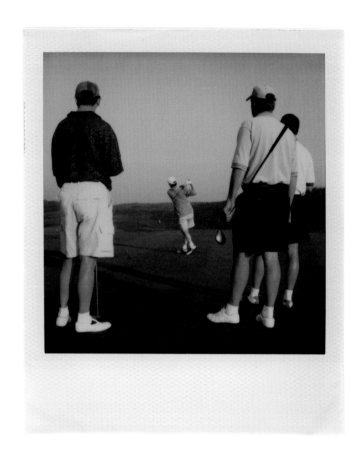

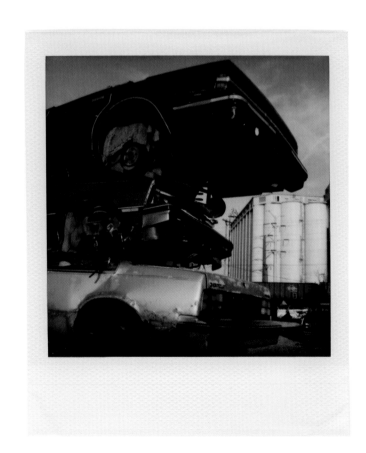

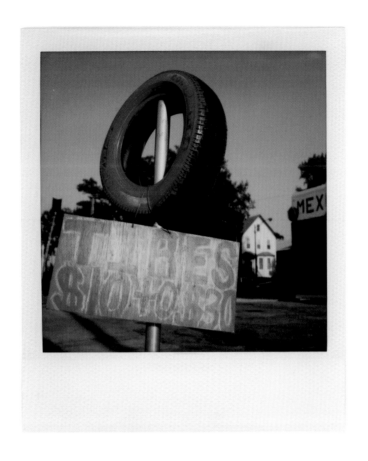

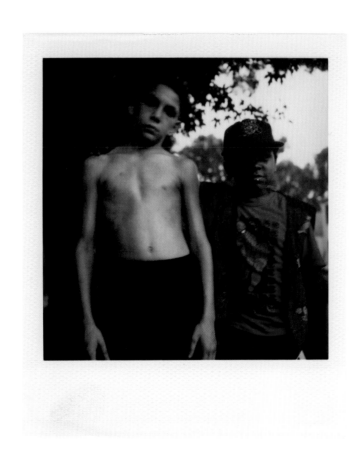

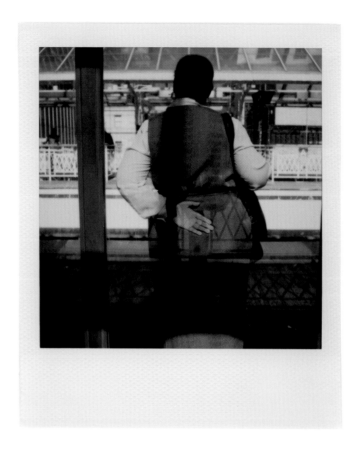

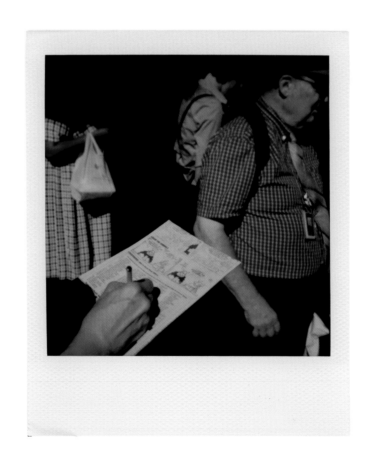

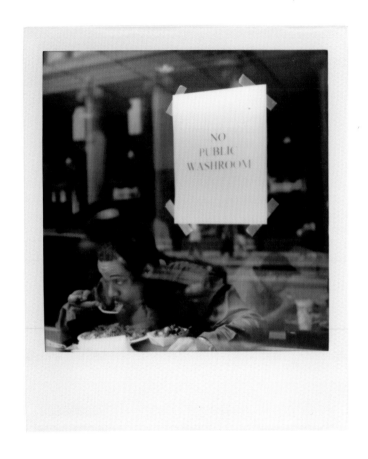

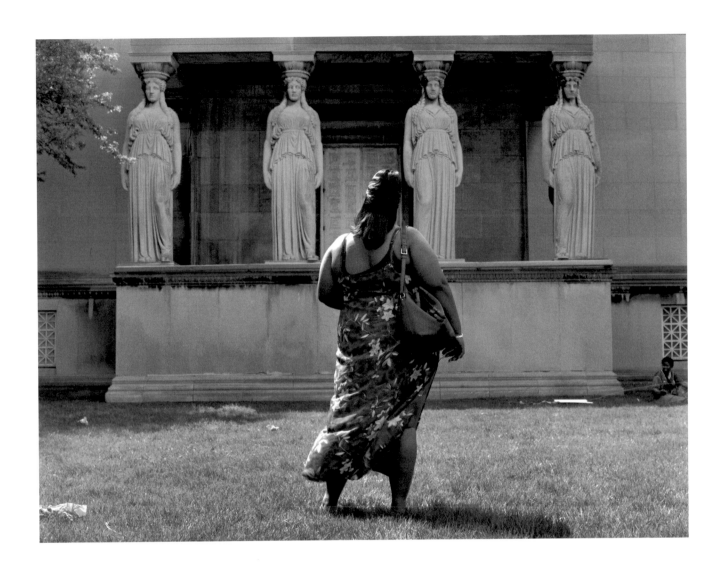

My wife is new to Chicago. Of course, she will label me a liar twice over for saying so. She will remind me that she was raised in Evanston—the northern suburb—and thus hails from a place near enough to Sweet Home. Or, she'll contend that she isn't actually new to Chicago itself at all, since she knows the ins and outs of the environs around the Howard Street border on the city's North Side. She is just new to my South Side, she'll say.

Were I in an arguing way, I'd reply that if she buys that tale about Chicago as the twisted knot that binds the country, then she must purchase my South Side smack-talk, too. Especially the part about how my South Side is the short, fat twin of the city people think they know. And the part about how all of the boasting and blathering other folks on the other side of that other street—separated by flashing lamps and tracks and cracks and smack, just so they won't slaughter each other—make it so. So—I could tell her—if you don't know this place and its thick, dividing bends and curves, you can't know a thing about Chicago, love.

She marvels at the ducklings that float in the Jackson Park Lagoon, mostly hidden by the woodsy growth behind the Museum of Science and Industry.

"How'd the birds get to 57th Street?"

"Cornell Drive," I correct.

"They're so yellow," she says as I idle the Nissan near this repaved bend where the planners curved Cornell into 57th Street so that the museum exit makes sense to Lake Shore Drive's tourists.

The museum, found at Lake Shore Drive along this bending, numbered east-west trail, is the beginning of the South Side for those who don't know; seeing as no tourists would catch themselves on Dr. Martin Luther King Boulevard right-minded. And, although I'm not really sure, I'm rolling dice on it without a blink: 57th and Lake Shore Drive is about as far east as you can go on the South Side of Sweet Home, without drowning. Gone too far, love, five miles south of the Loop, no turning back now.

"Like in the cartoon," I say as her head turns to trail the lagoon's disappearance behind tan stone. "*Tom and Jerry.*"

"That's a cat and mouse."

"I know," I say, "but there's this duck in some of those old episodes—Tom gets tired of chasing after the mouse with all his bad luck, so he gets to panting after a duckling in the woods. Tries to make a sandwich out of the bird. That duck was as yellow as them back there."

Because of me, my wife watches the MGM cartoons on cable, no matter that she doesn't dig-on biped water-color animals at all. "I bet Jerry got mighty jealous with Tom turning his attention to a bird."

At first listen, this is North Suburban spiel, some kind of clinical mush. The South Side smack in me wants to spout about how Jerry's no punk, much less a sissy. But Cornell Drive is about to become 57th Street and we're driving east toward the lake and then northbound, so I edit myself, "No, actually Jerry rises up on his two feet and saves the duck from Tom's paws. What I wonder is why Tom didn't just ask the bird and mouse to stop running after getting after them so long. Begged if it had to. Jerry and the duck had to get tired after all that running. Might not have minded Tom's paws and claws if the cat'd asked them to stop, at least slow down—asked like he had some sense, like he meant it."

"That's funny." My wife makes this noise, breathing question marks between m's and h's—not a laugh really, just breathing and ending with quiet doubt.

"Why?"

"Birds and mice have to survive, too. If they stop running, the game is over—Tom feasts." Again, the car is quiet aside for the dashboard radio, until she says, "Can't see how those birds make it through the winter back here."

"They don't," I say as Tavis Smiley's Down South logic mutters from the dashboard to do battle with the Lil John or Ludacris or 50 Cent rhyming, roaring, muttering in an Escalade that sits between us and the museum parking lot. "Folks bring them here every May."

"What folks?"

"The folks who built up the museum and the university and the park, the whole place, after the Fire. They ship the duckies in come springtime. Bring them here to commemorate new life in the city."

"Who are you talking about? God?"
"Yup," I answer, "God. All those gods, they bring them here to the lagoon."

"Wonder how the ducklings turn so brown when they grow big."

I hear no question mark at the end of her words, but I'm tooling about a street that I know, about to bend into a path that makes little sense to me. So I am in a self-flattering mood now. Vanity and pretending to know it all are my defense mechanisms, she says. "It's the melanin in their feathers," I shrug. "It comes over time, brown melanin: hue. Like me. I was born high bright, like my grandmother's people called it—yellow as the birds in that wading pool back there. Now look at me."

"You know I was joking, right?" she says. "The brown birds are geese."

"Geese? Hah." I look at myself in the rear-view mirror. "Been round this bend a thousand times, seen the lagoon. Those are museum ducks, brung here by the gods and grown to full hue."

She is bored with me, so I stare at the lake in front of us. "You're so over-determined," she says as Smiley's hour passes and the stoplight at the real 57th Street brings us to an eastbound pause.

I want to ask her what this means, if this is some Evanston-born way of calling me full of shit. But the 57th Street light goes green and I idle east again and three adult brown ducks amble from the curb, onto the concrete strip where my 57th Street gives way to the planners' twisted version, and Ludacris screams from a Caddie tank that winds toward Lake Michigan. And I'm already moving, trying to keep up with the fancy car and its Alpine sounds, too fast.

"Watch your colored ducks," my wife says, "don't you see?"

I slam the pedal hard as soles will allow, and I blink, and the lives of the waddling flash before me—flash me back to the southern end of this strip, not even the Cornell Drive stretch, no all the way down southwest of the bend where Cornell, 67th Street and Stony Island twist together.

The Drive ends on this island. There is a BP fill-up station and a McDonald's restaurant right there; been on South Stony Island since BP was Amoco, and Amoco was Standard Oil, and McDonald was just Ronald the Clown—since the Fire, I guess, maybe before then. Almost one year before our drive along the Jackson Park bend, I lost my cell phone in the garbage can between pumps at the BP. So I returned to search on a Tuesday morning, only to find these containers emptied.

I sought out the Man at this BP station—here, the Man isn't the owner or his Middle Eastern cashiers. The Man is a brown, bushy-haired, five-foot ten-inch, muscle-bound brother from some bad-assed part of the South Side whom the station employs as protection. He stands in the vestibule outside the cashier's bulletproof glass, next to the *Sun-Times* stacks, the ATM, the bubble-gum shelves and the Dunkin' Donuts display cases, 6 a.m. to 10 p.m. each day. Maybe the owner pays the Man in Bubblicious, stale doughnuts and twice-read tabloids, I don't know, but the Man seems happy in his place.

The Man rounds up the beggars who loiter about the massive BP lot, sweeps away their broken glass; chases off the real deal, mean knuckleheads; and quashes any discord between gas patrons, so irate at high petro prices that they slap their palms against the impenetrable double plate, and the fast-talking olive cashier standing way back from the open money-rudder slot with weary eyes on the Man. The Man just says three loud words to the irate—"PayMeNow!"—without pause, punctuation or transition between each, and the customers stumble from the station, those glass-slapping palms between legs, along with their tails. Afterwards, the cashier is free to put his eye back on counting his loot.

I found the Man and asked if his people had emptied the garbage cans that morning, and if so, what had come of the trash. He answered by telling me that all these pumps in the station were covered with white plastic Jewel bags because they were out of gas, seeing as some fools down on 95th Street hijacked a petro rig headed for a South Side station weeks prior. Now all the tanker drivers refused to come to Stony Isle. "Suckas," he said, "costing us much green paper over here."

I couldn't figure how this involved my cell phone, and I hadn't noticed the bagged pumps, but I wanted to know. "They catch um?"

"Who? The knuckleheads?" His voice bounced off the walls where my ear canals meet, bounced but lingered. "Course they caught um. Always catch um, somehow, don't they? Bah-stads put that truck on the Calumet . . . what they call it now? Bish-up Ford? Clowns put the tanker out there on the highway and couldn't work the gawd-damn gear shifters, got their asses stuck square in the middle of the road. Young knuckleheads love bein' the ass of somebody's joke, don't they? Live for it."

"Make the game funny to us," the cashier giggled behind his glass, crooked smile halfway lighting underneath his eyes. "All of you want to be gangsters."

"Gangsters?" The Man laughed louder than his story. "Yeah, they want to be gangsters all right, Sheik. Everybody wants to be a thieving gangster, but don't know what being a true Gangster means."

With this, the Man flexed his right pectoral and a pitchfork tattoo bulged from walnut-brown skin. Protruding with the bloody fork seeming to point heavenward, then switching hell's way with each flex.

"I dropped my cell phone in one of your garbage cans—that one over there, I think," I repeated, then pointed through the station's north window, toward a plastic bag flapping with the lake wind. "Did you empty those cans already? I need to find this phone—can I go through the steel bins back by the alley."

"Hold up." The Man stopped flexing and pointed through the north window, past my feeble digit, to the McDonald's lot across the street. A green city garbage truck rumbled from Mickey D's, cut diagonal across Marquette Drive then out onto Stony Island, then through a red light, headed south—its rusted steel shaking with the weight of muck and the turn of wheels too tiny for its load. A garbage collector hung from the truck's back railing, his sanitation department apron wound proud to the hip as he swung with their ride.

"Watch this here for me, baby," the Man said and darted from the station lobby, southeast across BP's lot, running after the city's green garbage truck. I wondered if the Man was ordering me to watch his station or if "baby" was another of his pet names for the money counter. Whichever, the Man chased fast as age and swollen limbs would allow and screamed at the swinging garbage collector all the while.

"You can't catch ..." the cashier said behind glass.

Still, the Man ran. *"Wait . . . hold up . . . mutha . . . Wait up . . . got something . . . Wait . . . gotta get . . . my man . . . mutha . . . sucka . . . you hear me . . . see . . . I'll get you . . .wait . . . something . . . "*

The Man ended his chase just south of the BP lot, then turned and limped back to us. The cashier had stepped from behind the door of his square bubble to watch the chase. But as the Man stumbled into the station—brown skin gone sick orange—the money counter laughed and cursed all at once as he closed the door to his safe room.

"Thanks, Man," I said to him. "You didn't have to ..."

"They'll . . . be back, " the Man panted, "ain't got . . . choice. Next Tuesday. I'll be here . . . still. Watch."

Moments before my soles can bring the Nissan to a halt between Cornell and 57th Street, the lead adult bird stops its waddle to glance up at the low-hanging clouds, our front bumper, or at me. It shrugs useless wings and turns back to the curb. The other two geese follow, and together they stand perched on the curb, quacking softly, audible only in the pauses between public radio transmissions; as if whoever shipped these birds up to the wading lagoon gave them whisper-inducing dope such that their words don't disturb the museum tourists.

But they laugh, I do hear them laughing as we screech to a halt. We're officially on the tourists' 57th Street asphalt now. I turn the steering wheel and straighten the machine from its twisted shriek to continue lake-bound beyond the bend. My wife, who is curious of birds who can't fly, no matter that she can do without ever watching the high-yellow ones chased by crazed cats in Hollywood cartoons—she laughs at me, my museum ducks and our muffled, quacking smack, too.

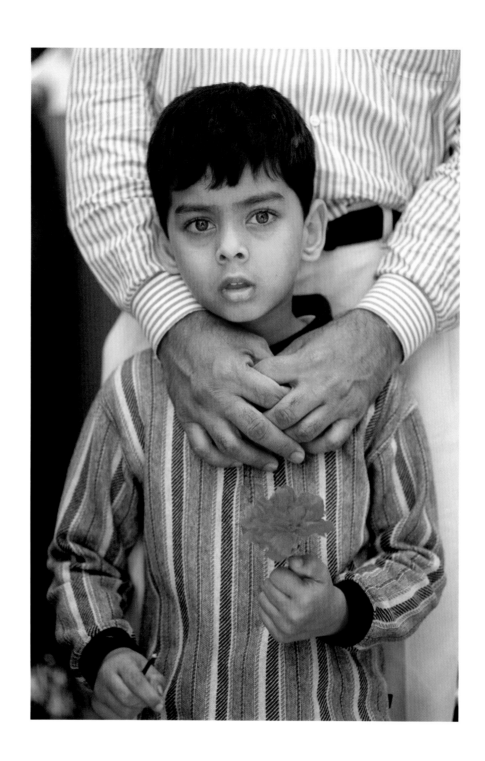

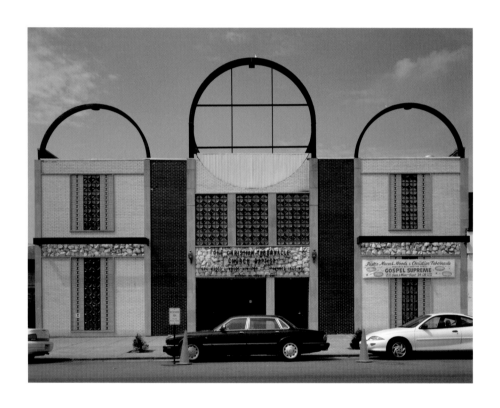

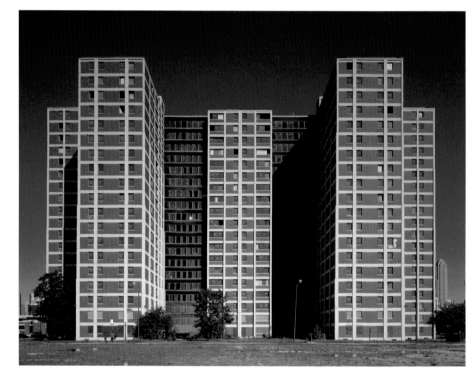

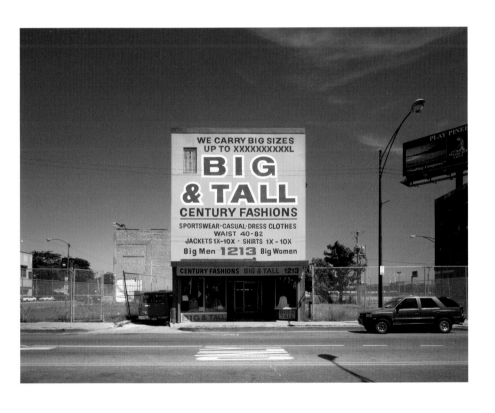

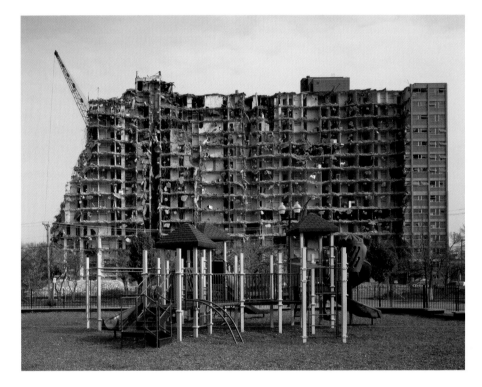

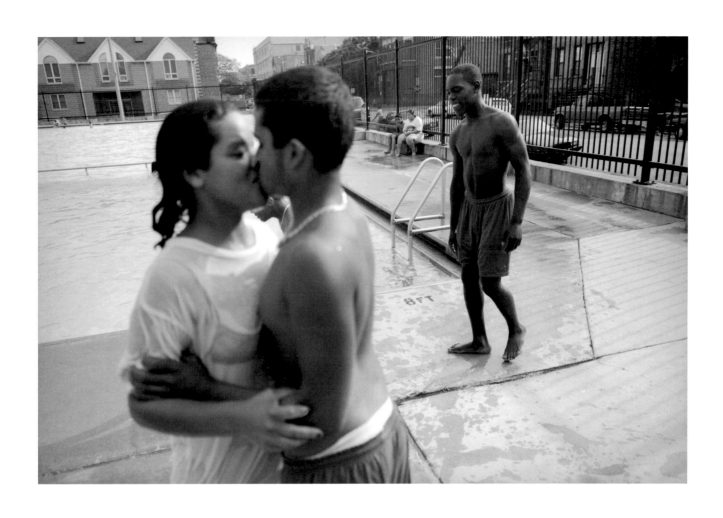

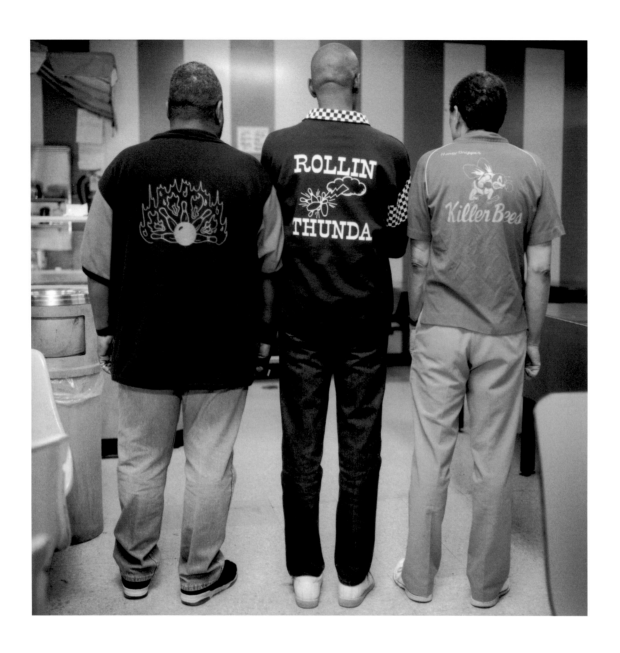

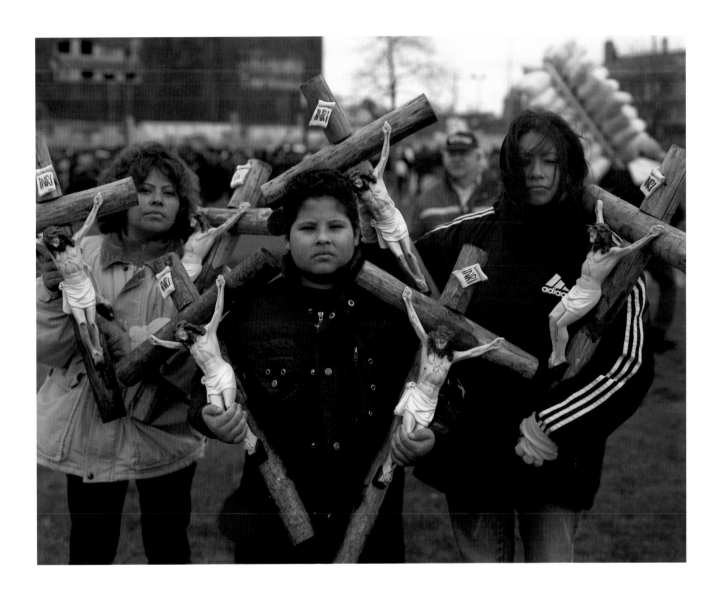

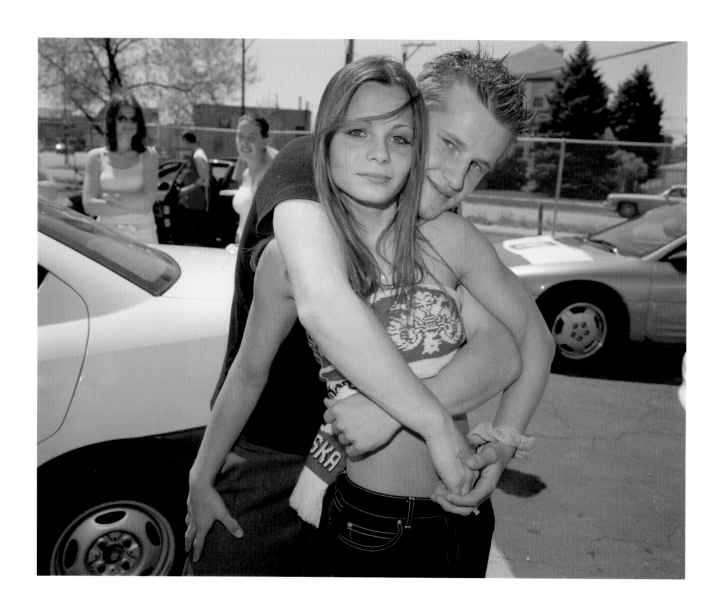

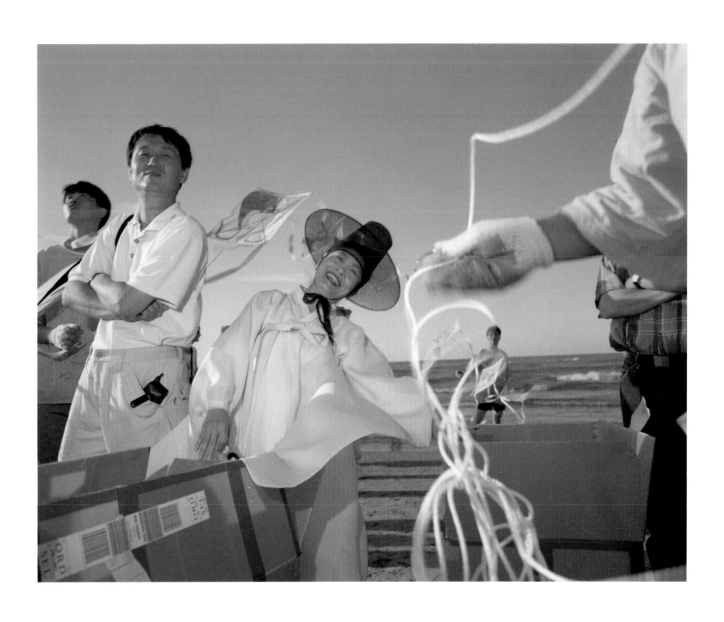

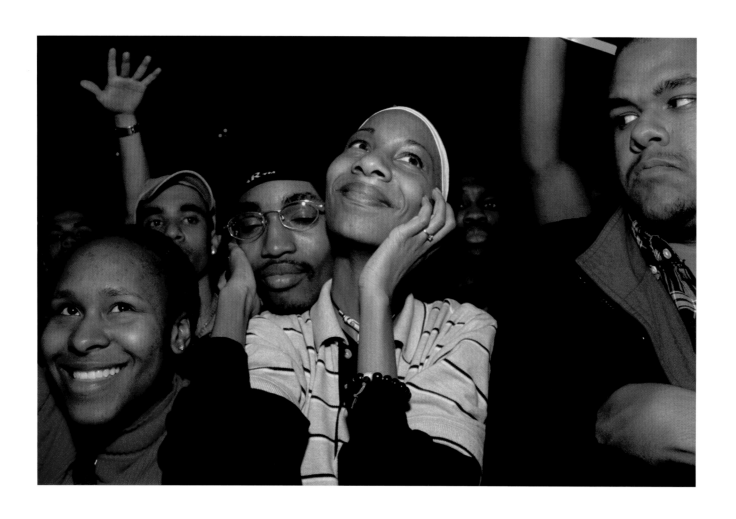

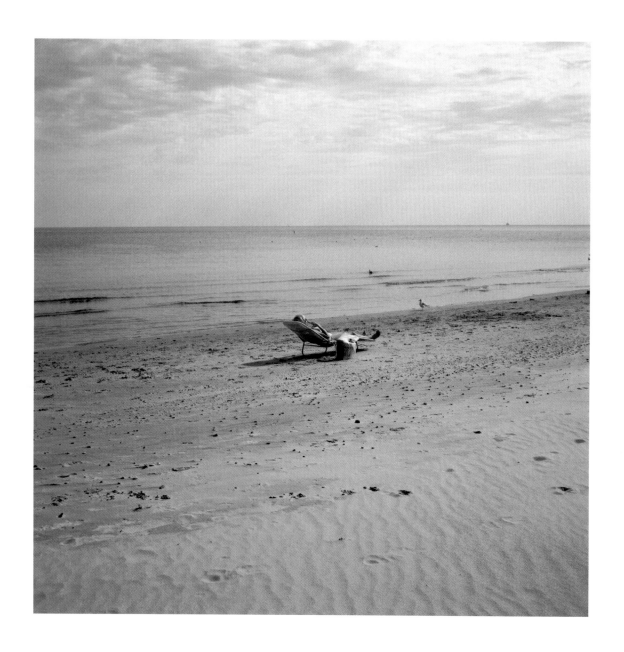

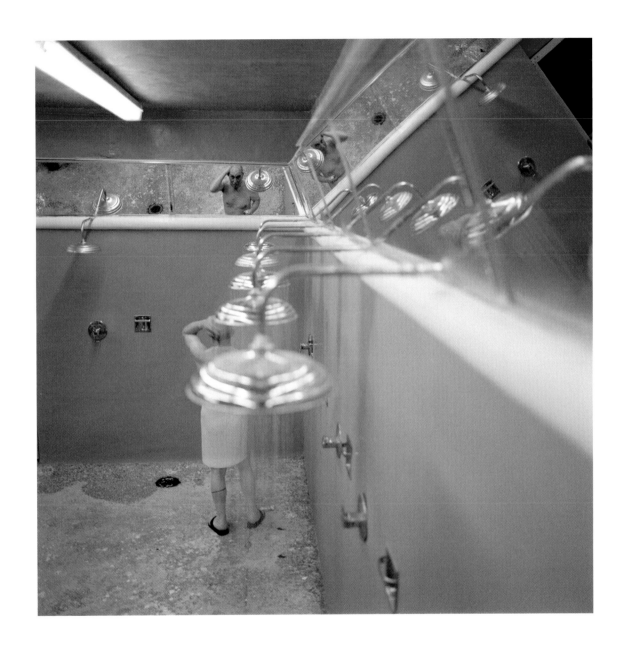

The railroad tracks reach back to South Shore from just about everywhere I've ever been: on an Amtrak train crossing the Hell Gate Bridge on the approach to Penn Station in New York City; on an airplane passing over sidings and spurs on the descent into Pittsburgh, Barcelona, or Wuhan; in my apartment in Brookline, Massachusetts, from which you can see and hear the D Line trains running behind the houses across the street. All the tracks connect to all the other tracks, and if you know the way you can ride them back to Bryn Mawr Station, 71st and Jeffery, and home.

I get off a southbound Illinois Central train at Bryn Mawr and walk the wrong way, west, to the end of the raised open-air platform that just ends, with no stairs leading down to street level. Everyone else who got off the train walks the other way, east, through the doors into the station house that in cold weather smells of steam and piss, and in hot weather of dust and sun-heated wood. The arriving passengers will go through the turnstiles in the station house and outside again through another set of doors, down the stairs, and into the middle of the intersection. That's the way out, the way you're supposed to go. My way, the wrong way, the secret way, feels to me like the way in—into the landscape, into South Shore.

The boards of the platform give a little beneath my sneakered feet. The wood has weathered unevenly—dry and splintered in some places, wearing into moist bluntness in others. Reaching the west end of the platform, I lean out for a moment to make sure there's no northbound train coming. Then I turn around, squat, put my palms on the edge of the platform's floor, lower my feet halfway to the tracks, and drop. It's not far, maybe chest height for a grown man, but I'm not full-grown yet; it feels far.

It also feels vaguely historical to drop from platform to tracks, like dropping into a seam in time. I'm old enough to know that the neighborhood, the city, has a history, but I know that history in only the vaguest terms. Once upon a time there were white kids in knickers and newsboy caps (for some reason, I see them picking up stray pieces of coal along the tracks), and before that there was prairie, like the high grass growing in vacant lots you can see from the windows of an IC train taking the turn at 71st and Stony Island. There's something unnameably industrial, and, behind that, something even more unnameably and remotely rural, about dropping to the uncertain footing of the wooden ties and weedy gravel bed between smooth rails that go out to the East Side, where the steel mills are, and extend beyond there all the way to Gary, the Dunes, the Mississippi Delta.

I squint up at the sky, a bug crawling along the neighborhood's spine. You're not supposed to linger on railroad tracks, but they're seductively intimate, private, even though they're right there in public view in the middle of 71st Street. Still, you could get mashed flat. I step over the far rail, watch for a gap in traffic on 71st, and cut across on the diagonal toward Euclid Avenue, my street. Before me, I think, there were kids who did the same thing, kids who knew the secret.

If not a train, then a bus. I get off at 69th and Jeffery. It happens only rarely that junior gangsters in pea coats and sideways Pittsburgh Pirates caps are waiting at the bus stop to mess with kids like me—white, black, they don't discriminate—who live in the Highlands, South Shore's high-rent district. But I like to be ready every time: to disappear or run, if practicable; to fight, only if I absolutely have to; or, as I prefer, to simply walk on, projecting dull purpose drained of both challenge and acquiescence, and never, ever stop, no matter what. When they come asking for a transfer or a dollar, anything to get you to stop and give in to them, you say no without breaking stride, going around them if you have to. They might walk along next to you, craning in close to your studiously blank face, double-checking—"You saying no to me, boy? What's your problem?"—but you keep going and don't bother saying it again. That's usually enough. We're all just kids, after all; I don't carry much worth taking, and they're not real gangsters yet. If you slide through, refusing to play, most of them will let it go—"Hey, I'm just playing with you"—and wait for the next candidate, the one who'll stop, which makes it more fun; the one who'll apologize when he says no, which means that he's ready to give up what he's got. You don't have to be a tough guy; you just have to seem slightly more inertial, slightly less worth the trouble, than whoever comes before or after you.

Still, there are days when I get off the bus a block or two early, or ride past my stop and get off a block later, just to mix it up and keep them off balance, to reduce traction so I can keep sliding through. It's not necessary, but I've got nothing but time to spare. I don't have anywhere I need to be.

This time I get off at my regular stop. Nobody's waiting there to mess with me. Walking home on 69th Street, I pass a garage door with a couple of gouges in it. My next-door neighbor Joe, who is a few years older than me, put them there one night. The guys on the next block, the last pack of white stoners left in the neighborhood, had a beef with Joe stemming from words exchanged one afternoon when he provoked them by swerving too close on his purple spider bike with yellow flames painted along the chain guard. They all wanted to see Joe get beat up but none of them wanted to fight him, so they brought in a ringer, a big black guy named Pierre from another part of the South Side. Joe, an American Indian adopted by Irish Catholics, was wiry and compact, hard-built from doing situps and pushups and pull-ups in his slant-eaved attic bedroom with the squirrel-infested closet. That night, we watched him go down to the corner to meet Pierre, walking with a pent-up prefight bounce and fitted out for battle: oily faded flare jeans, denim vest, no shirt, long black hair parted in the middle, a doubled length of heavy-duty chain held in one hand and draped over his shoulder. Joe disappeared from view in the dark, and a few seconds later everybody on both blocks—ours and theirs—heard a hoarse shout and then the dull chunk-chunk of his chain hitting the garage door and perhaps Pierre's body. Pierre did not stick around for an extended beating. He fled into late traffic on Jeffery, a Hector-for-hire refusing to face the Achilles of the 6900 block of Euclid.

That's Joe, not me. But the marks on the garage door offer a reminder: you don't have to slide through; you can take the hard way. In later years, after Joe loses a kidney when he and his father get shot up by home invaders who they nevertheless repel with their bare hands, Joe runs off to a reservation out West. The police ring our doorbell and tell us that if he ever turns up in the neighborhood again we should bolt the door and give them a call; they want to talk to him about a string of muggings. But he's long gone. The hard way.

My way home, most days and nights, goes through Jackson Park, the South Side's grandest and loneliest park. I'm looking out the window of a school bus grinding down Cornell Avenue, the park's main north-south drive, turning on Hayes Drive and passing the Golden Lady, the statue standing with arms upraised, copying a long-lost big sister's gesture of benediction over a city that vanished. I'm pedaling along the bike paths in slapstick fast-motion that grows less comic, more controlled as I grow older and stronger. But I'm increasingly on foot, having grown into a reedy, dreamy teenager who prefers to walk.

It's the end of another night of hanging around in Hyde Park, where most of my high school friends live, and it's time to go home. Crossing wide, empty Stony Island Avenue at 59th Street, I approach the dark tree line, choosing a place to enter the park. Beyond, deeper within the greater darkness of the park, the glow of streetlights lining the drives pinkens the sky. I pick my way through lightless groves, navigating by keeping the lights of Stony Island in view on my right and those of Cornell on my left. I hurry across Cornell, momentarily exposed, and continue south and east in woodland gloom again. I skirt the parking lot where guys cruise around in cars, sometimes with women in the passenger seat or in the back, looking for business or trouble or something else I can't provide.

Once across Hayes Drive, the Golden Lady behind me, the park feels darker, denser. I'm in long-haul rhythm, covering ground, firmly thumping my heel down on the turf with every step. I cross unlit stretches of grass and cut through narrow gaps between patches of brush, still keeping off the paved paths. I pass the locked-up marina, wondering, as always, if boats get stolen just like cars, and if joyriders crash them or bring them back. Then I cross Marquette Drive and enter the homestretch, my feet finding and following the path worn across the golf course by cross-cutters like me.

I see golfers in the daytime, and I understand that they enjoy walking around and hitting the ball and not being at their jobs, but I don't understand why there's a golf course here. It has something to do with the marina and the Golden Lady, I assume. They're historical, too. I'm grateful, in any case, for the expanse of grass and trees and water on the northern border of my neighborhood, the open territory where nobody lives, the way home.

The path crests a small hillock, drops, and runs across a flat stretch to another rise. At the far edge of the golf course, I put my hands on the top of a chest-high chain-link fence and vault over, leaving the park and continuing across 67th Street on the diagonal and down Euclid, under streetlights once more. The stately dark houses of my neighborhood, barred and grilled and burglar-alarmed, resemble a chain of frontier forts.

When I get to the high-shouldered brick house with no front door on the 6900 block of Euclid, I will remember to disarm the alarm before I unlock the door, and to rearm it once I'm in. I will find something in the refrigerator and see if there's anything on late TV, padding around the sleeping house, snug inside the castle with the drawbridge pulled up. But, really, walking down Euclid with the tight-shut houses of South Shore on either hand and the street all to myself, a freight train calling on the IC tracks in the distance, I'm already home.

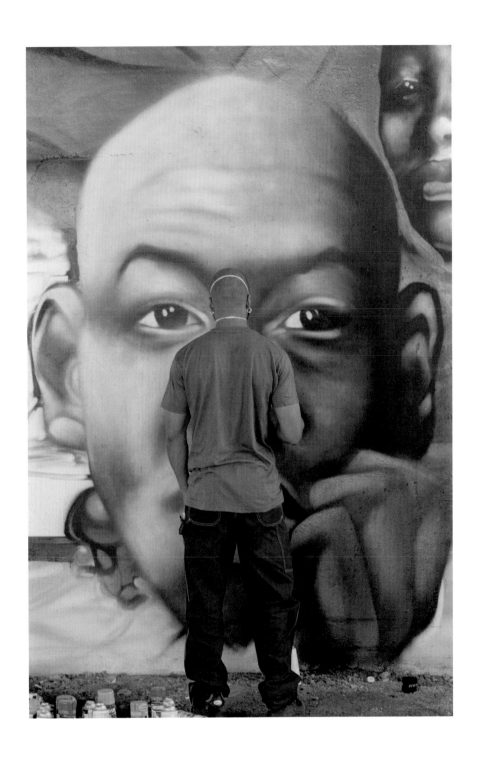

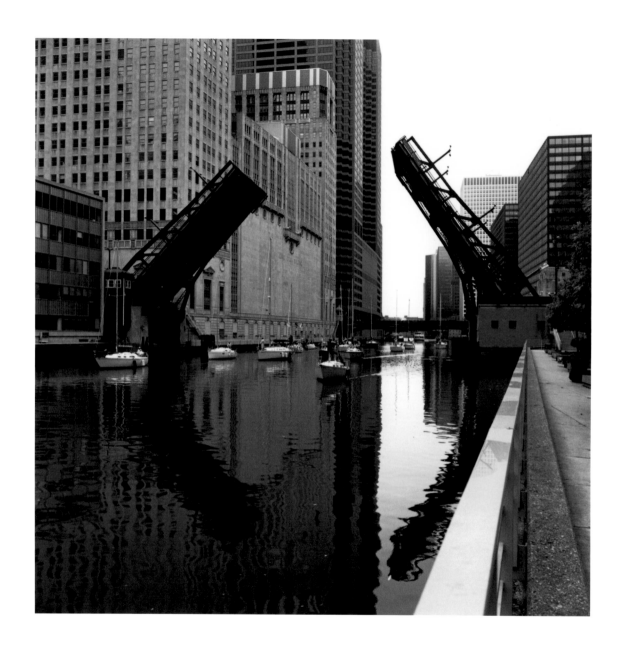

One summer my uncle Moe pissed on an Andy Frain. This was in 1977, at Comiskey Park, at a game between the Chicago White Sox and the Minnesota Twins. The game was a blowout, 7-to-nothing Twins by the 8th. Maybe that's why he did it. Or, maybe it was the beer.

My cousin Barney—Moe's son—was there, too, and Moe, my father, me and my father's friend Vince, who lived on the North Side. By the time I was 10, I'd seen them do any number of things. They drank together, smoked cigarettes, and they did other stuff together, too. One time, I saw my father and Moe beat a kid whom they caught spray-painting on my father's new garage door. Then, another time, I saw Moe pull a gun at a party for my cousin Brenda. "Don't shoot!" my father yelled at Moe. "Get him outside first!" I don't even remember who the troublemaker was.

What I didn't see for myself, I heard stories about—like the time they poured gasoline on my Aunt Rhonda's ex-boyfriend, Player, and threatened to set him on fire. A couple of days before, Player had poured gasoline on my Aunt Rhonda's porch and threatened to burn her and her kids out of their house. *"This is the gas we scraped off Rhonda's porch,"* I heard my father say as he recounted the story to my mother. He and Moe were at the kitchen table. My mother was making tacos. I was in the living room watching the Sox stomp the Oakland A's.

Moe was laughing. "He even started crying," he said. "Right then and there." I took a bite of my taco as I listened. On the television set, right-hander Francisco Barrios struck out another Oakland A.

That was the year of the "South Side Hitmen," the year the White Sox set a record for the most home runs in team history. The 1977 season was sandwiched between two real dry spells: pathetic, losing efforts by the Sox. I was 10 that year, and I was entirely convinced that the team's surprising wins—and its sudden ability to blast towering home runs—were all due to me and my White Sox helmet.

You see, the year before I had received a replica batting helmet as a gate prize at Comiskey Park. The helmet was thin plastic—full of static like an inflated balloon—so that when I pulled the helmet off my head my hair followed, snapping and crackling. But the helmet said "SOX," and it was a deep, dark, White Sox blue. On opening day, I wore it as I sat in front of the TV, watching the game. The third batter, Richie Zisk, hit a monstrous home run off Bill Singer of the Toronto Blue Jays. The Sox went on to lose that game—but for me there was no turning back. That night I vowed I would wear the helmet for every game that season; and, by June, the White Sox were in first place and hitting homers like I'd never seen before.

I wore the helmet to a game in July when the Sox beat the Kansas City Royals. Fifty-thousand people showed up for that game: There were so many people in the stadium that I was actually frightened. And then, in August, I wore the helmet to a game against the Seattle Mariners: The White Sox hit so many home runs that Bill Veeck's famous exploding scoreboard even ran out of fireworks. When backup outfielder Royle Stillman hit a one-run blast in the 7th, that scoreboard only issued a single, silent red streamer. By then the printed SOX logo on my helmet had been reduced to a faded, ghostlike image, and the plastic strap which held the helmet to my head had broken in so many places that the only thing keeping it together was a dingy, frayed strip of surgical tape. Still, I faithfully continued to wear my helmet.

By the end of August there were bad signs. While the South Side Hitmen had continued to blast home runs, they weren't winning. First, they were swept by the Kansas City Royals. Then, an Aug. 20th loss to Milwaukee knocked them out of first place for the last time. I kept wearing the helmet, though, hoping—like I am sure the rest of the South Side was hoping—that something would suddenly change. I even started wearing the helmet to school: My friends didn't laugh at it—instead, they asked if they could take turns wearing the helmet while we played baseball during recess.

I kept praying on the magic of my helmet, even during that game in September. Between the top and bottom halves of the 8th inning, after a four-run barrage by the Twins, my uncle Moe got up and casually walked down the concrete steps to the whitewashed railing that lined the breezeway into the concession area. "Moe," my father called out, "Moe." My uncle didn't respond. Instead he stood at the railing for a few seconds and then reached for his crotch.

No one said a word, not even the groups of people sitting on either side of the breezeway. They just watched and some pointed. One person was coming up the stairs, taking a sip of whatever he had in his cup, and he paused while my uncle relieved himself. Moe got weak in the knees at one point and he looked like he was going to flip over the railing. My father raced down the steps and yanked back on Moe's pants to keep him from falling the eight or so feet down into the breezeway.

I watched the entire thing. I watched the Andy Frain usher, wearing his fancy blue outfit with gold curlicues and shoulder bars, come walking out of the breezeway. He was holding his white captain's hat. His shoulder had turned a deep, uneven blue where my uncle's piss had hit him. The usher pointed up at my father and Moe, and an army of five or six huge men with yellow windbreakers marked "Security" came rushing around the corner.

They wrestled with my father and Moe for a few seconds. My father swung at one of the security guards and missed, while Moe pushed back on one of the guards, and the man fell over onto a couple sitting in aisle seats. The woman screamed—and then screamed again as Moe was tackled from behind and thrown to the stairs. Vince ran down and started yelling, claiming he was a lawyer and was going to sue everybody. One of the security guards punched him so hard in the stomach that Vince puked: The puke was clear and frothy, and it ran down the stairs like a spilled beer.

My father and Moe were both handcuffed, but Vince was simply taken by the arm. We were kicked out, of course, and we were told if we didn't leave fast we would be arrested for trespassing. By the time we found the Volkswagen, Vince was spitting up blood. Barney and I hurriedly climbed into the back seat, and Moe followed, his pants still wet from the wrestle and the piss he'd managed to get on himself. Vince pushed back the front passenger seat, reclining so far I was forced to sit sideways.

My father started to drive. I wasn't aware how drunk he was, but I noticed the sharp turns, the weaving and the sudden jabs at the brakes—and I know now, as an adult, what a drunk driver *drives* like. But, at 10, all I knew was that I wanted to get home, and that I wanted that day to end.

At Halsted and Archer, just before the South Branch of the Chicago River, my father nailed a pothole big enough to stand in. There was a huge pop, loud enough that it even woke Moe. We got out of the car and it was obvious we weren't going any farther. The front wheel on the driver's side was shattered: The tire was shredded, and from beneath the car a stream of oil was flowing steadily into the gutter. The street was empty and quiet: I could hear the steady flow from the South Branch and the buzz of the orange-lit street lamps.

Vince walked in a crouch and took a seat on the curb near the back of the car, holding his head in his hands. Moe walked up the street and kneeled alongside a fire hydrant. My father was looking under the car, at the wheels. He kept getting up, walking to the trunk, and then returning to crouch at the front of the car. I took a seat on the curb, far away from Vince, and far away from Moe, who had begun to vomit. Barney assessed the scene and climbed back into the car.

I looked back east, hoping to see a sign of the magic of the South Side Hitmen: I was looking for the bright lights of Comiskey Park, the blaze of fireworks from a bottom-of-the-9th rally. There was nothing lighting up the sky: All I could see were the tops of warehouses, apartment buildings and the viaduct for the old Burlington Northern Railroad lines.

I took off my batting helmet and inspected the strap, then I looked at its surface, all nicked and scratched from wear. I wiped at the front of the helmet, and I noticed that—for some reason in the orange of the street lamps—the faded SOX logo stood out just a bit brighter. I put the helmet back on. I breathed. And I waited for whatever came next.

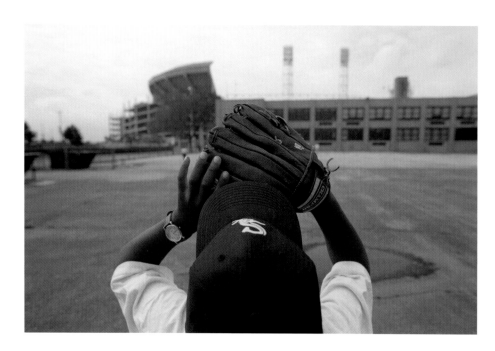

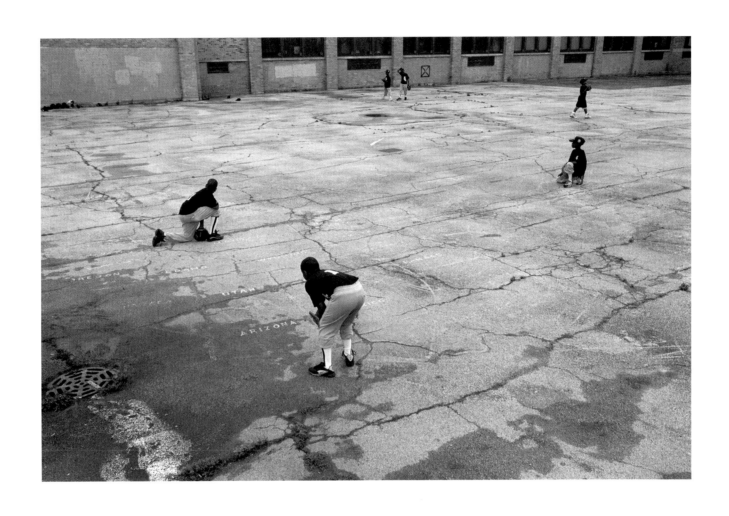

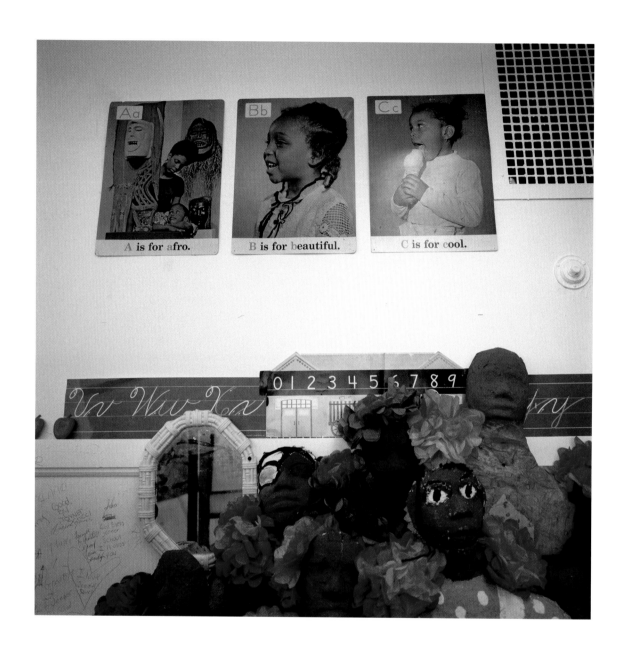

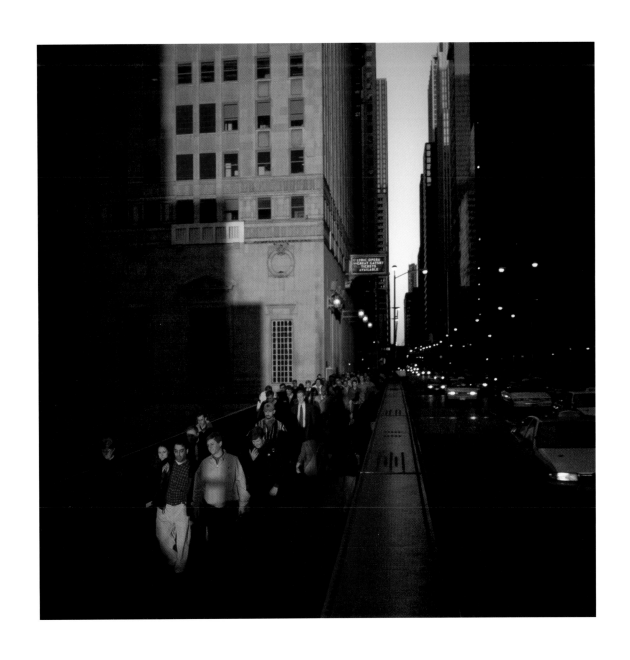

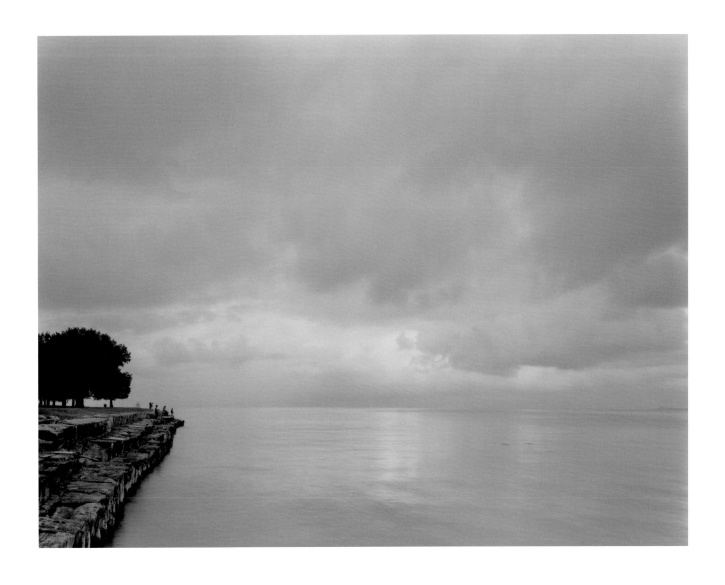

She said: *The lake like an open book, the day like the steady gaze of a reader.*

I said: *The day like a book we open between us, the lake a sentence we read together over and over, our voices ghost, bread, and horizon.*

She said: *A spoken song in several voices moving in and out of many rooms. And even the lake keeps changing its mind, undecided between the word for the end of August and the color just before grapes ripen.*

I said: *The mind like a lake, and your voice lost, a child of foam.*

She said: *The book a voice, its pages burning in rooms birds foretell every evening.*

I said: *The book summons the reader to read the destiny of water, wind, fire, dust, the destiny of voices.*

She said: *Voices in a room by the lake, the lake itself an older voice, unutterable law and companion to a brother and sister telling each other the missing parts of each other's stories.*

I said: *The lake is a book that opens onto our own first face.*
Open the book and the book says:

The city is full of people
and seldom is a person to be found.

The city is full of light,
but no one's seen a thing.

The city is all dark, yet a hand
finds its way to other hands,
a mouth its way to other mouths.

She said: *The lake keeps changing its mind, a book turning, now the shadows of clouds on the pages, now the shadows of pages on the waves.*

I said: *Shadows of birds and leaves blown in a wind have fallen on the pages of the book.*
Wind and birds and clouds and leaves in silent tumult among the pages.

The lake is a gate, an illegible stone, a garden, a woman with a book open in her lap.

Open the book and the book says: Silver, the women

sing of their bodies
and the men.

Darker,
the men sing
of their ancestors
and the women.

Darkest is the children's ambition
to sing every circle wider. Dying,
each sings at the edge of what he knows.
Inside him is the unknown, that chasm
singing makes visible
by over-leaping.

I said: *The lake is an unblinking gaze, the gaze is an open book turning in a day's fire, the pages shadowed by a reading face. The book, the gaze, the reader are one.*

She said: *It is the book that turns in the clear fire of the reader's gaze, the voices in the book arrive like waves.*

The waves arrive like the unfolding sum of our forgotten days speaking.

The pages are traveling, the book is without horizon, and over the foam-flecked body of fire, hands change places with wings.

Therefore, a voice was first, the world is after, and the book comes last. Open the book and the book says:

Ash and dew sing the founding notes
of world, book, time, and body.
The page remains the place where we can hear them.

I said: *Shadows of voices lie confused on the open pages.*
When the shadows move, we hear who is who.

A wind blows, the shadows are moving, the book is open
To a voice at evening asking, Are we many or one?

What do the past lives of the color blue have to do
with the fate of words and the future of wishing?

She said: *The lake's blue is the very memory of green.*
The waves whiten as evening grows darker.

And Time is a roasted egg, a sewing basket,
Time is the names of ships, a history of clocks.

Birds, turning in a flock, are a fleeting shape of Time's deafening voice.

The shadows of birds on a page almost tell a story.

I said: *Someone is making notes in the margins of his dream.*

She said: *The moon is empty.*

I said: *And then the first petal fall, the second petal fall, the seventieth petal fall.*
And the pages become illegible.

She said: *The lake, the first and the last page of the day, overwhelms every word written there.*

I said: *So who was running down the steps in front of the museum in the rain?*
Who woke sitting in the window of a moving train?

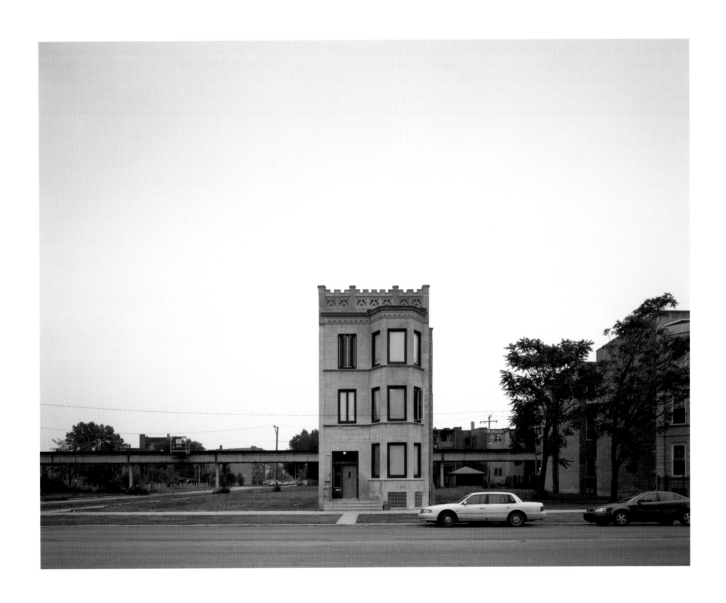

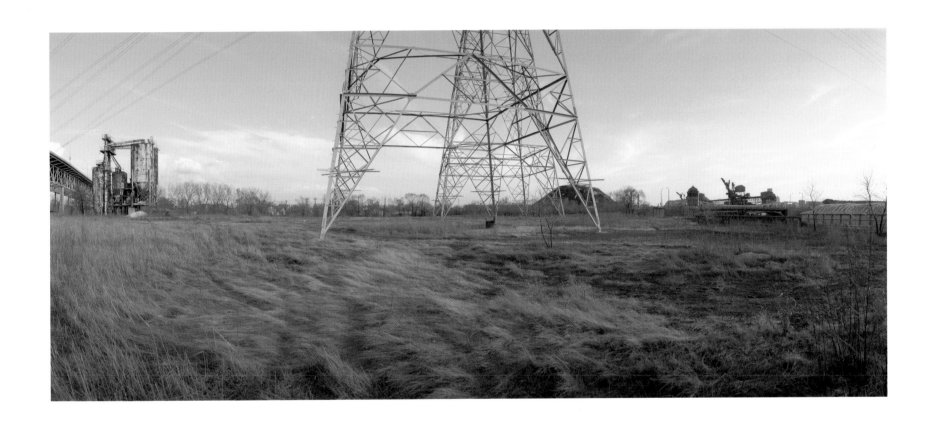

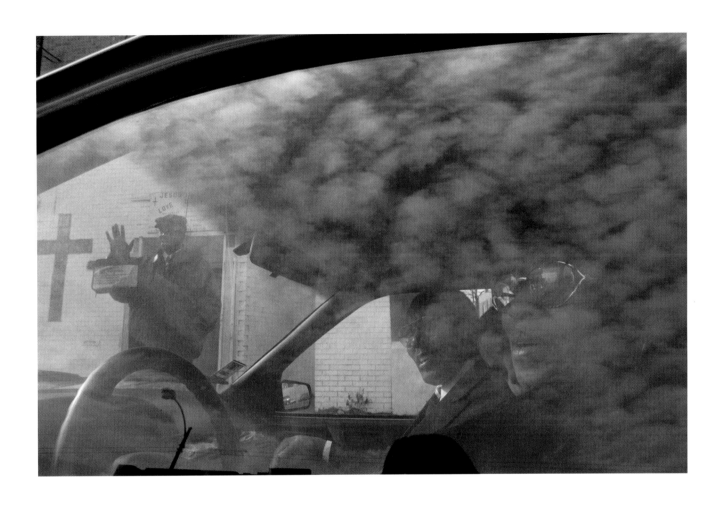

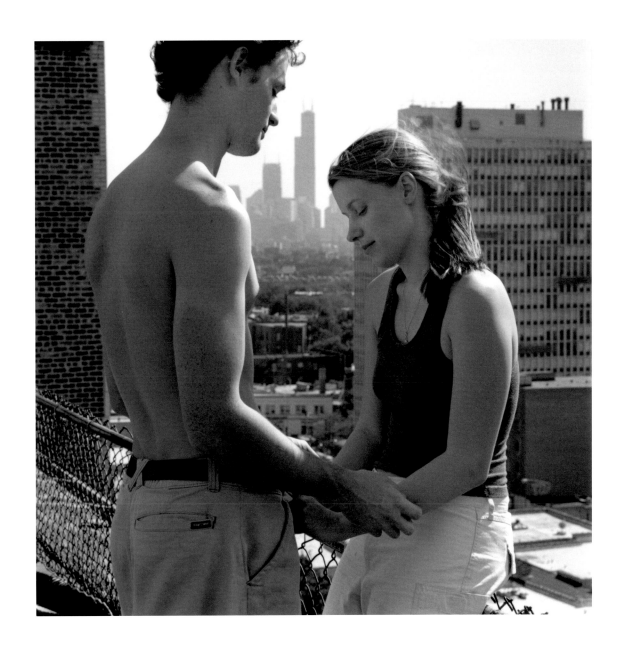

1) Driving west at sunset in the summer: Blinded by the sun, you cannot see the cars ahead; the ugly warehouses and body shops are blazing orange. When the sun sets, everything becomes deeper: The brick facades acquire a bluish hue; there are charcoal smudges of darkness on the horizon; the sky and the city look endless.

2) The way people in the winter huddle together under the warming lights on L stop platforms, much like young chickens under a light bulb. Human solidarity enforced by the cruelty of nature—the story of Chicago and of civilization.

3) The American vastness of the Wilson Avenue Beach, gulls and kites coasting above it, dogs sprinting along the jagged waves, barking into the void, blind to the distant ships on their mysterious ways from Liverpool to Gary.

4) Early September anywhere in the city, when the sunlight angle has changed and everything and everyone appears kinder, all the edges softened; the torments of the hot summer are over, the torments of the cold winter have not begun, and people bask in the perishable possibility of a gentle city.

5) The basketball court at Foster Avenue Beach, where I once watched an impressively sculpted guy play a whole game—dribbling, shooting, arguing, dunking—with a toothpick in his mouth: the hero of the Chicago cool.

6) The tall ice ranges along the shore when the winter is exceptionally cold and the lake frozen for a while, so ice pushes ice against the land. The process replicates the way some mountain ranges were formed hundreds of millions of years ago, tectonic plates pushing against each other. The primeval shapes are visible to every cranky driver plowing through the Lake Shore Drive mess, but most of them look ahead.

7) Looking directly west at night from any Edgewater or Rogers Park high-rise: Like stunned fireflies, airplanes hover and glimmer above O'Hare.

8) The blessed scarcity of celebrities in Chicago (Oprah, one of the Friends, and a couple of other people whose names I cannot recall). We like to ship them off to New York or Hollywood, where they can falsely claim their humble Chicago roots, while we can be proud of them without actually being responsible for the vacuity of their famous lives.

9) The Hyde Park parakeets, miraculously surviving brutal winters, a colorful example of life that adamantly refuses to perish, of the kind of instinct that has made Chicago harsh and great.

10) The downtown skyline at night as seen from the Adler Planetarium: lit windows within the dark building frames against the darker sky. It seems that stars have been squared and pasted on the thick wall of a Chicago night; the cold, inhuman beauty containing the enormity of life—each window a possible story.

11) The green-gray color of the barely foaming lake when the winds are northwesterly and the sky is chilly.

12) Humid summer days, when the streets seem waxed with sweat; the air is as thick and warm as honey-sweetened tea; the beaches are full of families: fathers barbecuing, mothers sunbathing, children approaching hypothermia in the lake's shallows. Then a wave of frigid air sweeps the parks, and a diluvial shower soaks every living creature. (Never trust a summer day in Chicago.)

13) Suburbanites in Hard Rock Café shirts patrolling Michigan Avenue, oblivious to the city beyond the shopping and entertainment areas; the tourists on an architectural boat tour looking up at the steep buildings; the bridges' halves symmetrically erected; the street performer in front of the Wrigley Building playing "Killing Me Softly With His Song" on the tuba.

14) The fact that every year in March, the Cubs fans start saying: "This year might be it"—the delusional hope usually betrayed by the time fall arrives. It is one of the early harbingers of the spring, bespeaking a beautifully naive belief that the world might right its wrongs simply because the trees are coming into leaf.

15) A warm day one February, when everyone present at Bornhofen, my butcher shop, remembered the great snowstorm of 1967: cars abandoned and buried in snow on Lake Shore Drive; people trudging home from work through the snow like refugees; the snow on your street up to the milk truck's mirrors. There are a lot of disasters in the city's memory, which results in a strange nostalgia somehow akin to Chicagoans' respect for and pride in "those four-mansion crooks who risk their lives in crimes of high visibility." (Bellow)

16) Pakistani and Indian families strolling solemnly up and down Devon on summer evenings; Russian-Jewish senior citizens clustering on Uptown benches, warbling gossip in soft consonants; Mexican families in Pilsen crowding Nuevo Leon for Sunday breakfast; African-American families gloriously dressed for church waiting for a table in the Hyde Park Dixie Kitchen & Bait Shop; the enormous amount of lives in this city worthy of a story.

17) A river of red and a river of white flowing in opposite directions on Lake Shore Drive, as seen from Montrose Harbor at night.

18) The wind: the sailboats in Monroe Harbor bobbing on the water, the mast wires clucking; Buckingham Fountain's upward stream turned into a water plume; the windows of downtown buildings shaking and thumping; people walking down Michigan Avenue with their heads retracted between their shoulders; my street completely deserted except for a bundled-up mailman and a plastic bag fluttering like a torn flag in the barren tree-crown.

19) The stately Beverly mansions; the bleak Pullman row houses; the frigid buildings of the LaSalle Street canyon; the garish beauty of old downtown hotels; the stern arrogance of the Sears Tower and the Hancock building; the quaint Edgewater houses; the sadness of the Cabrini-Green high-rises; the decrepit grandeur of the Uptown theaters and hotels; the Northwest Side warehouses and body shops; thousands of empty lots and vanished buildings that no one will ever remember—every building tells part of the story of the city. Only the city knows the whole story.

20) If Chicago has been good enough for Studs Terkel to spend a lifetime in it, it is good enough for me.

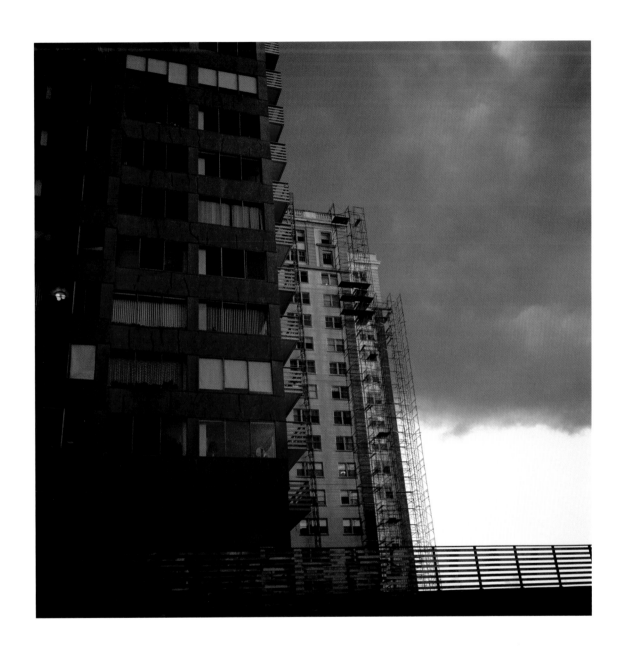

3 | Jon Lowenstein | Soul Queen Restaurant waitresses Doris Evans, left, and Lolita Gholson pose before a photograph of the restaurant's owner, Helen Maybell Anglin, with Muhammad Ali. The walls of the venerable Soul Queen feature photos of the panoply of luminaries who have visited the venue to sample the fare, which is served buffet-style and steeped in the tradition of the Old South. Opened by native Alabaman Anglin in 1971, the restaurant moved to its current location, 9031 S. Stony Island, four years later.

5 | Wes Pope | A photograph of Kansas City jazzman Count Basie graces the wall at Gerri's Palm Tavern on East 47th Street. During the mid-20th century, the Tavern was one of the primary haunts for performers working at the original Regal Theater at 47th Street and what was then South Park Boulevard. Both venues helped form the bustling commercial and cultural nucleus of the Black Belt (Chicago's all-black South Side, stretching—to varying degrees—between 31st Street and Hyde Park Boulevard). When the Regal closed, its proprietors gave the photograph collection to Tavern owner Gerri Oliver in recognition of the services her after-hours establishment provided. Gerri's Palm Tavern closed in 2001.

7 | Paul D'Amato | Junior and Janessa, Pilsen.

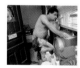

8 | Robert Murphy | A view of the Wicker Park neighborhood as the new century begins.

10 | Jon Lowenstein | The image of an American "Indian" stands tall over Capitol Cigars on Pulaski Road.

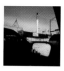

11 | Ron Gordon | This dilapidated remnant of an asphalt basketball court on Federal Street sits directly across the street from the Robert Taylor Boys & Girls Club, which offers a safer venue for pickup games.

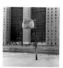

Despite the legendary popularity of "Da Bears" and the city's infamous cross-town baseball rivalry, historically speaking, Chicago is most prolific at fostering an appreciation and aptitude for basketball. City roundball legends Cazzie Russell, Tim Hardaway, Isiah Thomas, Marcus Liberty et al, were products of the outdoor game as played in and around housing projects.

13 | Patrick Linehan | The walk-down or "garden" apartment—here on North Honore Street in Wicker Park—is a common component of residential architecture in Chicago's North Side neighborhoods, much like bungalows and stone flats populate the Far North, South and West Sides of the city.

17 | Zbigniew Bzdak | In Englewood, Rev. Alex Crumble, left, and Rev. Otis Wooten, of Love of Christ Missionary Baptist Church, baptize Marneisha Toney, 9, at the Unity of Love Baptist Church. Marneisha and her family are members of the Love of Christ congregation, but their church does not have its own baptistery, so nearby Unity of Love generously shares its facilities.

18 | Lloyd DeGrane | Gathering the family around the dinner table is an important daily event in the Johnson household. Dinnertime is 5:30, so the family can finish in time to catch Pat and Vanna on TV's *Wheel of Fortune*. Serving the home-cooked meal are parents Todd and Susan; seated are the eldest, son Kyle, 12, and his sisters Kjerstin, 10, and 7-year-old triplets, Katherine, Kari and Kelsey.

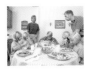

21 | Paul D'Amato | Dancers at the rodeo, Little Village.

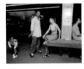

23 | Leah Missbach Day | Jerome White and Linda Gatson take a break from skating at the Rink Fitness Factory on 87th Street while Gibron North plays to the side. Gregory North, Gibron's father, catches his breath to the right.

24 | Antonio Perez | John Cooper, of the Chicago Department of Water, transfers a section of hose between portions of the "Deep Tunnel." The Tunnel and Reservoir Plan, or TARP, (aka Chicago's Deep Tunnel project), was nearing completion of its first major expansion phase as of 2000.

25 | Lloyd DeGrane | After spending the first 90 years of his life in the city, Chicagoan Mike Niksic is leaving his home at 107th and Ewing for Shelbyville, IL, where he will take up residence with his son and daughter-in-law. Mr. Niksic, who worked for many years at one of the East Side steel mills, reminisced over family photos from the 1930s (at his feet).

26 | Jon Lowenstein | At the corner of 22nd Street and Wentworth Avenue, politicians enjoy the Double Ten Parade in Chinatown while a Chicago police officer looks on. Double Ten Day commemorates the Wuchang Uprising of Oct. 10, 1911, which led to the establishment of the National Republic of China (now Taiwan), and it remains Taiwan's national day.

27 | Yvette Marie Dostatni | Still in her ivory dress, Zuleyma Alatorre braves the wind as she heads for a party in Pilsen to celebrate her First Holy Communion. She is accompanied by older sisters Olga (outside the picture's frame) and Brenda. This Roman Catholic sacrament is an annual springtime event in many Chicago neighborhoods.

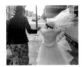

29 | Jon Lowenstein | Each June, Kenneth Morrison, left, throws a party for several hundred friends, family members and fellow Pilsen residents. He roasts a pig then holds belt sander races down a rough, hand-constructed plywood track. The "vehicles" for this race are modified power tools attached to long extension cords.

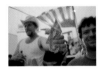

34 | Stephen Marc | Cotton Club, South Michigan Avenue.

37 | Jon Lowenstein | As the city stirs before sunrise, would-be workers gather at intersections—Lawrence and Springfield, Milwaukee and Belmont, Madison and Ashland, 67th and South Chicago—wherever construction sites can be found. They are day laborers soliciting work, offering their time and services to real estate developers and construction firms seeking those willing to paint, post drywall and haul materials for $40-$100 a day. On this February morning, these men are among the fortunate. They have won a job and now negotiate their fee.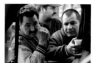

39 | Yvette Marie Dostatni | Decades after the glory days of Chicago Blackhawks legends Bobby and Dennis Hull, their iconic images loom over hockey fans in the United Center. The photograph of the legendary brothers captures their images, as well as a sense of the rugged style of play for which the Hulls (and their teams) were known. Bobby, left, the older brother, was inducted into the National Hockey League Hall of Fame in 1983.

40 | Wes Pope | Fred Villanueva—known as "El Sheriff" —rides at full gallop past a baseball field in the middle of the Cabrini-Green housing project. At this assembly for Black History Month, Villanueva performs for students from Edward Jenner Elementary School as a part of Black Cowboys Chicago. The Cowboys teach people about the oft-neglected history of blacks who worked and helped settle the American West during the 19th century. When he's not a Cowboy, Villanueva serves as an officer for the Cook County Sheriff's police.

41 | Ron Gordon | Chicago is famous for its downtown skyline but another skyline, to the southwest of the Loop, offers more smokestacks than skyscrapers. This Commonwealth Edison power generating station at Cermak and Throop is just one example of the architectural remains of Chicago's industrial heyday.

43 | John David Flak | The parking lot for Alcala's Western Wear shop is marked by its idiosyncratic neon signage. The shop was founded in 1972 by Luis Alcala and remains a family-owned enterprise. It is known for its selection of fitted hats (from wool to ten-gallon cowboy to chinchilla fur) and boots ($75 leather to $4,000 alligator). In 2000, 28 years after its opening, the store was one of the largest retailers of Western wear in the region.

44 | Wes Pope | A masonry worker hangs on while working on the façade of a new building in the Lincoln Park neighborhood.

45 | Wes Pope | Kids watch a Chicago Park District-sponsored basketball tournament in Wentworth Gardens, a Chicago Housing Authority project, on a hot day.

47 | Bill Kirby | Dummies used during junior lifeguard training sit at the bottom of the pool at Whitney Young High School. Water rescue skills were taught through a Chicago Park District program.

48 | Yvette Marie Dostatni | In a pre-game fit of derring-do, Bears fan Todd Keeling crushes beer cans against his forehead in the parking lot of the old Soldier Field. The Chicago Bears finished the 2000/2001 season with a 5-11 record.

The Bears played their last game in the "old" Soldier Field in January 2002, and returned to the renovated facility in September 2003.

49 | Leah Missbach Day | As many teenagers do, Elisabeth Garber-Paul, 13, uses her room as a getaway from outside life: a place to just sit and think. Among her thoughts in this solitary moment: the departure of friends, choosing a college, an older sister, and her own waning sense of immortality.

50/51 | Ron Gordon | The Maxwell Street Market's most unwavering truism was that all things were for sale, including salvation-in-scripture, old jazz and blues LPs, costume jewelry, hand-crafted artwork, white socks (in packages of twelve), hubcaps, pornography, Polish sausages—and eventually, even the land upon which the market was situated.

The final Maxwell Street lessons: all posted prices are negotiable, and all sales are final. In 2000, a public-private partnership began to develop the area into condominiums, townhouses, shops, and expanded student housing for the University of Illinois at Chicago.

53 | Kevin Horan | Lyric Opera patrons pause amid their engagement with Tchaikovsky's "The Queen of Spades" (as conducted by Sir Andrew Davis). The opening night performance at 20 N. Wacker was part of "The Millennium Year's Most Fabulous Gala Benefit," sponsored by the Aon Corporation.

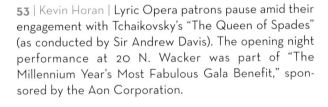

55 | Ron Gordon | The John Hancock and Water Tower Buildings as seen from the sixty-second-floor roof deck of Olympia Centre Southpark at the northern end of Michigan Avenue.

58 | Jane Fulton Alt | Tet, the Vietnamese New Year, was celebrated with a drum-infused, fireworks-emblazoned parade along North Broadway in the Little Vietnam community. After the celebration, a ritual dragon mask was discarded outside the Lucky Star restaurant, south of Argyle Street. Weeks later, Lucky Star was replaced by the Ba Mien restaurant.

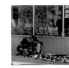

59 | Feng Liu | State Street is still "that great street" Sinatra sang about. Bustling crowds of people—in all styles of fashion—traverse its store-fronted sidewalks every day.

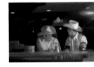

61 | Katrina Wittkamp | The Tropicana D'Cache nightclub at 2047 W. Milwaukee Avenue was home to the O.K. Corral lounge, where traditional Mexican dance music played throughout the night.

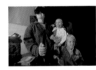

63 | Wes Pope | Rene Struck—from Waverly, Iowa, accompanied by her daughters, 1-year-old Paige and 5-year-old Lauren—plays a three-dimensional video game at the indoor Disney Quest theme park. The arrival of America's second Disney Quest facility was the apex of a transformation in the quadrant between Navy Pier, the Kennedy Expressway, the Chicago River and Chicago Avenue into a tourist haven. Although that portion of the city became a commercially bustling, family-friendly zone, Disney Quest itself ceased operation soon after the arrival of the new millennium.

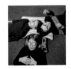

64 | Michelle Litvin | Iris, Julia and Annie top off their treatments—and their slumber party celebration of Iris' 9th birthday—by relaxing their young eyes underneath cucumber slices.

66/67 | Bill Stamets | The remains of the Paul & Bill Tailor Shop on West Maxwell Street are flanked by the Midwest Demolition Co.'s metal bucket.

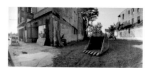

73 | Kevin Horan | Owned by Hines and J.P. Morgan Investment, 303 E. Wacker Drive, shown against the backdrop of downtown, won its second consecutive Office Building of the Year Award (Renovated category) from the Building Owners and Managers Association (BOMA) in 2000.

68 | Ron Gordon | A skeleton of a building at the Chicago Housing Authority's Robert Taylor Homes, at 44th and State Streets, marks the skyline in the shadows of downtown. Many of Chicago's infamous housing projects were well on their way to history's annals by 2000, as real estate developers cleared terrain.

76 | Richard A. Chapman | Over the years, Jean's Restaurant, near the Criminal Courts Building at 26th Street and California Avenue, has fed scores of judges and lawyers and court workers. Public defender Woody Jordan had worked the Homicide Task Force Unit for 17 years as of 2000; he often eats lunch at Jean's.

69 | James Iska | The 18th edition of Chicago's Puerto Rican Festival was held at the North Side's Humboldt Park. The June event regularly draws more than a half-million attendees to the community in celebration of the culture of the island and the contributions of Puerto Ricans who immigrated to this city.

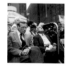

77 | Jon Lowenstein | Long before its first subway opened in 1943, Chicago was a city connected by public transportation. Even in the car culture of 2000, the Chicago Transit Authority bus and train commuter lines were responsible for carrying more than 1 million riders throughout Chicago and its suburbs. This comfortable commuter may be one of many who travel to and from work on the city's famous "L" trains.

70 | Robert A. Davis | Young Pilsen residents take sanctuary from the summer heat in their shallow curb-side swimming pool. The chair serves multiple purposes. It can quarter-off space for the pool in the summer, and after a winter snowstorm it can be used to secure the family's shoveled-out parking space.

78 | Bill Stamets | Before the Memorial Day Parade steps off, dignitaries, including Chicago Sun-Times columnist Irv Kupcinet, left, gather at Heald Square Monument at East Wacker and North Wabash. Kup, as he was famously known, died in 2003 at age 91.

71 | Liz Chilsen | The Northwest Side's Dunning neighborhood as seen from the porch of a Schorsch Village home, along North Oak Park Avenue.

79 | Robert A. Davis | Local Republican Larry Rojahn slumbers at GOP campaign headquarters at the Swissotel, East Wacker Drive at Stetson Avenue, while awaiting results of the U.S. presidential election. America soon learned that the election would not be decided that night.

80 | George Pfoertner | A patient receives treatment from the medical staff at Mount Sinai Hospital's trauma center. The 33-year-old was beaten with a pool cue after an evening of millennium celebration turned into a melee.

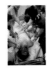

81 | George Pfoertner | Early on January 1, Derrick Hicks, left, and his Mount Sinai Hospital cleanup crew scour the ER after a shooting victim was taken to surgery. Chicago police officers fired on the man after he reportedly discharged a pistol from his balcony in celebration of the New Year. These emergency room employees are responsible for scrubbing floors, as well as collecting and discarding refuse such as bloodied towels and used syringes.

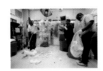

83 | Feng Liu | Frustration born of gridlock is commonly reflected in expressions of mid-day Michigan Avenue motorists.

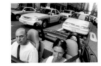

85 | Kevin Horan | The walls of International Harvester's Wisconsin Steel mill (closed in 1980) encase an Environmental Protection Agency cleanup site.

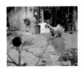

86 | Yvette Marie Dostatni | Before succumbing to the renovation and upward mobility in the new millennium, Chicago's Maxwell Street was home to a large homeless population, many of whom stayed at Maxworks, 717 W. Maxwell Street.

Of his Clue board game, Lewis "Bubble" Tucker says, "This here? This picture? This is a rich picture. This is how white people live, know what I mean?"

87 | Yvette Marie Dostatni | Lewis "Bubble" Tucker has no money for tobacco, so he smokes wax paper, which creates a lot of smoke. He has lived in his car for about 15 years.

He says he'd been living on Maxwell Street about 30 years. "I don't go nowhere else ever since I was about 10 years old. This (the car) is like a clubhouse, somewhere to sleep."

88 | Yvette Marie Dostatni | Avi and Tyner White store stuff in a hole under the sidewalk.

89 | Yvette Marie Dostatni | Althea, another resident, used to read tarot cards outside coffeehouses for money. Poppy and Muffy and Spookie were her pets who had disappeared. "Again! The card's about sweetness. There are miracles in life. Oh, I need a miracle. Oh, my beautiful pets," Althea says.

89 | Yvette Marie Dostatni | Wes, the owner of the Maxworks, also lived there.

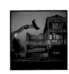

92/93 | Ron Gordon | After sitting vacant for months, this former Breyers ice cream shop at 1304 S. Halsted is reduced to rubble in the course of one August day.

94 | Robert A. Davis | Amid the square peaks and reaching antennae of the Water Tower and John Hancock Buildings, cranes, frames and girders rise. Crane operator Mike Femali takes a snack break—850 feet above the Magnificent Mile—at the site of the Park Hyatt.

96 | Robert A. Davis | Near 35th Street and Oakley Avenue, Queenie, a lifelong motorcycle enthusiast, tools about in celebration of her 68th birthday. Her Honda is emblazoned with her name scrolled on the gas tank, and she proclaims that she has been riding motorcycles since she was 12 years old.

98 | Robert A. Davis | A girl looks out the window of Lupe's Beauty Salon in Pilsen, watching the annual Good Friday re-enactment of the Stations of the Cross.

99 | Robert A. Davis | Junior the Barber provides a valuable service to the residents of a Cabrini-Green tower. Operating out of his ad-hoc seventh floor hallway "shop," 32-year-old Junior had been tending to residents' heads for some ten years as of 2000. "On a good day," he says, "I cut twenty people. Slow day: eight to ten." On this afternoon, he handles the style requests of Artese, 7, Duce, 11, and Mulkin, 4.

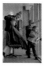

100 | Feng Liu | Students from a local private school take a lunch break near the greenery of downtown's Grant Park.

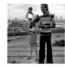

101 | Yvette Marie Dostatni | Charles Stevens, right, finds amusement in his westward view of the Kennedy Expressway from Wicker Park as his 18 year-old friend Matylda Wiacek plays with her companion, Farrah the ferret.

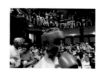

103 | Wes Pope | Fight Night is a 30-year tradition at Mount Carmel High School, one of the city's most renowned Catholic schools. The event features members of the all-male student body engaging each other in the pugilistic sciences and it draws devotees to the gladiator-esque, yet somehow collegial, festivities at the school's 64th Street and Dante Avenue campus each year.

104 | Colleen Dahlberg Plumb | 3039 N. Lincoln.

104 | Colleen Dahlberg Plumb | An empty elephant's pen at Lincoln Park Zoo.

105 | Colleen Dahlberg Plumb | Hamlin Park, sunset.

106/107 | Carol McLaughlin | Whether squares of patchy beige and green grass sectioned off by wire fence, or carefully cultivated gardens of wind chimes and sculptures, Chicago's back yards are a way to learn something about the city.

111 | Ron Gordon | The Amtrak rail yard at the Chicago River's South Branch on New Year's Day.

113 | Jon Lowenstein | Taxis wait at the CitiBank Center in the Loop.

114 | Antonio Perez | A mariachi places his order at the drive-thru window of a McDonald's on Cermak Road. The Mexican troubadour was part of a troupe participating in the Cinco de Mayo parade in Pilsen.

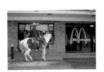

115 | Yvette Marie Dostatni | Second-hand TVs and vacuum cleaners line the shelves at the Swap-o-Rama at 41st Street and Ashland Avenue. It's at the edge of the Back of the Yards neighborhood, named such for its proximity to the stockyards of Chicago's meatpacking history.

116 | Feng Liu | Bradley of Wisconsin and Samna of California enjoy the fresh breeze and popcorn at Navy Pier.

117 | Robert A. Davis | Rather than braving the frigid winds in search of an after-midnight cab, these millennial revelers opt for a CTA bus to carry them from Michigan Avenue's Symphony Center to their next party.

118 | Robert A. Davis | Facing the weather head-on, resilient commuters cross the Chicago River. In the 2000/2001 winter season, Chicago received its first blast of snowy weather shortly after Thanksgiving and the last snowdrifts lingered well into the spring.

119 | Wes Pope | Martell Smith, 13, left, and Jonathan Heath, 15, search for rocks along the lakefront's sandless stretch between Oakwood Boulevard and 57th Street.

123 | Zbigniew Bzdak | Religious faith is as much a pillar of Chicago as the pizza, politics and never-say-die baseball the city is famous for. The forms and varieties of Chicago's spiritual beliefs are as varied as the city's skyline and just as important to its character and flavor.

Robert Fryerson, 8, holds hands with elder members of Blooming Rose Deliverance Church in Englewood.

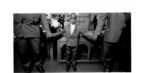

125 | Zbigniew Bzdak | Benyamin Ben Israel holds a Torah scroll after reading during Saturday service at the Beth Shalom B'Nai Zaken Ethiopian Hebrew Temple. He's with Rabbi Capers C. Funnye Jr., left, and Benyamin McCabe, right.

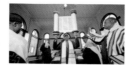

126 | Zbigniew Bzdak | Rev. John Wilkinson, of the Magnificent Mile's Fourth Presbyterian Church, splits a symbolic loaf of bread for Communion. Rev. Sarah Jo Sarchet joins him in celebrating a sunrise Easter service at Oak Street Beach.

127 | Zbigniew Bzdak | Traditional Sabbath prayers are offered at the home of Miriam Redleaf and her partner, Hanna Goldschmidt, both in background. The Redleaf children—from left Sahai, 11, Zenebesh, 15, Isaac, 15, and Hanna, 9 (not shown)—are raised in Jewish tradition. After a week of Hebrew school, the children gather in the family home on the Sabbath, lighting candles and offering traditional prayers before their kosher meal.

127 | Zbigniew Bzdak | At Bethany Evangelical Lutheran Church on West Thorndale Avenue, members of the largely Eritrean congregation dance after Pastor Tesfu Gedar's end-of-service blessing.

129 | Zbigniew Bzdak | Rabbi Moshe Perlstein (center, holding Torah) leads a procession of Orthodox Jews in front of Lubavitch Mesivta of Chicago, a Hebrew high school in West Rogers Park. The members carried older red- and yellow-bound copies of the Torah, keeping them carefully covered by a fringed canopy, to the school. To culminate the celebration, the Hasidim danced before entering the school building. Rabbi Perlstein compared the celebration to a wedding: The new Torah is brought into the congregational family and treated with reverence. "We're sort of married to it," he says, "It's our way of life."

130 | Zbigniew Bzdak | Ushers take up the collection as part of Christmas Eve Midnight Mass at Holy Name Cathedral on North State Street.

131 | Zbigniew Bzdak | Pastor Roberto Alveo, a visiting missionary from Puerto Rico, gives blessing at the Asamblea Apostolica church on West Superior Street, during a worship service. The congregation here is made up of Pentecostal immigrants from Latin American countries. At the culmination of service all congregants approach the front of the church for blessing and healing.

132 | Zbigniew Bzdak | In their mosque on West Sheridan Road, members of the Nigerian Islamic Association observe the end of the fast of Ramadan, the month when Muslims concentrate on strengthening their faith in Allah rather than on worldly consumption. In keeping with Islamic tradition, a curtain separates male and female worshippers while they are at prayer.

133 | Zbigniew Bzdak | The Wat Khmer Metta Kampuchean Buddhist Society conducts its Cambodian New Year celebration at Truman College, in the Uptown neighborhood. These young ladies, adorned in traditional Cambodian clothing, danced to bless the upcoming year.

135 | Kevin Horan | Sixty-six-year-old twins Jennie, left, and Julia Papilli pause upon the blazing sand at Oak Street Beach.

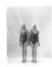

139 | Colleen Dahlberg Plumb | New Year's fireworks at Foster Avenue Beach.

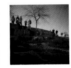

140 | Alison McKinzie | At the turn of the century, Tempel Steel Co. on Wolcott Avenue could rightfully proclaim itself "the largest producer of magnetic steel laminations for the electronic and electrical industries for use in motors, ballasts and transformers." The 55-year-old manufacturer employed some 1,500 workers in factories in Chicago, Mexico and Canada as of 2000.

141 | Alison Bixby | Young friends wait for the train on the Belmont "L" platform. This elevated station was in its 100th year of service as of 2000. Originally a feeder for the old Northwest Elevated system, the contemporary Belmont station serves the CTA's Red (Howard-95th), Brown (Kimball-Loop) and Purple (Evanston) commuter lines.

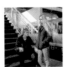

142/143 | Jed Fielding | The chalkboard in Dan Dillon's classroom at Jamieson Elementary School is both a portal for exploration of the universe beyond what is visible to the naked eye and a tool for enhancing the curiosity and imagination of students. The second photo charts the contribution of Dillon's students to one of the day's exercises.

144 | Jon Lowenstein | Even as technology revolution-ized the investment industry, the Chicago Mercantile Exchange's traditional "open outcry" system remained the center of commodities, futures and index trading for the global marketplace. Almost three quarters of a tril-lion dollars worth of buy-and-sell agreements were forged via the Merc, 30 S. Wacker Drive, in 2000.

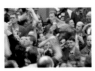

145 | Wes Pope | Chicago-based TV House Inc. produces streaming content for Internet broadcasts. TV House was founded in 1999, just as the Western technology market-place approached its apex. Even after "boom" became "bust" in the industry, the company continued to diversify services under CEO Ted Holsteen, far right, and it thrived through the turn of the century. Here, some TV House staff members receive an advanced Photoshop lesson in a conference room in their Financial District office.

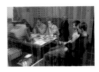

146/147 | Suzy Poling | Uptown Theatre, 4816 N. Broadway

149 | Yvette Marie Dostatni | Stack testers represent their occupation and their local by donning union hats to march in the 45th Annual St. Patrick's Day Parade through downtown Chicago. The stack testers are responsible for ensuring that output from the city's smokestacks meets Environmental Protection Agency emissions standards.

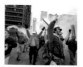

151 | Feng Liu | A gentleman, impeccably dressed in the style of a bygone era, pauses in the midst of his walk through Lincoln Park.

152/153 | Lloyd DeGrane | While incarcerated, these men completed a religion class. On the opposite page is a traditional lunch at the Criminal Courts Building holding facility at 26th and California where the men were being held.

154/155 | Lloyd DeGrane | Residents of the City that Works dress up, and down, for the duties they take on every day.

159 | Robert A. Davis | At Michigan and Grand, craftsman Pete Willy welds metal brackets that would attach the old façade onto the renovated John Buck North Bridge Building. The new structure would contain retail space, a hotel, and living spaces. The city designated the original art deco façade a historic landmark.

161 | Paul L. Merideth | Barge traffic continues to travel beneath the 95th Street bridge of the Chicago-Indiana Skyway.

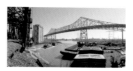

162 | Zbigniew Bzdak | Animal Kingdom pet store employee Amber Toledo takes a break outside the shop on North Milwaukee Avenue. The store is a 50-year-old staple of the Milwaukee Avenue commercial strip. In years past, the store's inventory included a lion, kept safely in the back room. By 2000, the king of the jungle's place in this Animal Kingdom had been taken by a monkey.

163 | Micah Marty | Beneath the Green Line tracks at Lake Street and Racine Avenue.

164 | Ron Gordon | Two fashionistas-in-training stop to pose under "L" tracks in Little Village. Their split t-shirts illustrate one of 2000's fashion trends—popular with the younger set, but not always approved of by their parents.

165 | Yvette Marie Dostatni | Cheerleaders from Cooper City, Fla., prepare for the third annual National Cheerleaders Association/National Dance Association competition at Navy Pier. The March event affords more than 1,400 performers chances to vie for recognition in some 35 categories.

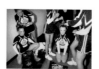

167 | Tom Arndt | Natalie Ortiz admires Felix Ortiz's close fade, a common hairstyle, at the Puerto Rican Festival.

169 | Leah Missbach Day | LaTanya Foster-Thomas, part of a team of teachers providing home schooling to pregnant adolescents unable to attend traditional high schools, feels a powerful prenatal kick.

171 | Yvette Marie Dostatni | At North Avenue Beach, Sebastian the dog loses a flock of seagulls in the fog.

175 | Jane Fulton Alt | Joe Torres receives assistance bathing from his hospice home health aide, Elvina Joseph. Mr. Torres, 76, was diagnosed with Parkinson's disease in 1994. Gloria, his wife of 38 years, served as his primary caregiver for the first six years of his illness. With Mr. Torres' condition in its final stages, the family received additional assistance from Hospice of the North Shore's support services.

176 | Jon Lowenstein | The 2000 edition of the annual "Player's Ball," hosted by Chicago legend Bishop Don "Magic" Juan, was held at the East of the Ryan lounge on 79th Street. Juan and his annual birthday party were featured in the HBO documentary *Pimps Up, Ho's Down*.

177 | Wes Pope | Thomas L. Willis, right, and Theodore Reams, both 43, share space at Cook County Hospital's Ward 20. This wing provided specialized care to those with HIV-related illnesses. Half a million Americans were known to be living with HIV at the turn of the century.

178 | Jon Lowenstein | In the hub of the old First Ward, a newspaper vendor hawks updates on the presidential ballot battle between Al Gore and George W. Bush.

179 | Yvette Marie Dostatni | On North Michigan Avenue, Barbie Patton, who has appeared on Jerry Springer and Jenny Jones' television talk shows, performs before her own in-house mirrors, accompanied by one of the three karaoke machines she owns. Patton compares her performance style to that of Janis Joplin.

180 | Alison McKinzie | Millennial handbag fashions are on display at the Gucci store at 900 N. Michigan. Gucci shares the address with Bloomingdale's and other high-end retailers.

181 | Alison McKinzie | As of 2000, well-entrenched residential neighborhoods, such as West Rogers Park, remained largely untapped and untargeted by the forces of gentrification, enabling small privately owned businesses to thrive.

Connie's Beauty Parlor, West Touhy Avenue.

181 | Alison McKinzie | Vogue Cleaners, West Touhy Avenue.

183 | Lloyd DeGrane | Every afternoon, while she eats her lunch, Flo watches over her Southwest Side neighborhood, near 71st Street and Kedzie Avenue, through her dining room window.

187 | Jon Lowenstein | Loop

188 | Jon Lowenstein | Southeast Side

188 | Jon Lowenstein | Southeast Side

189 | Jon Lowenstein | Southeast Side

189 | Jon Lowenstein | Southeast Side

190 | Jon Lowenstein | Loop

190 | Jon Lowenstein | Loop

191 | Jon Lowenstein | Loop

193 | Bill Stamets | Archways in the 57th Street viaduct along the Illinois Central tracks.

195 | Jane Fulton Alt | A woman stops to admire statues at the Museum of Science & Industry, 57th Street and Lake Shore Drive.

200 | Antonio Perez | In the Andersonville neighborhood, Omar Mujahid and his father participate in a protest march against domestic violence. The march began at the Women and Children First bookstore on North Clark Street.

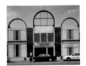

202 | Micah Marty | Amid the train lines, the gentrification and the discount clothing and beauty shops along 47th Street, the Christian Tabernacle Baptist Church stands out.

202 | Micah Marty | For the second half of the 20th century, housing projects stood as entry portals at each of the city's sides. The Harold Ickes and Raymond Hilliard communities looked to the South, the Henry Horner Homes looked to the West, and Cabrini-Green, which housed approximately 6,000 residents in 2000, looked to the North.

203 | Micah Marty | The Big and Tall men's clothing store at Halsted and Maxwell was one of the last traditional venues still open for business in the Maxwell Street Market corridor, as the University of Illinois at Chicago laid the foundation of its University Village housing and retail development.

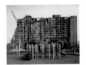

203 | Micah Marty | This view of an early stage of the Near North Redevelopment Initiative shows the demise of a Cabrini-Green building. This plan, backed by federal and private funding, sought to dismantle Cabrini-Green in increments with the goal of creating a mixed-income community.

205 | Bill Kirby | A young couple steals a kiss at the Pulaski Park swimming pool on Blackhawk Street.

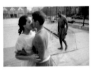

206 | Yvette Marie Dostatni | Even in 2000, Marzano's Miami Bowl is replete with Coke machines still dispensing glass bottles and with vintage bowling lanes. Balls and pins crash at deafening levels, burying the bass of stereo-amplified rhythm and blues. High-fives and laughter find concert in the cacophony.

207 | Kevin Horan | As the Stations of the Cross procession makes its way beyond 18th Street at Damen Avenue, the Rivera sisters, Mariana and Sylvia, joined by Pedro Alvarado, sell crucifixes to the faithful at Pilsen's Harrison Park. The homemade icons cost $20 each.

208 | Yvette Marie Dostatni | A couple pauses after the automobile procession that was part of the revelry at the Polish Highlanders Alliance's Constitution Day celebration.

209 | Yvette Marie Dostatni | The Korean Kite Flying team prepares to fly more than 2,000 kites over Lake Michigan at Montrose Beach. The display was a symbolic expression of appreciation for renewed peace talks between North and South Korea.

210 | Carlos J. Ortiz | Hip-hop artist Mos Def delivered a virtuoso performance at the House of Blues on a Monday in 2000, promoting his first solo album, *Black On Both Sides*. A contingent of his Chicago-area fans display their feelings at the show.

212 | Alison McKinzie | A woman relaxes at Edgewater Beach in October, after a summer when this beach—and others—were often closed due to high bacteria counts.

213 | Katja Heinemann | A Division Street bathhouse.

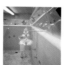

219 | Cecil McDonald | Artist Byrant Anderson pauses to assess his contribution to the mural at 87th Street, beneath the Chicago-Indiana Skyway.

220 | Ron Gordon | The bridge system atop the redirected flow of the Chicago River's main channel was a fixture of travel in downtown Chicago through much of the 20th century. Constructed to allow land traffic to cross the river without impeding the course of stacked industrial barges and commercial vessels, the bridges' rise was somewhat rare by 2000. Here, the Lake Street Bridge parts to allow the passage of a procession of small boats.

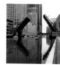

221 | Jane Fulton Alt | A couple in a Lakeview apartment.

223 | Jon Lowenstein | Cleverly displayed eggs sit ready to be consumed during the breakfast rush at MOD restaurant on North Damen Avenue in Wicker Park.

225 | Bill Stamets | Members of the Jehovah's Witness faith watch the broadcast of a religious pageant on the scoreboard of Comiskey Park, the former home of the Chicago White Sox. Nearly 20,000 Jehovah's Witnesses gathered in the ballpark for worship services in July 2000. These bilingual services, in Spanish and English, took place over several Saturdays and included sermons, Bible study, and full-immersion baptisms.

228/229 | Wes Pope | With Comiskey Park on the horizon, the Wentworth Avenue White Sox practice in the concrete lot adjacent to an elementary school at 68th Street and South Wentworth Avenue. Made up of 8-to-12-year-olds from the Wentworth Gardens housing community, the Sox are one of 16 Inner City Little League teams. Administered by the Park District as of 2000, the league's teams include Chicago Housing Authority residents and compete at the South Side's Washington Park; squads share the names of Major League Baseball teams, and the league is partially sponsored by the Chicago Cubs' Cubs Care foundation and the Chicago White Sox.

235 | Bob Thall | Clouds shroud the horizon beyond Montrose Harbor.

241 | Micah Marty | A "corner" flat sits on South Prairie Avenue in Bronzeville.

230 | Jon Lowenstein | As the inheritor of big-city America's last municipal dynasty, Mayor Richard M. Daley carries the burden of Chicago's political history on his shoulders.

243 | Paul L. Merideth | An electrical tower sprouts from land scoured by industry east of the Calumet River at the city's southern end. By 2000, a good deal of the East Side's manufacturing quadrant had been deserted.

232 | Bill Stamets | The walls of Jenner Elementary Academy of the Arts are decorated with artifacts including student artwork, graphics, photographs and even stuffed dolls.

245 | Zbigniew Bzdak | Love of Christ Missionary Baptist Church pastor Alex Crumble waves to Christian Jones, right, A.B. Jones, and other congregants after Sunday service at the South Halsted Street church.

233 | Jon Lowenstein | West Loop commuters make their way past the Lyric Opera and across the Madison Street Bridge.

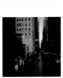

246 | Steven Szoradi | Roseland Pumping Station

247 | Steven Szoradi | South Water Purification Plant

249 | Jane Fulton Alt | A couple perch on the balcony of their Lincoln Park apartment.

253 | Alison McKinzie | Late summer storm clouds sweep past the apartment and condominium high-rises on Sheridan Road in Edgewater.

255 | Jon Lowenstein | In keeping with longstanding Chicago tradition, a North Side resident stakes out a shoveled parking place with a chair. A blizzard hit Chicago in early December 2000, producing many scenes like this one.

Jane Fulton Alt was born in Chicago in 1951; her photographs explore universal issues of humanity. Her work can be found in several permanent collections, including the Museum of Fine Arts in Houston, Beinecke Library at Yale University, Centro Fotografico Alvarez Bravo in Oaxaca, Mexico, and the Harry Ransom Humanities Research Center, and has been exhibited nationally and internationally.

Tom Arndt has been a photographer for 35 years, crisscrossing America to watch, listen and chronicle the people he sees.

Alison Bixby, born in Princeton, N.J., earned her MFA from the School of Visual Arts in New York, N.Y., and has exhibited her photos nationally and internationally since 1988. Working as a photographer and real estate agent, Alison currently lives in Chicago where she continues her series of color photographs titled *Signs of Life in America*.

Zbigniew Bzdak, born in Poland, has been documenting the Amazon region for many years, including the Huaorani tribe in Ecuador and the first kayaking team to successfully navigate the Amazon River. His work has appeared in National Geographic. He has also spent the last several years documenting religion in immigrant communities, and was on staff during CITY 2000. He is a staff photographer for the Chicago Tribune.

Richard A. Chapman has been a staff photographer for the Chicago Sun-Times for 15 years. Previously he worked for various newspapers in the Chicago suburbs.

Liz Chilsen has taught photography in Chicago for 24 years and lectured nationally. Her work in photography, film and writing has been published in the United States and abroad. She is co-author of *Friends In Deed: The Story of U.S.–Nicaragua Sister Cities*.

Paul D'Amato lives in Chicago where he teaches at Columbia College Chicago. He is also a photographer.

Robert A. Davis is a freelance photographer who lives and works in Chicago. He believes that the power of photojournalism lies in its ability to tell a story by documenting moments in time and reflecting them back to the viewer. He was a staff photographer during CITY 2000.

Leah Missbach Day is an MFA graduate of and adjunct professor at Columbia College Chicago. Her portfolio of documentary photography can be found within the Midwest Photographers Project at the Museum of Contemporary Photography in Chicago and as part of the Refco and LaSalle Bank Collections. She was a staff photographer during CITY 2000.

Lloyd DeGrane is a Chicago-based freelance photographer. He is working on two documentary photo essays: *Dinnertime at Home* and *The Care and Maintenance of the American Lawn*.

Yvette Marie Dostatni is a freelance photographer who lives in Chicago. She was a staff photographer during CITY 2000.

Jed Fielding's photographs are represented in public and private collections including the Museum of Modern Art, New York, the Museum of Contemporary Photography, Chicago, and Walker Art Center, Minneapolis. His monograph *City of Secrets: Photographs of Naples* was published in 1997.

John David Flak, a former Chicagoan, currently lives in Philadelphia, where he is a professional stage manager and part-time photographer. He usually shoots with his Holga camera.

Ron Gordon was born on the South Side of Chicago and did his graduate studies in language and literature. He started photographing architecture in the 1970s and has worked extensively in historic preservation photography over the last three decades. His residence and studio are in the Pilsen neighborhood in Chicago.

Katja Heinemann is a documentary and editorial photographer living in Brooklyn, NY. Represented by Aurora Photos, she has been working on a new media documentary, *On Borrowed Time*, which chronicles the lives of children and teenagers who have grown up with HIV/AIDS in the United States.

Kevin Horan lives in Chicago where he is a magazine and fine art photographer specializing in portraits and landscapes. He was a staff photographer during CITY 2000.

James Iska has been a working photographer, documenting many aspects of the urban landscape, most notably in Chicago, since 1980 after graduating from the Institute of Design.

Bill Kirby is a working art photographer and photo instructor in Chicago. He has an appreciation for the humorous aspects of our society and culture.

Patrick Linehan

Michelle Litvin lives and works as a photographer in Chicago.

Feng Liu moved to Chicago from Shanghai, China, as an engineer in 1999. He has been photographing the life of the city of Chicago for several years.

Jon Lowenstein is a freelance photographer based in Chicago. He was a staff photographer during CITY 2000.

Stephen Marc is a photographer/digital montage artist and a professor of art at Arizona State University. He is documenting Underground Railroad sites throughout the United States. Raised in Chicago, he taught at Columbia College Chicago for 20 years.

Micah Marty is a Chicago-based photographer focusing on sacred space, especially as evidenced in Western religious architecture.

Cecil McDonald lives in Chicago where he works as a photographer.

Carol McLaughlin

Alison McKinzie lives in Chicago and works in digital imaging and archiving. She is also a photographer and painter.

Paul L. Merideth has been a Chicago-based freelance editorial photographer for 21 years. He was born in Pontiac, Michigan, in 1954 and received a MFA in photography in 1980.

Robert Murphy was born in Milwaukee, Wisconsin, and trained as an architect, before coming to photography somewhat later in life. He lives and works in Chicago.

Carlos J. Ortiz was born in San Juan, Puerto Rico, and raised in Chicago. He developed a love for photography at an early age and now is a freelance photographer in Chicago. He was a staff photographer during CITY 2000.

Antonio Perez is a documentary photographer who has been shooting Chicago's far Southeast Side for more than 20 years. He is a staff photographer for the Chicago Tribune.

George Pfoertner is a freelance editorial and corporate photographer who also works with non-profit organizations. He studied art and photography.

Colleen Dahlberg Plumb earned a MFA in Photography and currently teaches part-time at Columbia College Chicago. Her work is included in the permanent collections of the Museum of Contemporary Photography in Chicago and the Beijing Natural Cultural Center, Beijing, China, and has been exhibited and published nationally.

Suzy Poling, a recent transplant from Chicago to the San Francisco Bay Area, has shot for many publications and her work has been exhibited nationally. She has been teaching photography and creative writing to youths for five years.

Wes Pope, a photojournalist, was born in 1971 and grew up in Auburn, Washington. He has a BA in cultural anthropology and is currently a staff photographer at the Chicago Tribune. He was a staff photographer during CITY 2000.

Bill Stamets, a former contributor to Impact Visuals, is a freelance photographer and film reviewer in Chicago, shooting Widelux panoramas and Super-8 films. He also teaches part-time at the School of the Art Institute of Chicago and Columbia College Chicago.

Steven Szoradi

Bob Thall is the chair of the Photography Department at Columbia College Chicago and has photographed the Chicago landscape since 1972. He has published four books of photographs, the most recent is *At City's Edge: Photographs of the Chicago Lakefront* (2005).

Katrina Wittkamp is a freelance photographer from Durham, N.C. A graduate of the University of North Carolina in 1994 with a photojournalism major, she now lives in Chicago with her husband, Steve, and daughter, Ella.

Rosellen Brown, whose most recent novels are *Half a Heart* and *Before and After*, has also published collections of poetry and stories. She teaches in the graduate writing program at the School of the Art Institute of Chicago.

Stuart Dybek is the author of three books of fiction including *The Coast of Chicago*, which was a One Book, One Chicago selection. His most recent book is a collection of poetry titled *Streets In Their Own Ink*.

Jonathan Eig is a reporter in the Chicago bureau of The Wall Street Journal and the author of *Luckiest Man: The Life and Death of Lou Gehrig*. He lives in the Lakeview neighborhood of Chicago with his wife and children.

Joseph Epstein, born in 1937, attended Chicago public schools and later, the University of Chicago. He is the author of nineteen books, among them *Snobbery* and *Fabulous Small Jews*.

Alexai Galaviz-Budziszewski grew up and still lives on the South Side of Chicago. His work has appeared in many journals including Triquarterly, Alaska Quarterly Review and Ploughshares.

Aleksandar Hemon is the author of *The Question of Bruno* (2000) and *Nowhere Man* (2002). Born and raised in Sarajevo, Bosnia-Herzegovina, he has lived in Chicago since 1992.

Peter Bacon Hales teaches at the University of Illinois at Chicago. A writer and photographer, he is currently completing two books: a history of the postwar American cultural landscape and a study of the contemporary landscape, tentatively titled *Freeways, Now*.

Rick Kogan is a Chicago newspaperman.

Alex Kotlowitz is the author of three books: *There Are No Children Here*, *The Other Side of the River* and *Never a City So Real*. He regularly contributes to *The New York Times Magazine* and public radio's *This American Life* and is a writer-in-residence at Northwestern University.

Li-Young Lee, the author of two books of poetry, *Rose* and *The City in Which I Love You*, was born in Jakarta, Indonesia, and moved to the United States in 1964. He lives in Chicago with his wife, Donna, and their children.

Achy Obejas is the author of three books, including the critically acclaimed *Days of Awe*. She teaches writing at the University of Chicago.

Bayo Ojikutu is the Chicago-born author of the novels *47th Street Black* (2003) and *Free Burning* (2006). He teaches in the Department of English at DePaul University and in the Division of the Humanities at the University of Chicago.

Carlo Rotella is the author of *Cut Time*, *Good With Their Hands* and *October Cities*. He is director of American Studies and professor of English at Boston College.

Studs Terkel has been an actor, lawyer, radio host, pioneering television star, author, lifelong activist and Pulitzer Prize winner. He lives in Chicago.

Teresa Wiltz writes for The Washington Post covering arts and culture. She wrote for the Chicago Tribune from 1991-1999, before moving to Washington, D.C.

Production coordination, art direction and editing by Teri Boyd. Photography consultants include Ken Burkhart, Shashi Caudill, Peter Bacon Hales and Mike Zajakowski. Design by Ken Harper and Andy Frazier. Photographic printing and digital imaging by Ron Gordon, Christopher Ferrari, John Hennion, Alison McKinzie, Mark Sarazen, Jasmin Shah and Sandy Steinbrecher. Text editors include Rick Kogan, Melissa Maday, and copy editor Cristi Kempf, with captions written by Teri Boyd, Melissa Maday, and Bayo Ojikutu.
Acknowledgements to The Comer Archive of Chicago in the Year 2000 (CITY 2000), University Library, University of Illinois at Chicago.
With special thanks to Massimo Tonolli and associates.

city Copyright © 2006 by 3 Book Publishing.
939 W. North Avenue Suite 850, Chicago, Illinois 60622, USA
312-274-0546

This book is distributed by the University of Illinois Press
1325 S. Oak Street, Champaign, Illinois 61820-6903
www.press.uillinois.edu

Printing and binding by Trifolio, Verona, Italy

Trade edition ISBN 0-252-03177-6
 ISBN 978-0-252-03177-9
Deluxe edition ISBN 0-252-03199-7
 ISBN 978-0252-03199-1

Complete Cataloging-in-Publication data is available from the Library of Congress.